Marine Paintings and Drawings in Mystic Seaport Museum

by

Dorothy E. R. Brewington

Mystic Seaport Museum, Inc.

Mystic, Connecticut

1982

Mystic Seaport Museum, Inc., Mystic, Conn.
 Paintings and drawings in Mystic Seaport
Museum, by Dorothy E. R. Brewington. Mystic,
1982.
 x, 220 p. illus., 18 col. plates. 29 cm.
 1. Paintings – Mystic Seaport Museum – Catalogs.
2. Drawings – Mystic Seaport Museum – Catalogs.
I. Brewington, Dorothy E. R.
NC25.M9

Photography by Mary Anne Stets and Claire White-Peterson
Design by C. Freeman Keith
Composition by The Stinehour Press
Printing by The Meriden Gravure Company
Binding by Robert Burlen & Son
FIRST PRINTING, 1982
Copyright © 1982 by Mystic Seaport Museum, Incorporated
ISBN 0-913372-25-0
This catalog has been published through a generous grant from
the Andrew W. Mellon Foundation

CONTENTS

FOREWORD

THIS VOLUME, which for the first time thoroughly catalogs the marine paintings and drawings in Mystic Seaport Museum, has been fifty years in the making. When Mystic Seaport was brought into existence the founders clearly anticipated that paintings would be key elements in the history they sought to preserve. The first painting acquired by The Marine Historical Association, Incorporated, as Mystic Seaport Museum was originally known, arrived in 1931. This catalog not only reflects the growth of the collection since that date but also is symbolic of the stature it has achieved.

Not only did Mystic's painting and drawing collection begin fifty years ago, but so did a relationship of shared interest and mutual support between Marion V. Brewington and his wife, Dorothy. Their involvement in the maritime field steadily grew, and their professional reputations developed. While Curator of Maritime History at the Peabody Museum in Salem, Massachusetts, Marion published on a variety of maritime subjects, including figureheads and navigational instruments. With Dorothy and Marion working together, the *Marine Paintings and Drawings in the Peabody Museum* was published in 1968, and this work remains a major source for maritime art researchers, collectors, and curators. Later, at the Kendall Whaling Museum in Sharon, Massachusetts, they published catalogs of the paintings and prints in that collection.

The Brewingtons had watched Mystic Seaport grow and mature, and we were honored when they accepted positions as Senior Research Associates on our staff in early September of 1974. They came to create a catalog of the Mystic collection. Tragically, Marion died within three months, and Dorothy faced a decision. After more than forty years of working as a team, could she take on this entire project herself? Her courage was clearly demonstrated when, three days after Marion's death, Dorothy said, "I've got to get back to work." And, on the fourth day, she did.

In the seven years that have passed Dorothy Brewington has meticulously cataloged the more than one thousand items in this book. Through it she has established her own reputation independently and has created a lasting tribute to her husband and mentor, Marion.

Over the years a great number of donors, lenders, curators, and conservators have helped to build and care for our collection, and they deserve our thanks. I would like to express our particular appreciation to the following: Laurence J. Brengle, Jr., William C. Brengle, Wendell P. Colton, Carl C. Cutler, Mrs. Thomas S. Gates, Jr., H. H. Kynett, the C. D. Mallory family, the P. R. Mallory family, Mrs. James McBey, The New York Yacht Club, The Savings Bank of New London, the Stillman family, Mrs. Carll Tucker, and Arthur R. Wendell. Generous support from the Andrew W. Mellon Foundation has made the publication of this volume possible.

Finally, I thank Dorothy E. R. Brewington for what she has achieved on behalf of Mystic Seaport Museum, and for what she has contributed in the maritime museum field.

J. REVELL CARR
Director

CATALOGING CONVENTIONS AND ACKNOWLEDGMENTS

This catalog is arranged overall into Western and Oriental artists, with subcategories as given in detail in the table of contents. Within each section the arrangement is alphabetical by the surname of the artist. Measurements have been made to the nearest sixteenth of an inch, height preceding width. All dimensions given are those of the painting itself. Unless otherwise indicated, all oil paintings and embroideries are on canvas; watercolor, pastel, gouache, and tempera paintings and pen and ink sketches are on paper.

Titles have been transcribed from the paintings, with ships' names in single quotes for emphasis. Titles in brackets are those supplied by the compiler. Each signature has been given as the artist wrote it. The attributions are those of the compiler, but some previous attributions by others have been accepted.

All photographic reproductions were made at the Mystic Seaport Museum photographic division by Mary Anne Stets and Claire White-Peterson. I want to acknowledge and give special thanks to two members of the Seaport staff, John Sholl and Philip L. Budlong, Registrar.

D.E.R.B.

WESTERN ARTISTS

IDENTIFIED ARTISTS

Abrams, Lucien
American (1870–1941)

1. [River scene; two vessels moored at pier.] Oil. 16 x 20 in. Attributed to Lucien Abrams. (Not illustrated.)
Source: Mr. and Mrs. Morgan Chaney. 65.715

2. *Rockport Harbor*. Oil on panel. 10½ x 13¼ in. Signed on reverse: Lucien Abrams. Source: Mr. and Mrs. Morgan Chaney. 65.713

Andersen, Carl
American

3. *Oyster boats dredging off Bpt* [Bridgeport] *Conn.* Oil. 20¹⁄₁₆ x 26 in. Signed and dated: Carl Andersen, 1969.
Source: Carl Andersen. 69.37

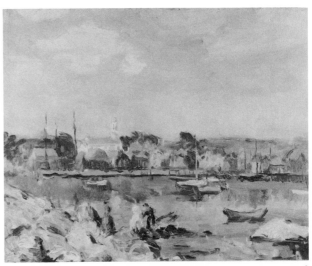

2

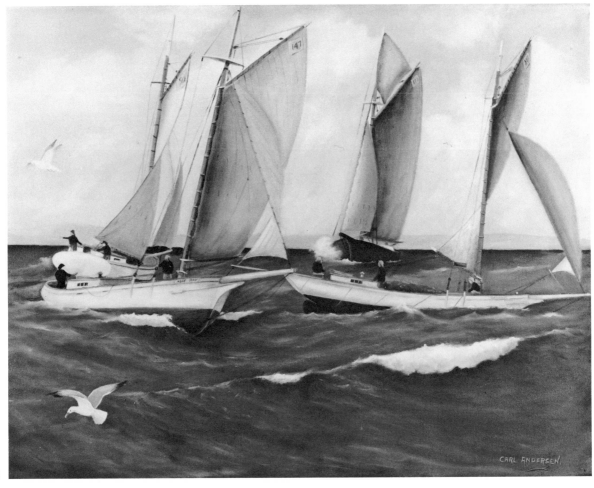

3

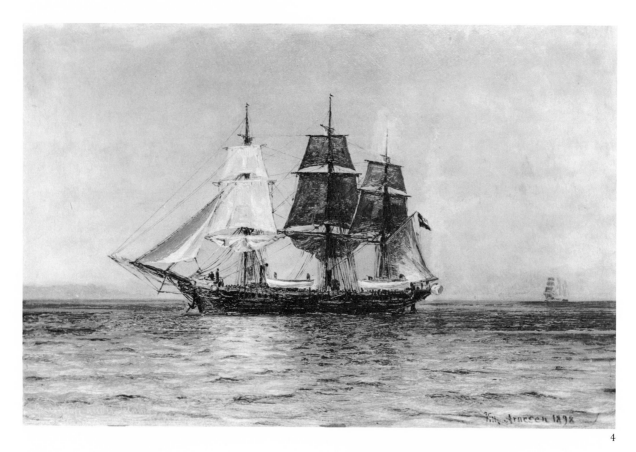

4

Arnesen, Vilhelm Karl Ferdinand
Danish (1865–1945)

4. *'Georg Stage' under Letning Strand möllen den 22 Jun 1898.*
Oil on board. 12 x 18½ in. Signed and dated: Vilh
Arnesen, 1898. Danish auxiliary ship, built 1882, Copen-
hagen, Denmark. 212 tons. 111′ x 25′2″ x 13′2″. Became
the American ship *Joseph Conrad*. Source: Museum
purchase. 72.20

Ashley, Clifford Warren
American (1881–1947)

5. [Gray Fog.] Oil. 35 x 29¼ in. Attributed to Clifford
Warren Ashley. Source: Ensign Everett W. Fabyan.
See color illustration on frontispiece. 49.754

Ashley, H. Percy
American

6. Four books of house and signal flags. Watercolor, pen,
ink. Ca. 8 x 11 in. Signed by and attributed to H. Percy
Ashley. (Not illustrated.) Source: W. P. Stephens and Dr.
Karl Vogel. VFM 668

Atkins, George F.
American

7. *Annie W. Weston.* Oil. 17¾ x 25¾ in. Attributed to
George F. Atkins. American bark, built 1867, Boston,
Massachusetts. 740 tons. 149′ x 31′ x 19′. Source: Harry
O. Winsor. 52.1424

8. *'Benares' of Boston 1440 tons. George B. Wendell Com^r,
Passing Holyhead for Liverpool Sept 25^th 1857.* Oil. 26 x
39¼ in. Attributed to George F. Atkins by donor.
American ship, built 1856 by Hugh McKay, East Boston,
Massachusetts. 1440 tons. 185′ x 41′ x 25′5″. (Not
illustrated.) Source: Arthur R. Wendell. 43.1154

9. *'Benares' of Boston, Geo. B. Wendell Master off Cork, Ireland,
November 1857.* Oil. 23¼ x 34 in. Attributed to George
F. Atkins by donor. American ship, built 1856 by Hugh
McKay, East Boston, Massachusetts. 1440 tons. 185′ x
41′ x 25′5″. (Not illustrated.) Source: Arthur R. Wendell.
43.1155

Babbidge, James Gardner
American (1844–1919)

10. *William Bisbee.* Oil. 21½ x 33⅜ in. Signed and dated:
J. G. Babbidge, 1903. American three-masted
schooner, built 1902, Rockland, Maine. 309 tons.
133′1″ x 31′2″ x 9′3″. Source: Museum purchase.

77.174

7

Babcock

American

11. *Genesta*. Pen, ink. 5⅝ x 7 in. Signed and dated:
Babcock, Nov. [18]85. British sloop yacht, challenger
for *America*'s Cup 1885, built 1884 by D. & W. Henderson,
Glasgow, Scotland. 74 tons. 85'6" x 14'6" x
11'7½". Source: Mrs. Harry Eide. 55.708

12. *'Puritan' entering Vineyard Haven*. Pen, ink. 5⅝ x 7 1/16 in.
Signed and dated: Babcock, Nov. [18]85. American
sloop yacht, defender of *America*'s Cup, 1885, built 1884 by
George Lawley & Son, Boston, Massachusetts. 140 tons.
93' x 23' x 8'2". Source: Mrs. Harry Eide. 55.710

Badger, Samuel Finley Morse

American (active 1882–1913)

13. *George W. Wells*. Oil. 18½ x 29½ in. Signed:
S. F. M. Badger by Permission of N. L. Stebbins.
Taken from N. L. Stebbins Copyrighted photograph. On
reverse: S. F. M. Badger 5 Trenton St. Charlestown,
Mass. American six-masted schooner, built 1900 by H.
M. Bean, Camden, Maine. 2740 tons. 319'3" x 48'5" x
23'1". Source: Museum purchase. 78.117

14. *'Jennie R. Dubois'—Captain E. B. Sneed*. Oil. 21½ x
35⅛ in. Signed: S. F. M. Badger, Charlestown, Mass.
American five-masted schooner, built 1902, West Mystic,
Connecticut. 1952 tons. 249' x 46' x 26'9". Source:
Museum purchase. 57.10

15. *'Mascotte,' New York. Capt. G. P. Buckley*. Embroidery,
satin sails, velvet hull, oil. 19½ x 31½ in. Attributed
to Samuel Finley Morse Badger. American barkentine,
built 1881, Greenport, New York. 593.94 tons. 141' x
32'6" x 19'3". Source: Mrs. Mary Stillman
Harkness. 33.5

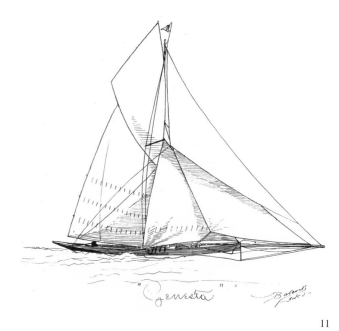

11

12

13

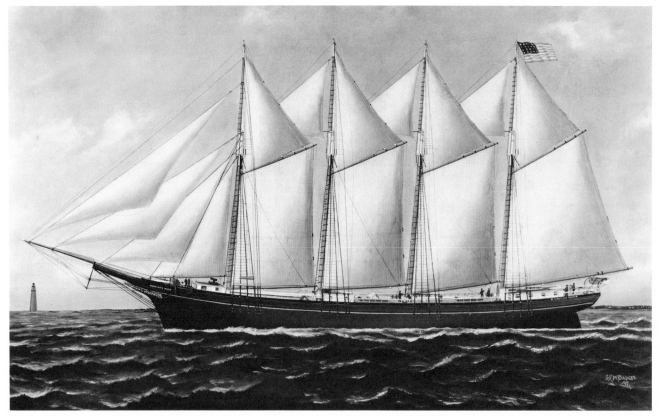

16

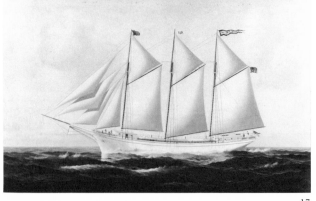

17

Bailey, T.
American

Baker, Elisha Taylor
American (1827–1890)

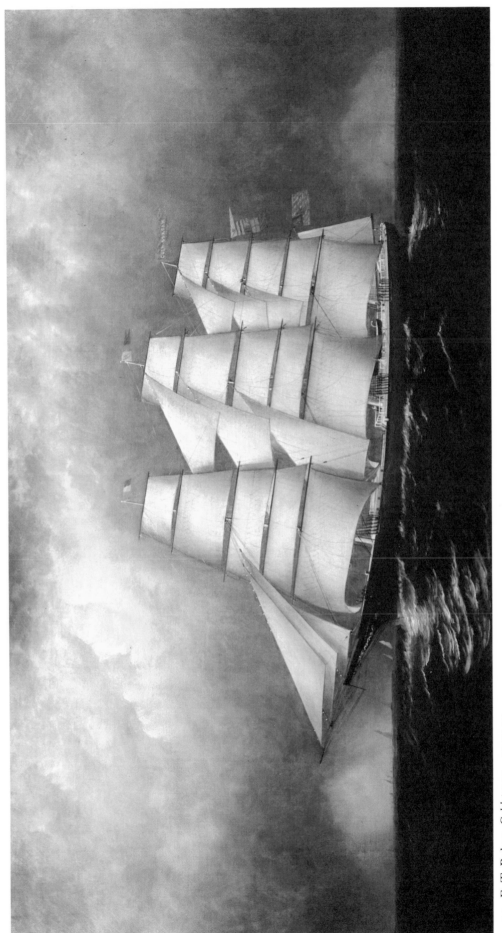

20. E. T. Baker, *Coldstream* 53.2552

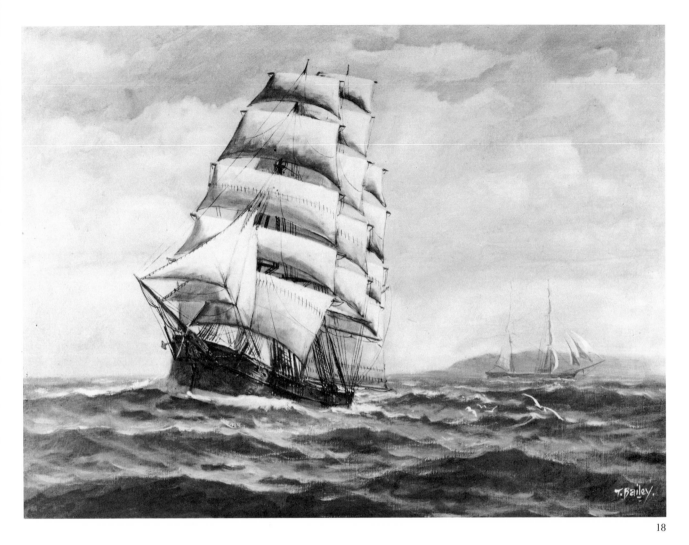

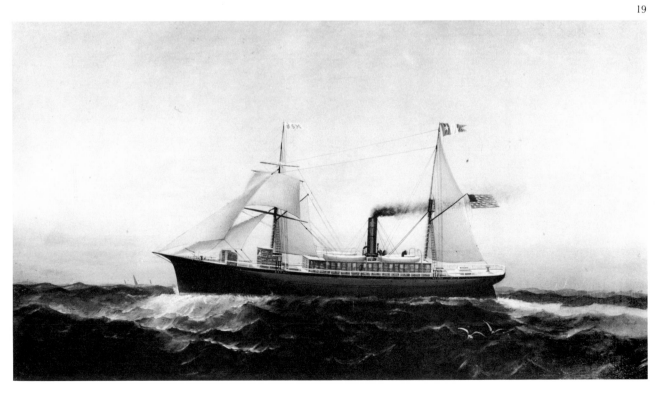
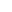

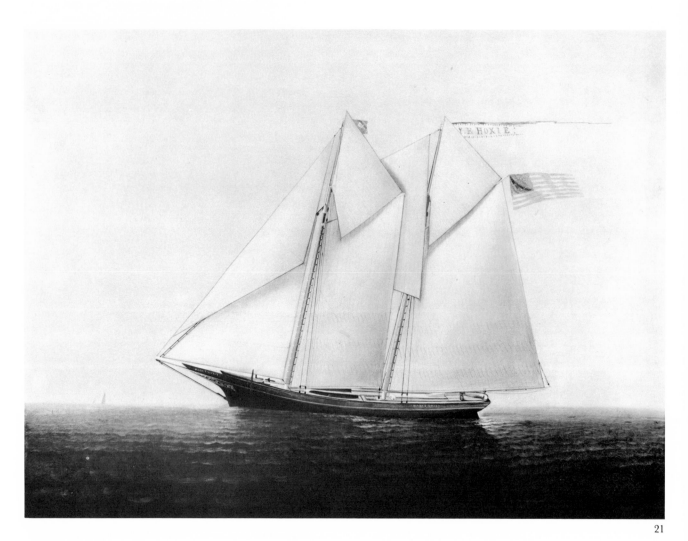

21. *Mary E. Hoxie*. Oil. 23¹/₂ x 31⁹/₁₆ in. Attributed to
 Elisha Taylor Baker. American two-masted
schooner, built 1868, Noank, Connecticut.
Source: George Costello. 39.588

Barreto, Gualter M.
Azorean

22. [Whaling off Pico, Azores.] Oil. 11 x 19³/₄ in. Signed:
 Gualter M. Barreto, Lages do Pico. Whaleboats after
sperm whales in Pico Channel, Azores. Source: Manuel
P. S. Macedo. 65.1069

Beal, Gifford Reynolds
American (1879–1956)

23. *Swordfisherman*. Pen, pencil, wash. 20 x 15⁹/₁₆ in.
 Signed: Gifford Beal. Source: C. D. Mallory Estates.
 49.1416

24. Unidentified figurehead. Oil. 49¹/₂ x 39¹/₂ in. Signed:
 Gifford Beal. Source: Mrs. George van Santvoord.
 73.448

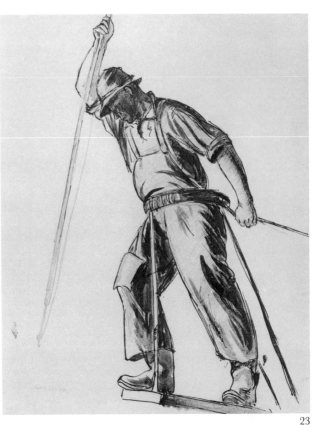

23

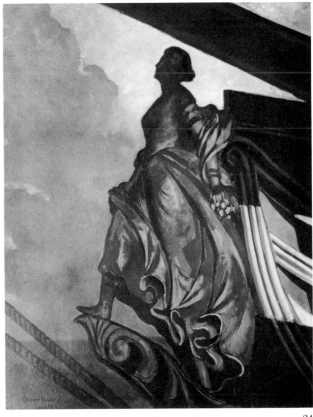

24

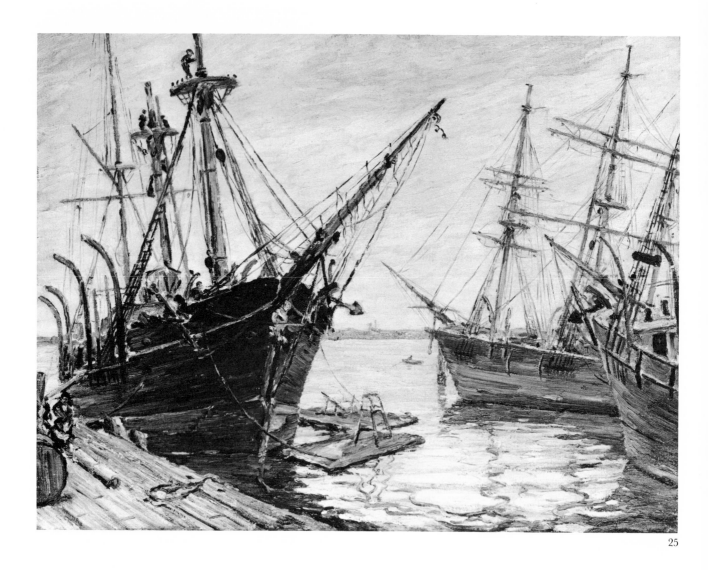

Beal, Reynolds
American (1867–1951)

25. *'Alice Knowles,' 'Platina,' 'Mystic.'* Oil. 35⅝ x 47½ in.
 Signed: Reynolds Beal. *Alice Knowles*, American
whaling bark, built 1878, Weymouth, Massachusetts. 303
tons. 115' x 28' x 16'7''; *Platina*, American whaling bark,
built 1847, Westport, Massachusetts. 214 tons. 94' x
25'3'' x 15'2''; *Mystic*, American whaling schooner,
rebuilt 1908, Mystic, Connecticut. 202 tons. 123' x 25'3''
x 10'7''. Source: Mrs. Reynolds Beal. 55.959

26. [Composite view of Mystic and Noank,
 Connecticut.] Oil on masonite. 25½ x 35½ in.
Signed and dated: Reynolds Beal, 1941. (Not illustrated.)
Source: Philip R. Mallory. 75.462

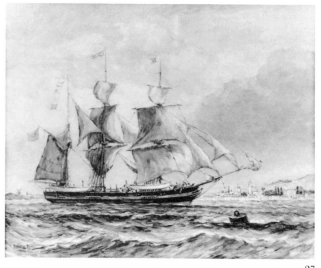

27. *Coriolanus*. Oil. 28½ x 35½ in. Signed and dated:
 Reynolds Beal, 1940. American whaleship, built
1827, Portland, Maine. 269 tons. Condemned abroad,
1861. Source: C. D. Mallory Estates. 45.327

28. [Deacon Palmer's shipyard, Noank, Connecticut.]
 Oil on board. 11½ x 15½ in. Signed and dated:
Reynolds Beal, 1903. (Not illustrated.) Source: Clifford
D. Mallory, Sr. 40.407

29. *'Ella May' in Noank Harbor*. Oil. 23¼ x 35⅜ in. Signed and dated: Reynolds Beal, 1903. British two-masted schooner, built by James Rourke, St. Martin, New Brunswick. 95 tons. 75'1" x 26' x 7'5". (Not illustrated.) Source: Reynolds Beal. 40.406

30. [Noank shipyard.] Oil. 25⁵/₁₆ x 35½ in. Signed and dated: Reynolds Beal, 1903. (Not illustrated.) Source: C. D. Mallory Estates. 45.340

31. *Noank Shipyard, Whaler 'Rosa Baker' on ways*. Oil. 25⁵/₁₆ x 35½ in. Signed and dated: Reynolds Beal, 1906. American whaler, built 1867, Scituate, Massachusetts. Source: Reynolds Beal. 40.405

32. [Pistol Point shipyard, Mystic, Connecticut.] Oil on board. 5¾ x 8¹⁵/₁₆ in. Signed and dated: Reynolds Beal, 1903. (Not illustrated.) Source: Clifford D. Mallory, Sr. 40.410

33. *Rosa Baker*. Oil on board. 3 x 5 in. Signed: Reynolds Beal. American whaler, built 1867, Scituate, Massachusetts. 82'6" x 22'6" x 8'9". (Not illustrated.) Source: Clifford D. Mallory, Sr. 40.407–A

34. *'Rosa Baker,' fitting out*. Oil on board. 3⁵/₁₆ x 5¾ in. Signed: Reynolds Beal. American whaler, built 1867, Scituate, Massachusetts. 109 tons. 82'6" x 22'6" x 8'9". (Not illustrated.) Source: Clifford D. Mallory, Sr. 40.408

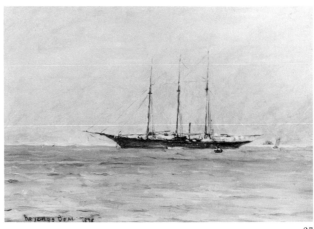
37

35. Unidentified American yachts. Watercolor. 15⅜ x 22 in. Signed and dated: Reynolds Beal, 1934. (Not illustrated.) Source: Philip R. Mallory. 67.247

36. Unidentified ship. Oil. 25½ x 35⅜ in. Attributed to Reynolds Beal. (Not illustrated.) Source: Thaddeus R. Beal. 73.491

37. *Utowanna*. Oil on board. 6¹/₁₆ x 9⅛ in. Signed and dated: Reynolds Beal, 1898. American auxiliary schooner yacht, built 1898, Port Jefferson, New York. Source: Clifford D. Mallory, Sr. 40.409

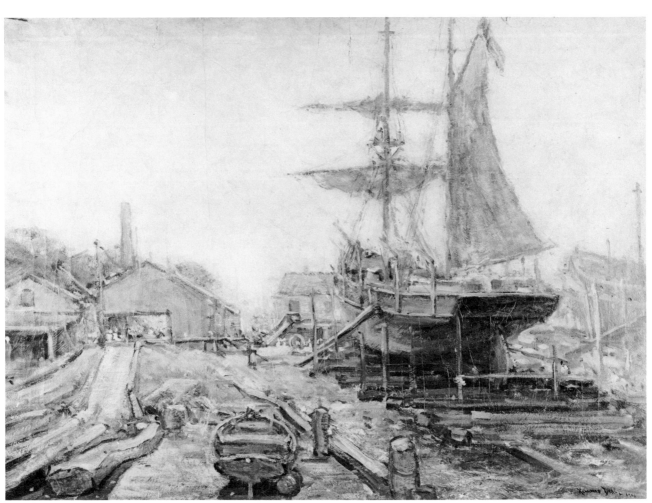
31

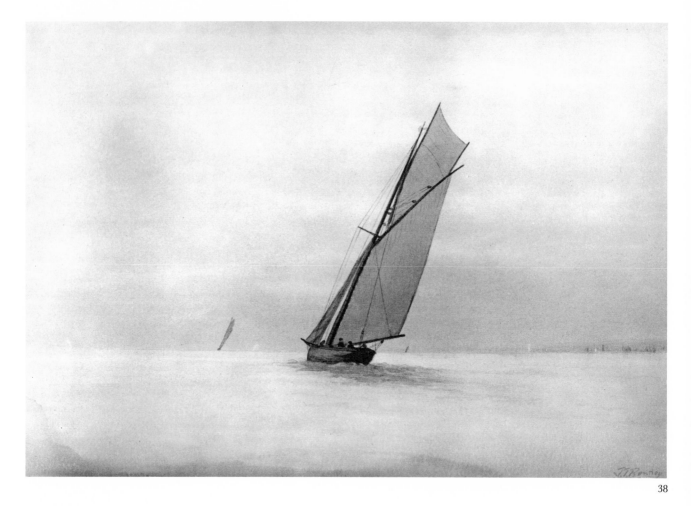

38

Bentley, J. T.

38. Unidentified British cutter type of vessel. Wash.
 13³/₈ x 19³/₄ in. Signed and dated: J. T. Bentley
 [18]88. Source: Henry Rudolph Kunhardt. 64.278

Bergen, Claus
German (1885–1964)

39. *Hudson's flagship The 'Half Moon' in sight of the coast of*
 Nova Scotia. Watercolor. 7 x 10³/₄ in. Signed: Claus
 Bergen. British vessel. Source: Mrs. E. R. Behrend.

 57.768

40. *'Mayflower' Landing of the Pilgrim Fathers on the Coast of*
 Massachusetts December 1620. Watercolor. 7 x 10¹³/₁₆ in.
 Signed: Claus Bergen. British vessel. Source: Mrs. E. R.
 Behrend. 57.769

39

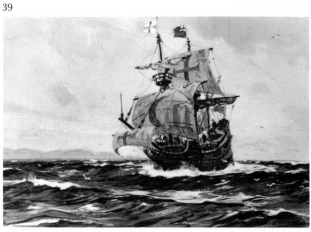

40

Bigelow, Albert S.
American

41. [Barnegat Bay sneakbox.] Oil. 17½ x 23½ in.
65.792

42. [Cape Ann dory.] Oil. 14¼ x 19¹/₁₆ in. 65.793

44

41

45

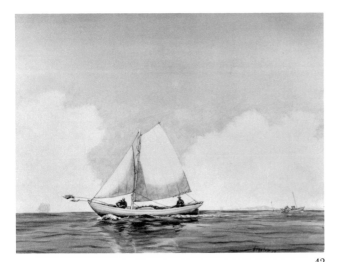
42

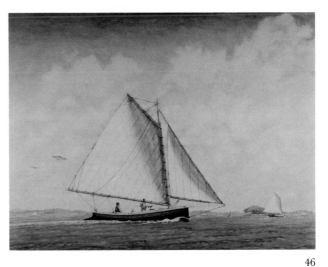
46

43. [Catboat.] Oil. 23⅛ x 31¹/₁₆ in. 65.890

44. [Friendship sloop.] Oil. 23⅛ x 31¹/₁₆ in. 65.892

45. [Kingston lobster boat.] Oil. 23⅛ x 31⅛ in. 65.891

46. [New York sloop.] Oil. 23³/₁₆ x 31⅛ in. 65.794

43

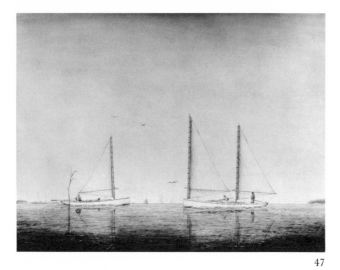

47

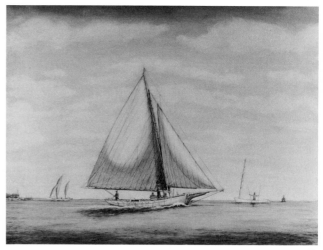

48

[BIGELOW]

47. [Oyster tongers, sharpies.] Oil. 23⅝ x 31½ in.
 65.893

48. [*Prudence*, Chesapeake Bay skipjack.] Oil.
 23⅝ x 31⅝ in. 65.894

All signed and dated: Bigelow [19]65. Source: Albert S.
Bigelow.

Birch, Thomas
Anglo-American (1779–1851)

49. [New York harbor.] Oil. 30¾ x 47½ in. Attributed
 to Thomas Birch. Source: The James Foundation of
 New York, Inc. 65.55
 See color illustration opposite.

Birchall, William Minishall
English (active 1928–1934)

50. *An Outgoing Voyager.* Watercolor. 10¼ x 14⅝ in.
 Signed and dated: W. M. Birchall, 1928. Source:
 Laurence J. Brengle, Jr., William C. Brengle, Mrs.
 Thomas S. Gates, Jr. 53.75

Blunt, John S.
American (1798–1835)

51. *U.S.S. America.* Oil on board. 11½ x 9½ in. Signed
 and dated at one time: J. S. Blunt, 1834. American
 ship-of-the-line. Source: Charles Wright. 40.221
 See color illustration opposite p. 32.

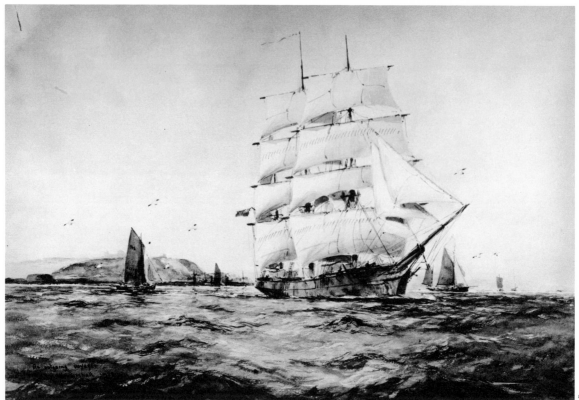

50

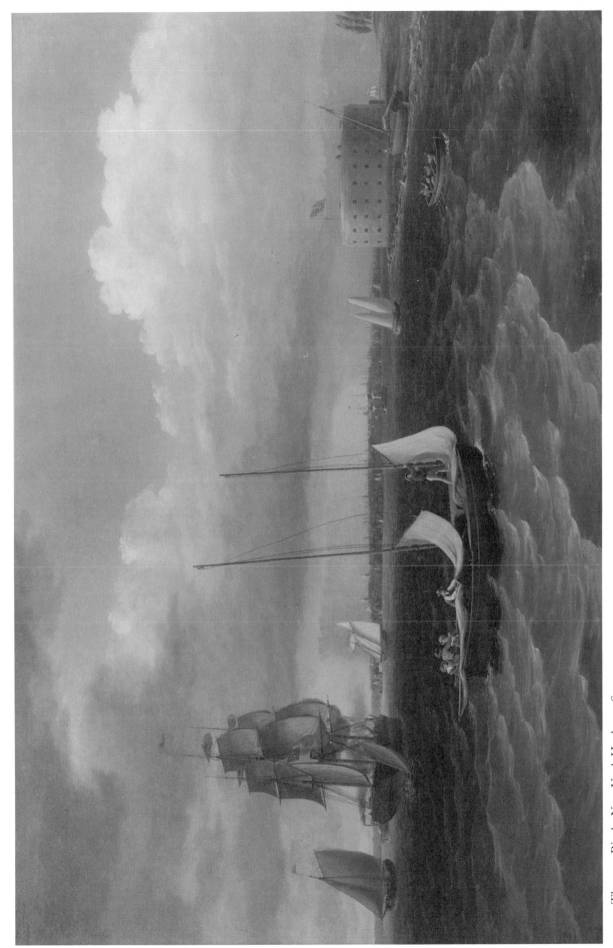

49. Thomas Birch, New York Harbor 65.55

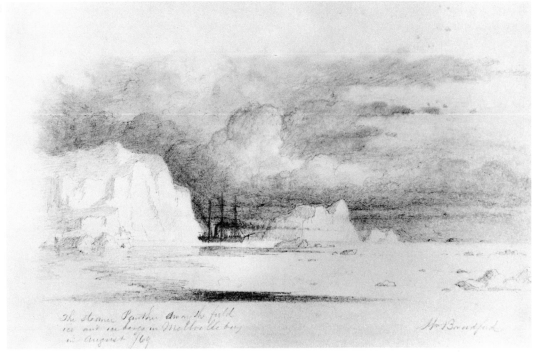

Bradford, William
American (1823–1892)

52. *The Steamer 'Panther,' among the field ice and icebergs in
 Mellville bay in August /69.* Pencil. 5⁹/₁₆ x 8⁵/₈ in.
Signed: Wm Bradford. Page torn from sketchbook. British
auxiliary steam whaling bark of St. John, New Brunswick,
built 1866, Miramichi, New Brunswick. 238 tons. 135′ x
28′ x 14′1″. Museum purchase. 75.442

53. *Whalers in the Arctic.* Oil, charcoal. 19¹/₂ x 29¹/₂ in.
 Signed: Wm Bradford. Source: Frederick A. Darling.
 78.33

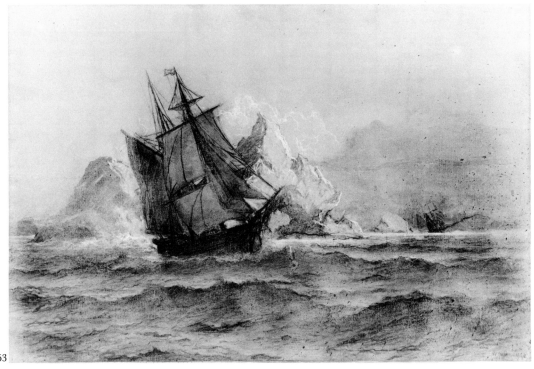

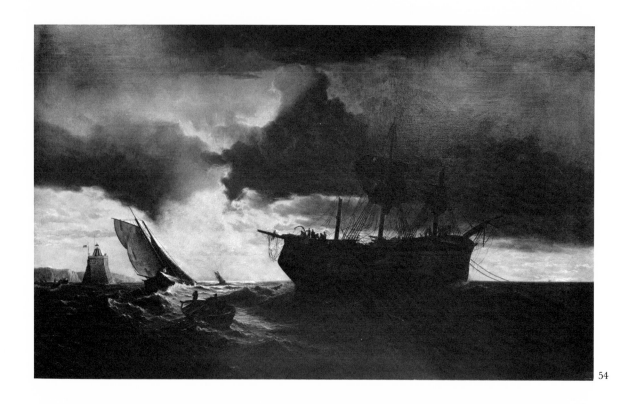

54

[BRADFORD]

54. [Wreck off St. John's.] Oil. 43¼ x 71¼ in. Signed
 and dated: Wm Bradford, 1865. Source: Federal
Insurance Co. 76.147

Bradley, Edward Eugene
American (1857–1938)

55. *'Mary Whittridge,' Taking on Pilot off Hong Kong Apr.
 1876*. Oil. 11⅝ x 17¾ in. Signed and dated: E.E.B.
[18]77. American ship, built 1855, Baltimore, Maryland.
862 tons. 168' x 34' x 21'. Source: Mrs. B. MacDonald
Steers. 64.38

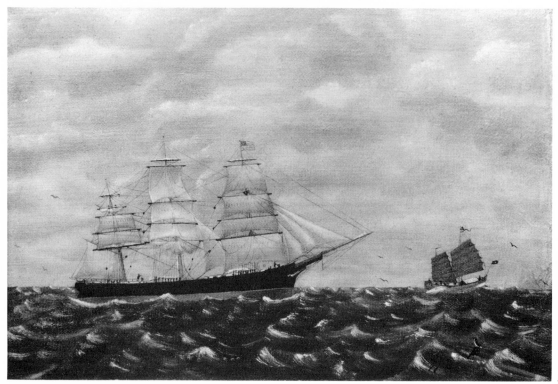

55

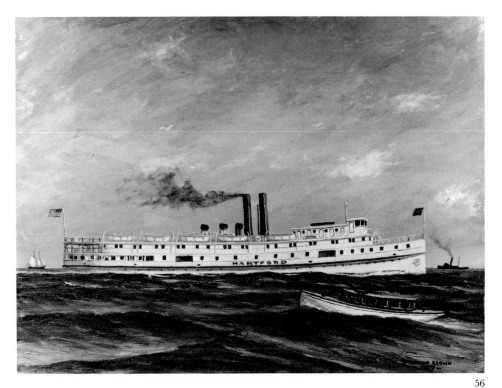

56

Brown, Harrison
American

56. *Hartford*. Oil on board. 18 x 24 in. Signed and dated: Harrison Brown, 1957. Steel screw steamer, built 1899 by the Columbian Iron Works and Dry Dock Company, Baltimore, Maryland. 1488 tons. 243′3″ x 45′7″ x 12′5″. Source: Harrison Brown. 66.286

Brown, John

57. *Ship 'Caspian' of Bath. J. H. Torrey master during a Corra [sic] in the Gulf of Venice August 7th 1847*. Watercolor, gouache. 17³⁄₈ x 21³⁄₄ in. Signed: John Brown fecit. American ship, built 1834 by John Larrabee, Bath, Maine. 529 tons. 131′10″ x 29′8″ x 14′10″. Source: Laurence J. Brengle, Jr. 53.3949

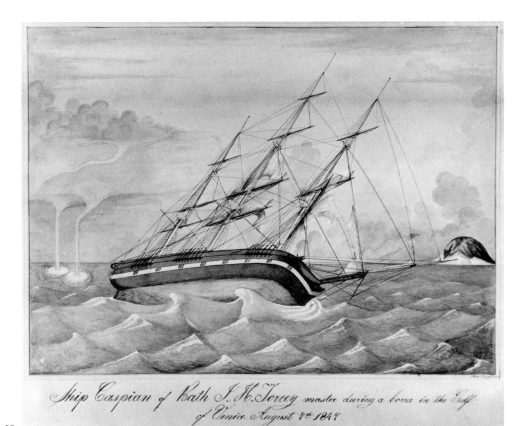

57

58

59

60

Browne, Robert Temple

58. Unidentified brig. Watercolor, gouache. 13½ x 19⅜
in. Signed and dated on reverse: Robert Temple
Browne, 1843. Source: Laurence J. Brengle, Jr. 53.3958

Bull

59. *Charter Oak*. Oil. 24 x 29¼ in. Signed: Bull. American
ship, built 1854, Searsport, Maine. 964 tons. 168'3" x
35'8" x 22'. Source: Mrs. Mary Stillman Harkness. 33.8

Burns, Milton J.
American (1853–1933)

60. *Catching the Cod—Dory #8*. Watercolor, gouache.
18⅜ x 28⅝ in. Signed: Burns. Source: Museum
purchase. 75.293

61. *Cod Fishing Monhegan Sep* [18]*78*. Pencil. 9⁹⁄₁₆ x 12 in.
Attributed to Milton J. Burns. Source: Museum
purchase. 75.35

62. [Fisherman in yellow slicker; two views.] Watercolor.
13 x 10 in. Attributed to Milton J. Burns. (Not illus-
trated.) Source: Museum purchase. 79.39

61

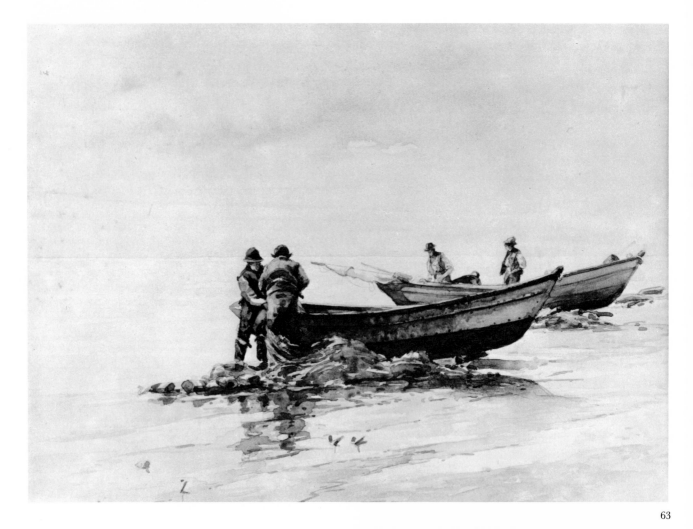

63

63. [Fishing dories.] Watercolor. 10 x 13¹⁵/₁₆ in.
Attributed to Milton J. Burns. Source: Museum
purchase. 75.32

64. *'Galatea.' Sketch for Clipper Ship 'Galatea' Hurricane—
Time 8³⁰ P. M. Rain & Lightning.* Wash. 8 x 10³/₄ in.
Signed: Burns. American clipper ship, built 1854 by J.
Magoun, Charlestown, Massachusetts. 1041 tons.
Source: Arthur R. Wendell. 44.230

65. *Gloucester Fisherman—The Skipper—hummed old ditties.*
Gouache. 11⁵/₈ x 7⁵/₈ in. Signed: Burns. (Not illus-
trated.) Source: Museum purchase. 78.99

66. [Ketch-rig catboat.] Oil. 5¹/₂ x 9⁵/₈ in. Signed: Burns.
Source: Museum purchase. 75.399

67. *Lost in the fog off Monhegan.* Pencil. 9⁵/₈ x 12 in.
Attributed to Milton J. Burns. Source: Museum
purchase. 75.34

68. *On board ship from Hamburg Aug. 1—01.* Pencil. 7 x 10
in. Attributed to Milton J. Burns. (Not illustrated.)
Source: Museum purchase. 75.36

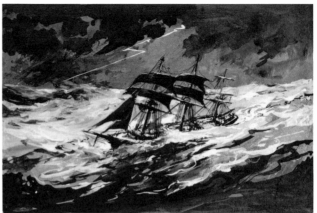

64

66

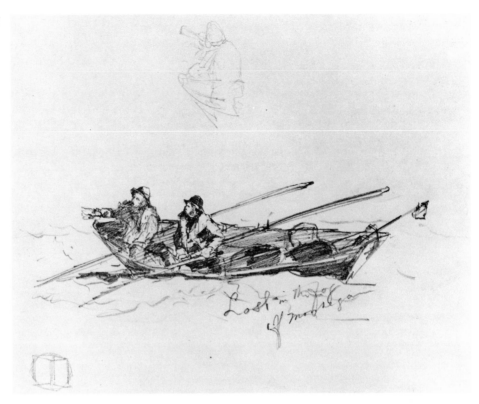

69. [Running free.] Watercolor. 10½ x 14⅞ in. Signed: Burns. First sketch for painting. (Not illustrated.)
Source: Museum purchase. 75.400

70. *Sandy Hook Light Ship March 10ᵗʰ 95.* Pencil. 9⅞ x 13⅞ in. Attributed to Milton J. Burns. (Not illustrated.)
Source: Museum purchase. 75.37

71. [Seine boat with nine men and nets.] Oil. 23½ x 38¼ in. Signed on reverse: Burns. Source: Museum purchase. 75.291

72. [Ship rolling—cook in galley.] Pencil, gouache. 12¾ x 9⁹⁄₁₆ in. Signed: Burns NY. (Not illustrated.)
Source: Museum purchase. 75.33

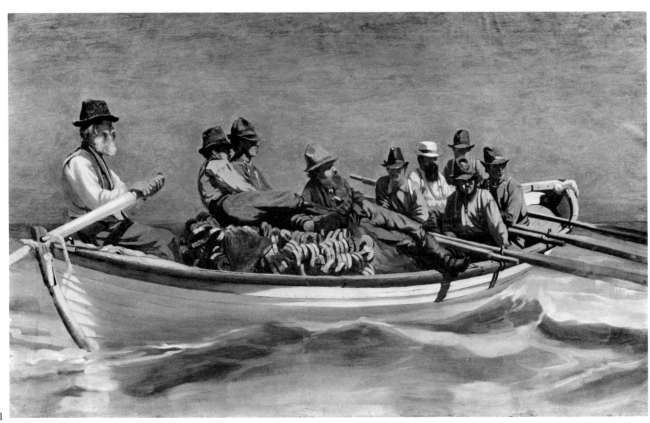

71

Buttersworth, James Edward
Anglo-American (1817–1894)

73. *America*. Oil on board. 7³/₄ x 11³/₄ in. Signed: J. E.
Buttersworth. American schooner yacht, built 1851
by W. H. Brown, New York. Off Dover Cliffs. Source:
Raynham Townshend. 63.461

74. *America*[?]. Oil. 26⁵/₈ x 33¹/₂ in. Signed: J. E.
Buttersworth. American schooner yacht, built 1851
by W. H. Brown, New York. Source: Harold H. Kynett.
49.3175

75. *Goodell*. Oil. 16⁵/₈ x 23⁵/₈ in. Signed: J. E.
Buttersworth. American bark, built 1866, Searsport,
Maine. 839 tons. 160' x 33' x 22'. Off Holyhead, England.
Source: Mrs. Carll Tucker. 67.74

76. *Haswell*. Oil. 11¹/₄ x 15¹/₂ in. Signed: J. E.
Buttersworth. American sloop yacht, built 1858,
Mystic, Connecticut. 38 tons. 50'6" x 18'3" x 5'.
Rounding South West Spit, American yacht race. Source:
C. D. Mallory Estates. 48.957

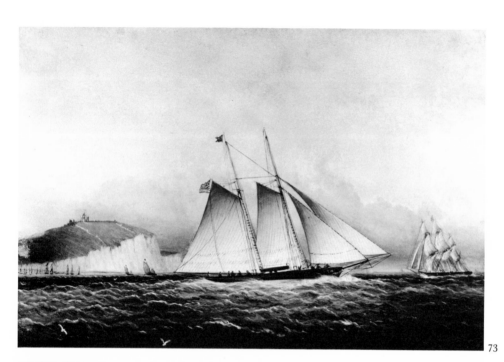

73

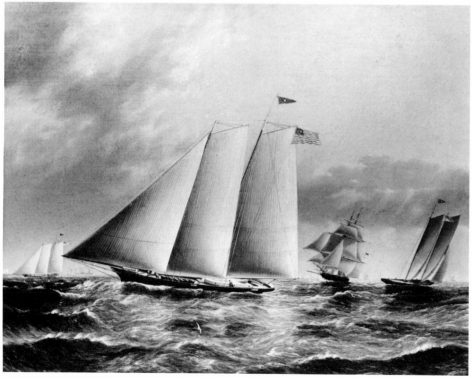

74

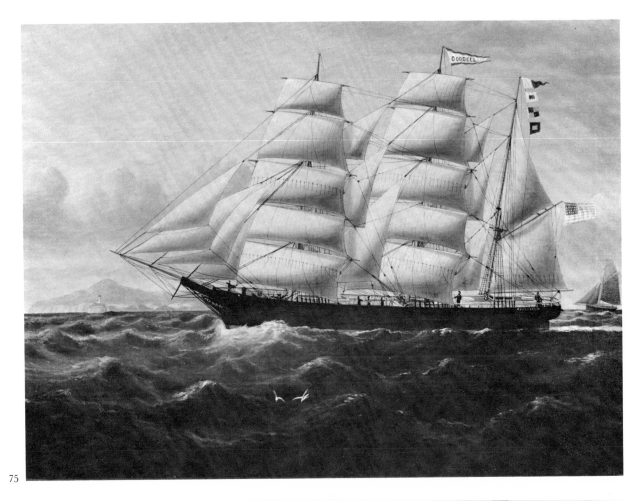

75

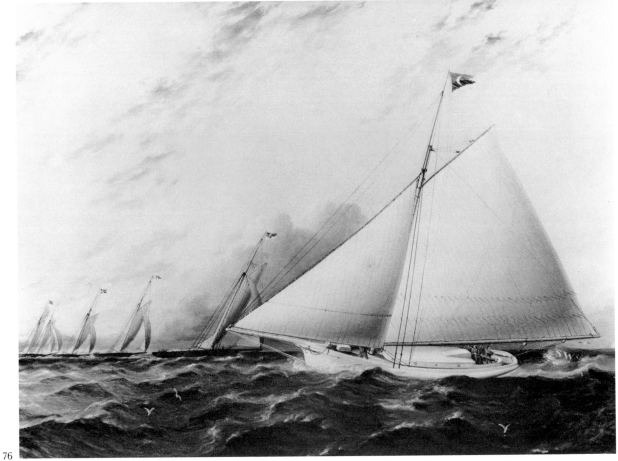

76

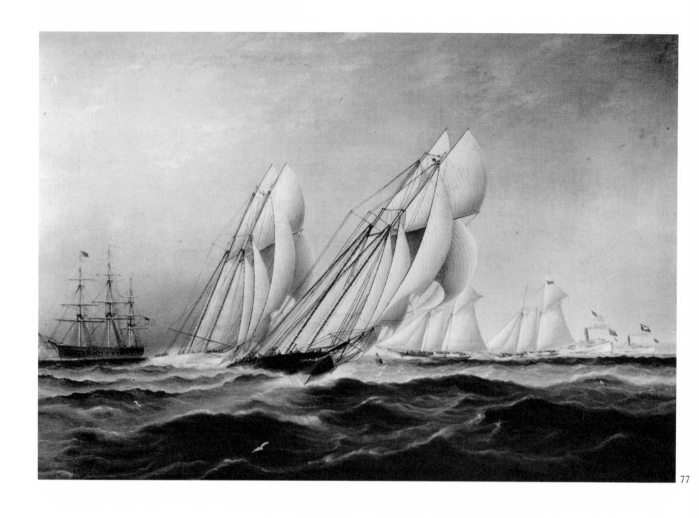

77

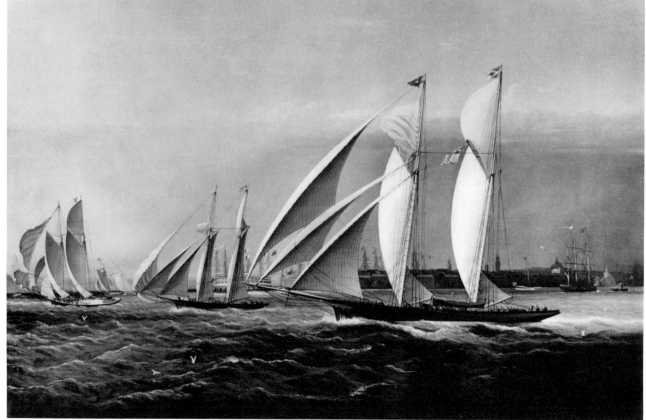

78

77. *New York Yacht Club Race*. Oil. 19⅝ x 29½ in. Signed:
 J. E. Buttersworth. Source: Harold H. Kynett.
 49.3177

78. [Race off the Battery, schooner *Dauntless*, ex-
 L'Hirondelle.] Oil. 19½ x 29½ in. Signed: J. E.
 Buttersworth. American schooner yacht, launched 1866,
 built by Forsyth & Morgan, Mystic, Connecticut. 126.40
 tons. 123'11" x 25'7" x 9'3". Source: George Murphy.
 76.172

79. Unidentified American sloop yacht. Oil. 19⅜ x 29⅛
 in. Signed: J. E. Buttersworth. Source: Francis L.
 Kellogg. 56.70

80. Unidentified ship. Oil. 17½ x 23½ in. Signed: J. E.
 Buttersworth. Companion to 49.3176. Source:
 Harold H. Kynett. 49.3174

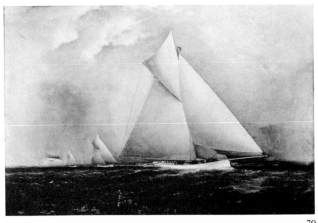

79

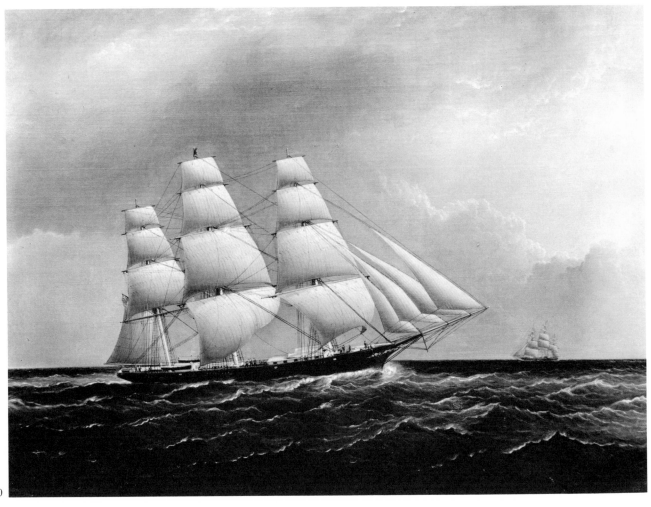

80

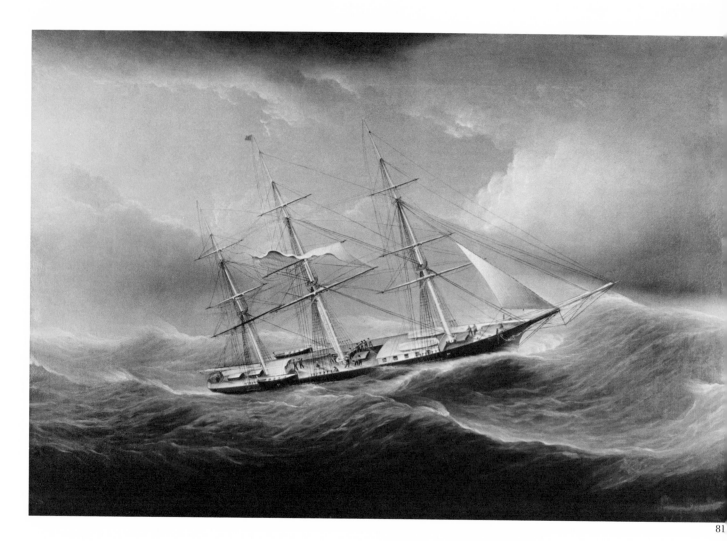

[B U T T E R S W O R T H]

81. Unidentified ship in a gale. Oil. 19½ x 29½
 in. Signed: J. E. Buttersworth. Companion to
49.3174. Source: Harold H. Kynett. 49.3176

82. *Volunteer.* Oil on board. 7¾ x 11¾ in. Signed: J. E.
 Buttersworth. American sloop yacht, built 1887,
defender of the *America*'s Cup, 1887. 85'9" x 23'2" x 10'.
Off the Battery, New York. Source: Museum purchase.
 59.1362

83. *'Washington' and 'Hermann.'* Oil. 26½ x 33⅝ in.
 Signed: J. E. Buttersworth. U.S. Mail steamships.
Washington built 1847 by Westervelt and MacKay, New
York. 1640 tons. 230'5" x 38'6" x 27'. *Hermann* built 1847
by Westervelt and MacKay, New York. 1734 tons. 234' x
39'6" x 27'. Off the Battery, New York. Source: Clifford
D. Mallory, Sr. 38.561
See color illustration opposite p. 48.

84. *Yachting in Boston Harbor.* Oil on board. 7¾ x 11¾ in.
 Signed: J. E. Buttersworth. Source: Museum
purchase. 59.1363

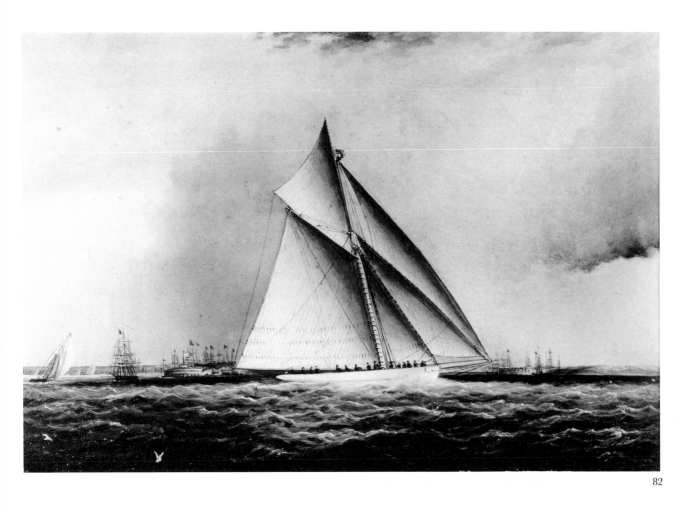

82

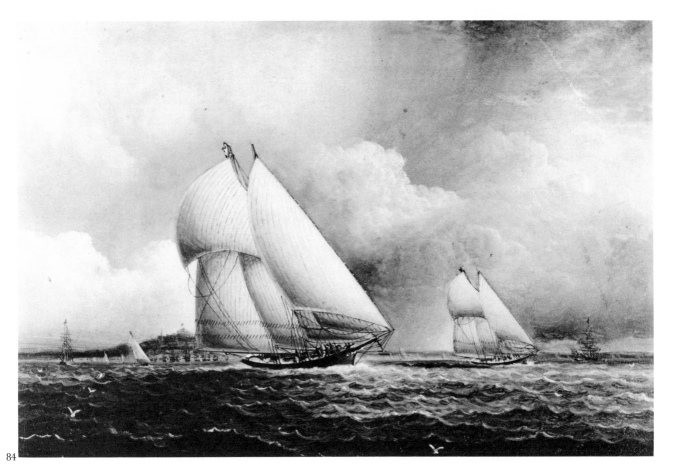

84

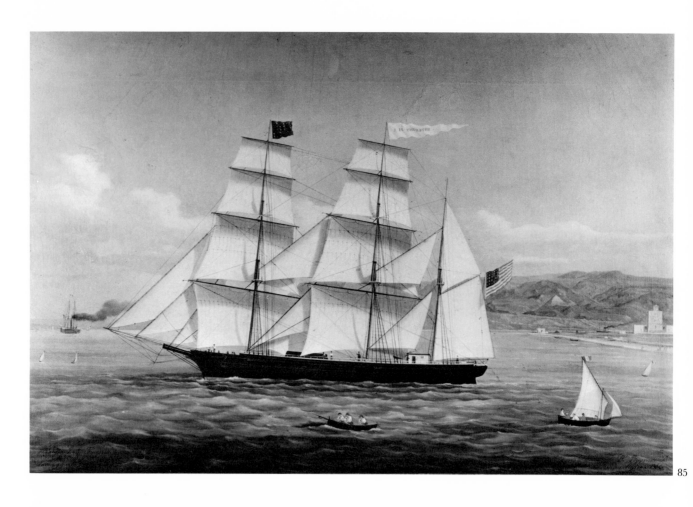

85

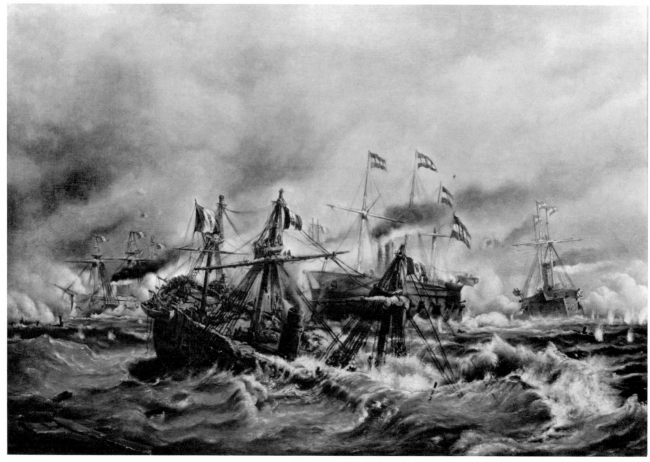

86

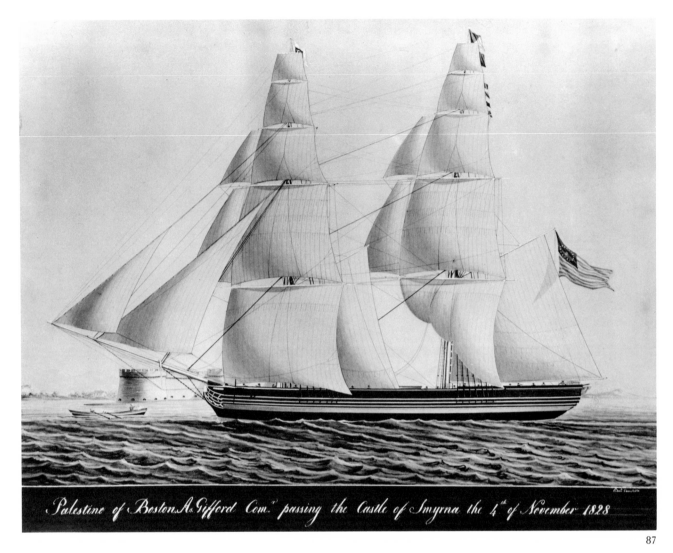

Palestine of Boston A. Gifford Com.ʳ passing the Castle of Smyrna the 4ᵗʰ of November 1828

87

Bygrave, William
(active 1858–1860)

85. *Barque 'J[ane] M. Thurston.' P. L. Gilkey Master Leaving
 the Port of Messina*. Oil. 22⁷/₈ x 34¹/₂ in. Signed and
dated: W. Bygrave P [inxit]. Messina, 1860. American
bark, built 1859, Brewer, Maine. 387 tons. 123′4″ x 27′6″
x 20′6″. Source: William C. Brengle. 62.476

Caffi, Ippolito
Italian (1809–)

86. *Battle of Lissa 18, 19, 20, July 1866*. Oil. 32³/₄ x 46³/₄ in.
 Attributed to Ippolito Caffi. Source: Mrs. Eva
Rindner, in memory of Mr. and Mrs. Richard C. Werfel.
 74.1074

Camellatti (or Camillati), Edmund
Italian (active 1828–1832)

87. *'Palestine' of Boston A. Gifford Com.ʳ passing the Castle of
 Smyrna the 4ᵗʰ of November 1828*. Watercolor. 17¹/₂ x
21¹/₂ in. Signed: Edmᵈ Camellatti. American brig, built
1828, Charlestown, Massachusetts. Source: William C.
Brengle. 55.1157

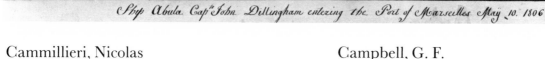

Ship Abula. Cap.ᵗ John. Dillingham entering the Port of Marseilles May. 10. 1806

88

Cammillieri, Nicolas

88. *Ship 'Abula' Cap.ᵗⁿ John Dillingham entering the Port of Marseilles May 10. 1806.* Watercolor. 16¹/₂ x 22¹/₈ in. Signed: Nicolay Cammillieri. American ship, built 1805, Haddam, Connecticut. 307 tons. Source: Museum purchase. 75.448

89. *Brig 'Dove' of Boston John C. Huffington Master, coming into Malta 1838.* Watercolor. 16³/₈ x 21³/₄ in. Attributed to Nicolas Cammillieri. American brig. (Not illustrated.) Source: Savings Bank of New London.
 39.1586

Campbell, G. F.

90. *'America' passing Royal Yacht 'Victoria & Albert' off Alum Bay, I.O.W. 5:30 P. M. August 22ⁿᵈ 1851.* Oil. 11¹/₂ x 15³/₄ in. Signed and dated: G. F. Campbell N.Y. [18]67. American schooner yacht, built 1851 by W. H. Brown, New York. 108' x 22' x 9'. Off the Needles. Source: Rudolph J. Schaefer. 75.187.18

Carmichael, James Wilson
English (1800–1868)

91. *The Discovery of America. Columbus landing on Watling Island in the Bahamas 12ᵗʰ October 1492.* Oil. 30¹/₄ x 42 in. Attributed to J. W. Carmichael. Source: Mrs. Frank C. Munson. 53.2562

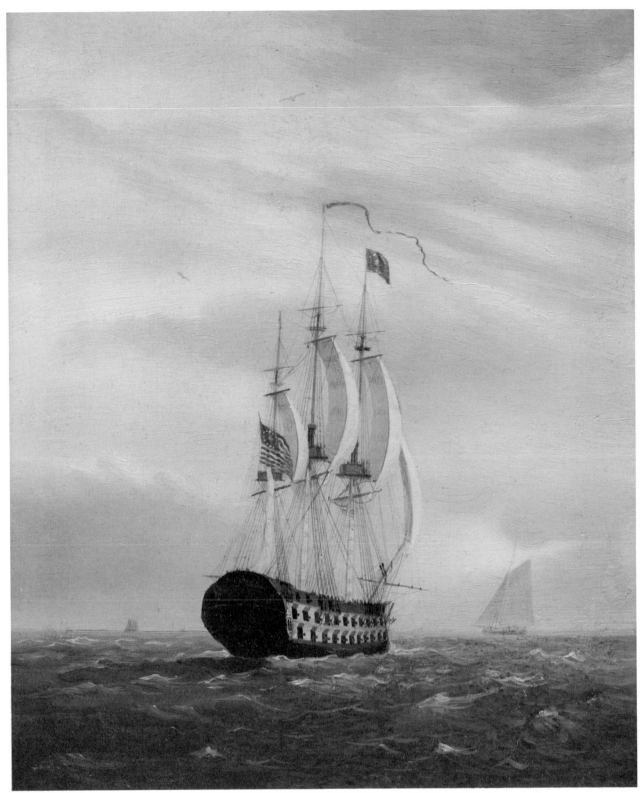

51. J. S. Blunt, *U.S.S. America* 40.221

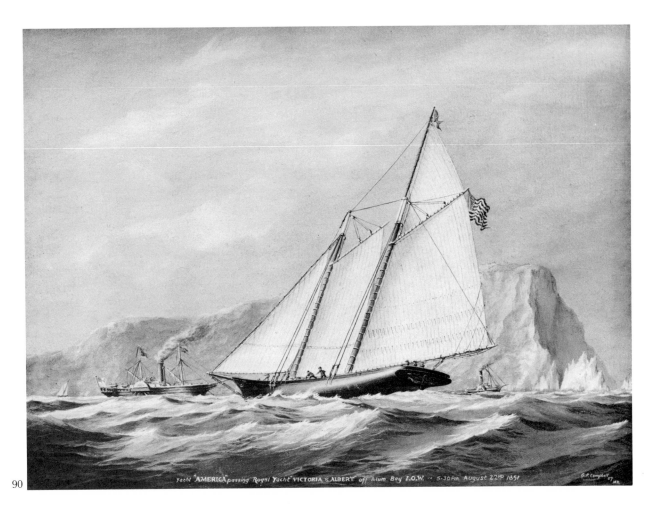

90

Yacht "AMERICA" passing Royal Yacht "VICTORIA & ALBERT" off Alum Bay I.O.W. — 5.30pm August 22nd 1851

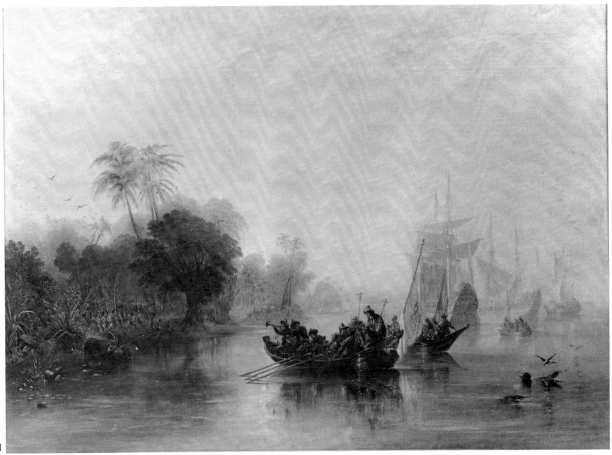

91

33

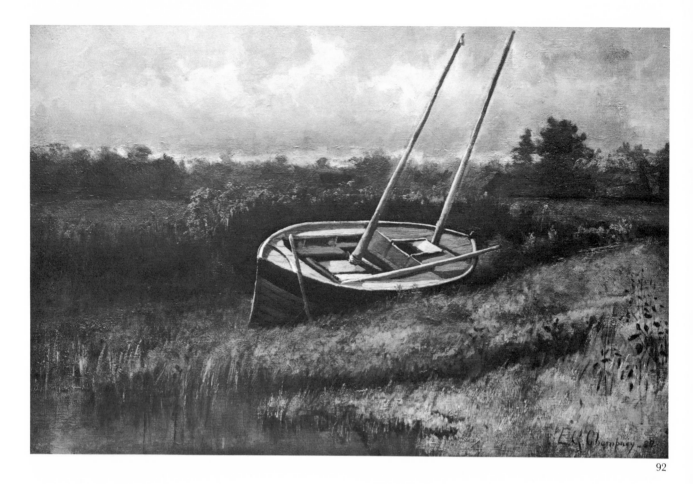

92

Champney, Edward Graves
American (1842–1899)

92. [Block Island boat.] Oil. 15½ x 23⅝ in. Signed and dated: E. G. Champney [18]89. Source: Museum purchase. 63.882

Chenoweth, David A.

93. Unidentified motor yacht. Pencil. 10⁷/₁₆ x 20⁷/₈ in. Signed and dated: D. A. Chenoweth [19]31. (Not illustrated.) Source: Anonymous. 65.237

94. Unidentified motor yacht. Pencil. 10⁷/₁₆ x 20¾ in. Signed and dated: David A. Chenoweth [19]33. Source: Anonymous. 65.236

Clayton, M. T.

95. *Bark 'Alice,'* [Joseph] *Swain Master, off Cape Horn May 22 1893 in the Ice.* Oil. 15½ x 26¾ in. Signed and dated: M. T. Clayton, 1894. American bark, built 1881, Weymouth, Massachusetts. 818 tons. 161'2" x 34'8" x 20'5". Source: Museum purchase. 48.888

Close, Susan

96. [*Wisconsin*, Black Ball packet.] Oil. 23¼ x 35¼ in. Signed on reverse: Susan Close, New York. American ship, built 1847, New York. Sold to Liverpool, 1865; sold to South America, 1869. 943 tons. 161' x 35'10" x 21'6". Source: Estate of Eliza Denison Schoonover. 79.24

94

96

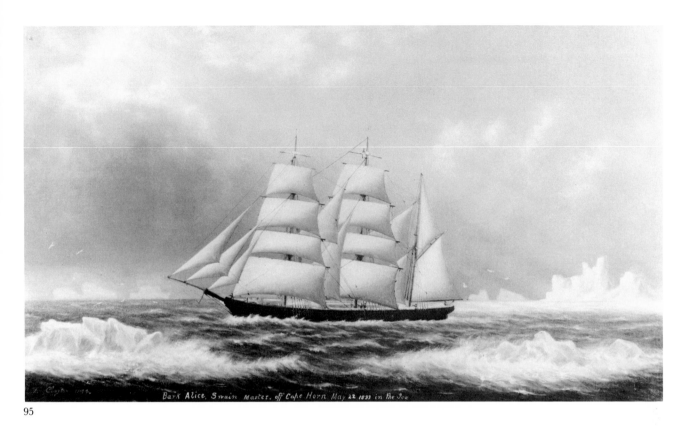

95

Collet, Yves Etienne ainé
French (1761–1843)

Twenty-one figurehead, bow, and stern decorations for
French vessels. Wash, pen, pencil. 13⅝ x 20½ in. – 25⅛
x 20⅛ in. Signed: Y. E. Collet ainé.
97. Figurehead, frigate *Cérès*. 60.282

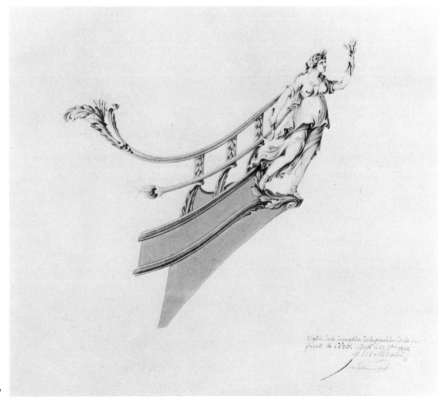

97

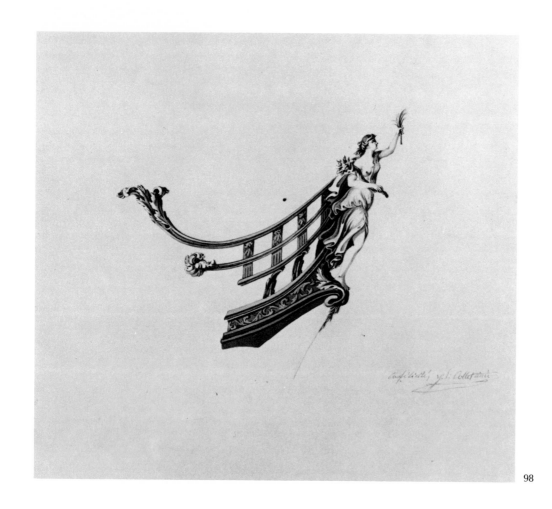

98

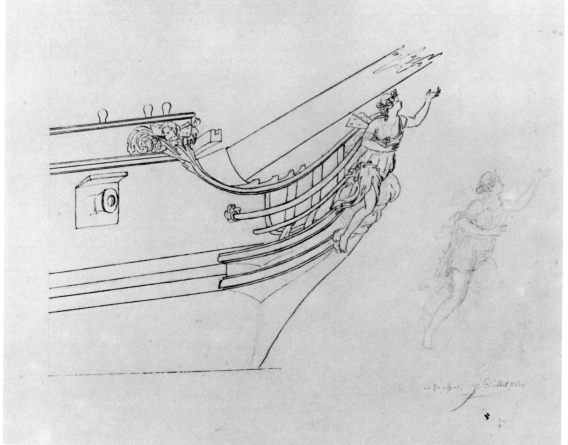

99

36

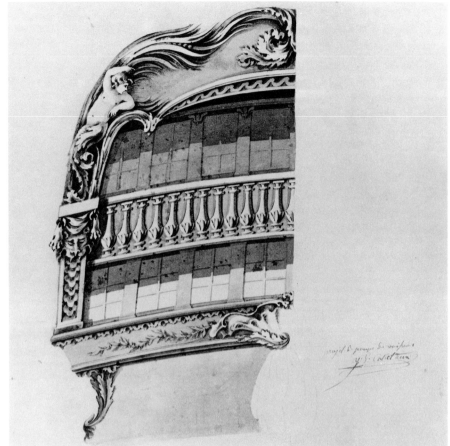

100

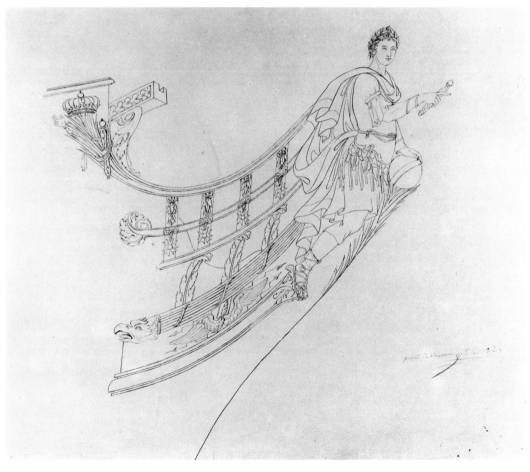

101

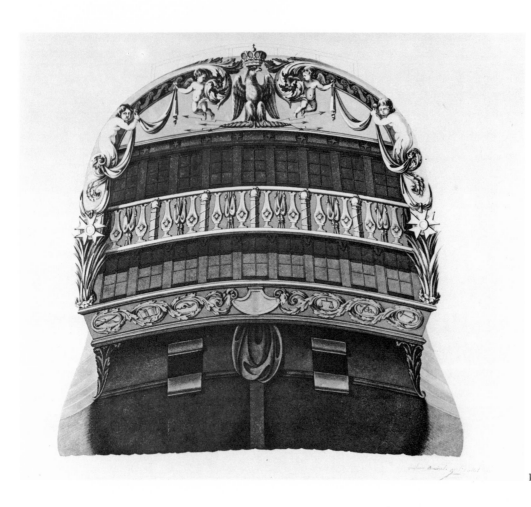

102

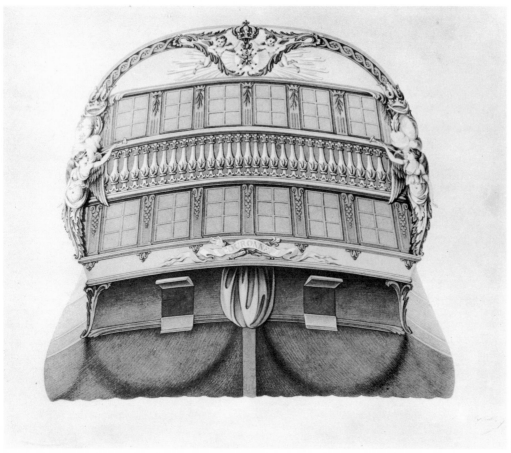

103

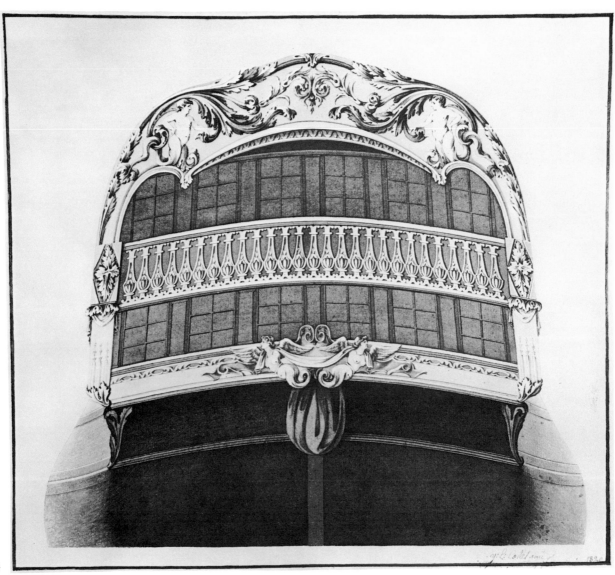

104

[COLLET]

102.	Stern.	60.279
103.	Stern, *Couronne*.	60.284
104.	Stern, *L'Océan*.	60.280

Thirteen not listed. Source: Richard S. Perkins.

60.274–60.294

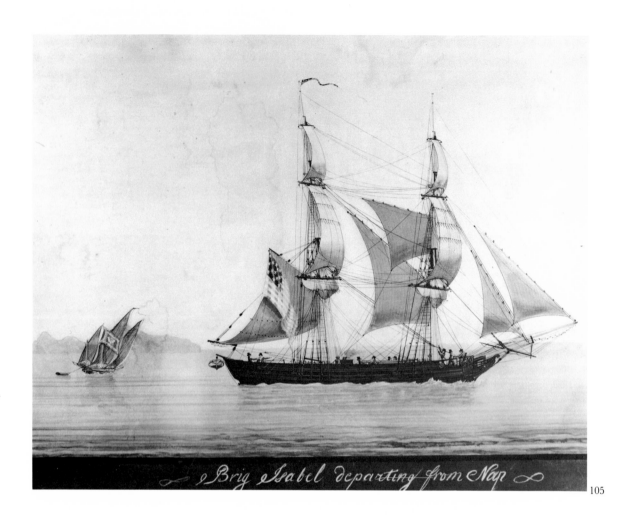

Brig Isabel departing from Nap

105

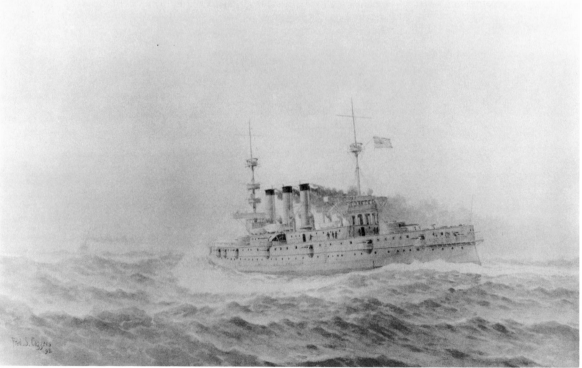

107

Cornè, Michele Felice
Italo-American (ca. 1752–1845)

105. *Brig 'Isabel' departing from Nap*[les]. Gouache. 14³/₈ x
18⁷/₈ in. Attributed to Michele Felice Cornè.
American brig. Source: Alexander O. Vietor. 61.19

Cozzens, Frederick Schiller
American (1856–1928)

106. *'Flying Fish.' Laying to for a Pilot after Beating the
Clipper Fleet Round the Horn—1853*. Watercolor. 15 x
21⁵/₈ in. Signed and dated: Fred S. Cozzens [19]27.
American ship, built 1851 by Donald McKay, East
Boston, Massachusetts. 1505 tons. 207' x 39'6" x 22'.
(Not illustrated.) Source: Estate of William Dinsmore
Banks. 79.189.2

107. *New York*. Watercolor. 14 x 21⁷/₈ in. Signed and
dated: Fred S. Cozzens [18]98. American armored
cruiser, built 1890–1893 by William Cramp & Sons,
Philadelphia, Pennsylvania. 381' x 64' x 28'. Source:
Harold H. Kynett. 61.224

108. *Clipper 'Rainbow.' Designed by Griffith. First vessel built
with concave lines*. Watercolor, gouache. 11¹/₄ x 22 in.
Signed and dated: Fred S. Cozzens [19]16. American
ship, built 1845 by Smith & Dimon, New York. 757 tons.
159' x 31'10" x 18'4". (Not illustrated.) Source: Estate of
William Dinsmore Banks. 79.189.1

110

109. [Shore scene.] Watercolor, paper mounted on
board. 13¹/₂ x 23 in. Signed and dated: Fred S.
Cozzens [19]07. (Not illustrated.) Source: Portia
Takakjian Roach. 78.197

110. Unidentified paddlewheel steamship. Wash, pencil.
7⁵/₈ x 9⁵/₈ in. Signed and dated: F. S. Cozzens
[18]79. Source: New York Yacht Club. 49.2779

111. Unidentified steamship and sailing vessel.
Watercolor. 18³/₁₆ x 15¹⁵/₁₆ in. Signed and dated:
Fred S. Cozzens 1902. Source: Harold H. Kynett. 61.223

111

112

113

112. Unidentified yachts. Watercolor. 14½ x 21¾ in.
 Signed and dated: Fred S. Cozzens [18]95. Source:
Philip R. Mallory. 67.251

Cree, James
Scottish-American (1867–1951)

113. *Frederick Billings*. Watercolor. 21½ x 30 in. Signed
 and dated: James Cree 1917. American bark, built
1885, Rockport, Maine. 2497 tons. 278' x 44'9" x 29'.
Source: Mr. and Mrs. Herbert L. Gilkey. 69.313

Dandy Napley (?)

114. Unidentified armed auxiliary ship. Watercolor,
 gouache. 16 x 25¼ in. Signed: Dandy Napley. (Not
illustrated.) Source: Miss Elsie B. Clark. 55.507

D'Angelo, Ivan

115. *House Flags Western Ocean Packets*. Watercolor. 7⁵/₁₆ x
 5½ in. Signed on reverse: Ivan D'Angelo. Copy of
unknown collection. Source: Wendell P. Colton, Jr.
 65.1028

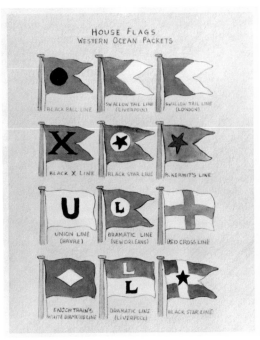

115

Dawson, Montague
English (1895–1973)

116. *Saucy 'Arethusa' engaged with a French Ship. British 5th
 rate of 1781, broken up 1814*. Oil. 27½ x 41½ in.
Signed: Montague Dawson. Source: Col. W. P. Draper.
 48.36

Reproduced courtesy of Frost & Reed, Ltd., London

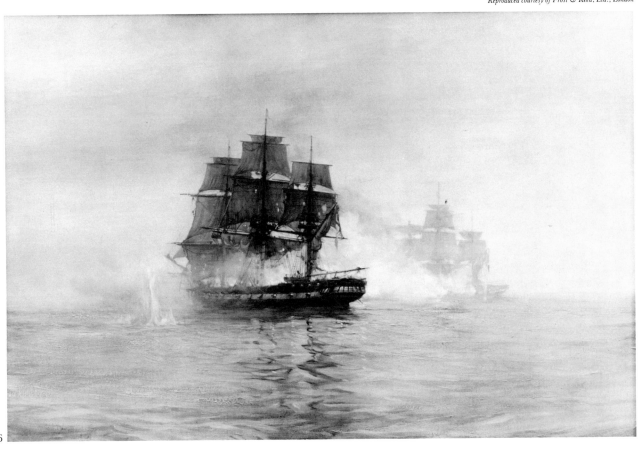

116

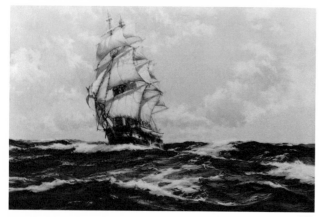

117

[DAWSON]

117. *Charles W. Morgan*. Oil. 27½ x 41½ in. Signed:
 Montague Dawson. American whaling ship, built
1841, New Bedford, Massachusetts. 351 tons. 113′11″ x
27′2½″ x 13′7¼″. Source: Harold H. Kynett. 49.3178

118. *Mallory*. Oil. 19¾ x 23⅜ in. Signed: Montague
 Dawson. American sloop yacht, built 1859, Mystic,
Connecticut. After Currier & Ives lithograph of 1861.
Donor: Philip R. Mallory. 67.250

118

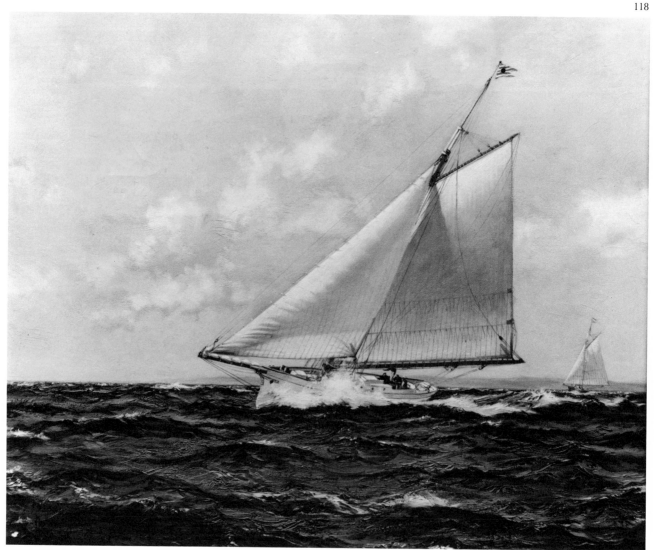

119. Unidentified ship. Oil. 21⁵/₈ x 29⁵/₈ in. Signed:
Montague Dawson. Source: Daniel Catlin, Jr.
77.322

120. *H.M.S. 'Warspite' and destroyers in Narvik Fjord* [World
War II]. Tempera. 20³/₄ x 29⁵/₈ in. Signed:
Montague Dawson. British battleship, completed 1915.
600′ x 104′ x 33′5″. Source: Harold H. Kynett. 48.958

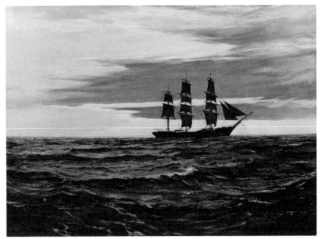

Reproduced courtesy of Frost & Reed, Ltd., London 119

120

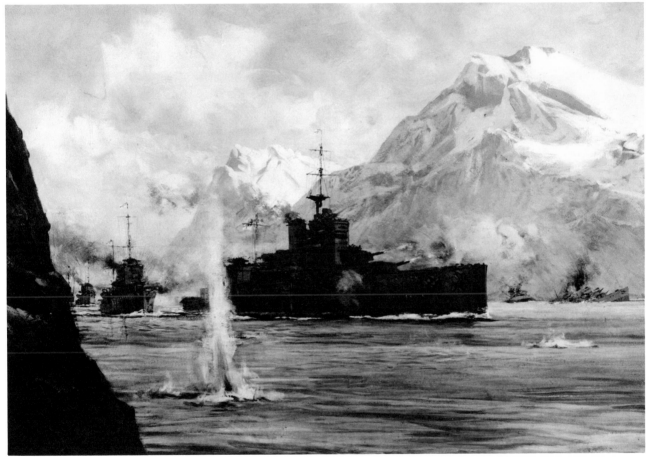

Reproduced courtesy of Frost & Reed, Ltd., London

121

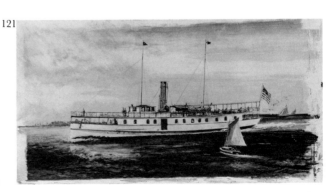

De Simone, see Simone.

Deese

121. *Clifton.* Watercolor. 8¹/₂ x 16¹/₂ in. Signed and
dated: Deese [19]60. American steam yacht, built
1888 by John Roach & Son, Chester, Pennsylvania. 154
tons. 101′ x 16′1″ x 8′6″. Source: Philip R. Mallory.
70.607

45

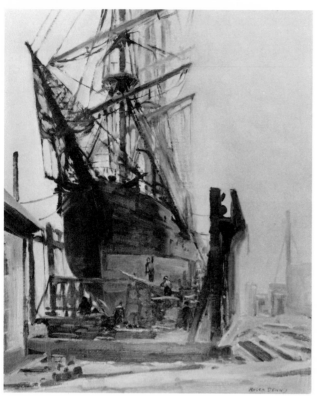

122

Dennis, Roger W.
American (1902–)

122. *Joseph Conrad.* Oil. 19³/₄ x 15¹⁵/₁₆ in. Signed: Roger
Dennis. American auxiliary ship, built 1882,
Copenhagen, Denmark. 212 tons. 111′ x 25′2″ x 13′2″.
Source: Roger W. Dennis. 54.1209

Detwiller, Frederick Knecht
American (1882–1953)

123. *Port of Noank, Conn. 1918.* Oil. 29¹/₄ x 35¹/₄ in. Signed:
F. K. Detwiller. Source: Mrs. Thomas B. Enders.
49.2740

123

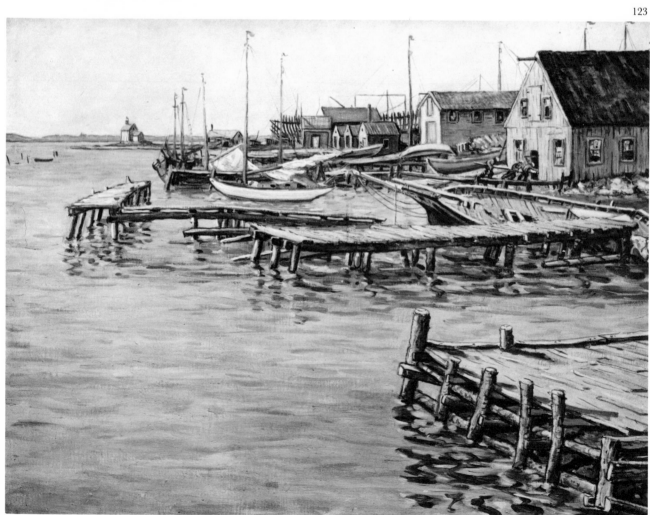

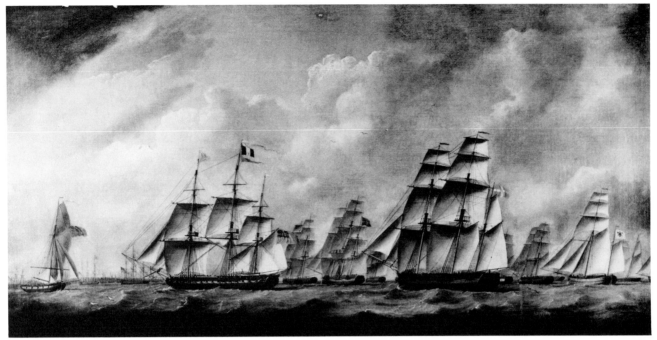

Dodd, Robert
English (1748–1815)

124. [International fleet.] Oil. 23¹/₂ x 47¹/₂ in. Signed
 and dated: R. Dodd, 1813. Source: Mrs. Carll
Tucker. 67.76

125. [International fleet.] Oil. 24¹/₈ x 48¹/₈ in. Signed
 and dated: R. Dodd, 1813. Source: Mrs. Carll
Tucker. 67.78

125

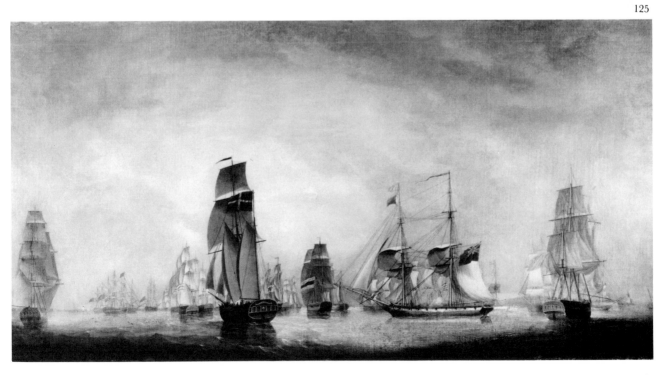

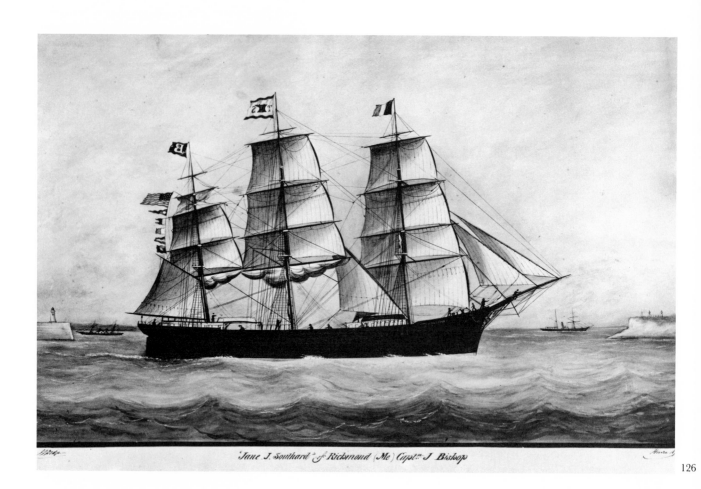

Jane J. Southard of *Richmond (Me) Capt.n J. Bishop*

83. J. E. Buttersworth, *Washington and Hermann* 38.561

Dodge, J. T.
American (?) (active 1854–1872)

126. *'Jane J. Southard' of Richmond (Me) Captn J. Bishop.*
Watercolor. 23 1/8 x 34 3/4 in. Signed and dated: J. T. Dodge, Havre 1870. American ship, built 1864 by J. Southard, Richmond, Maine. 1120 tons. 184'5" x 36'2" x 18'. Entering Le Havre, France. Source: Laurence J. Brengle, Jr., William C. Brengle, Mrs. Thomas S. Gates, Jr. 53.84

129

Drew, Clement
American (1806–1889)

127. *Dauntless.* Oil. 21 1/8 x 29 3/4 in. Attributed to Clement Drew. American schooner yacht, launched 1866, built by Forsyth & Morgan, Mystic, Connecticut; formerly *L'Hirondelle.* 126.40 tons. 123'11" x 25'7" x 9'3". Source: Capt. Marion Eppley. 56.1053

128. *'Hound.' Charles Mallory builder 1853.* Oil. 29 1/16 x 41 1/2 in. Attributed to Clement Drew. American ship, built 1853 by Charles Mallory, Mystic, Connecticut. 713 tons. (Not illustrated.) Source: C. D. Mallory Estates. 45.326

129. *Mary L. Sutton.* Oil. 29 1/2 x 41 1/2 in. Attributed to Clement Drew. American ship, built 1855 by Charles Mallory, Mystic, Connecticut. 1448 tons. 192' x 40' x 22'. Lost on Baker Island, 1864. Source: C. D. Mallory Estates. 45.323

130

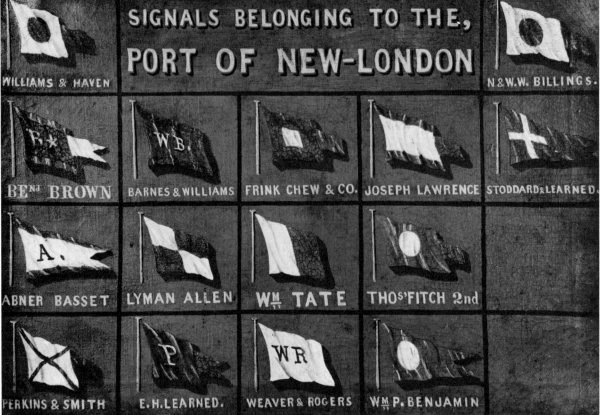

SIGNALS BELONGING TO THE,
PORT OF NEW-LONDON

WILLIAMS & HAVEN

N.&W.W. BILLINGS.

BENt BROWN

BARNES & WILLIAMS

FRINK CHEW & CO.

JOSEPH LAWRENCE

STODDARD & LEARNED.

ABNER BASSET

LYMAN ALLEN

WM TATE

THOS FITCH 2nd

PERKINS & SMITH

E.H. LEARNED.

WEAVER & ROGERS

WM P. BENJAMIN

132

130. Unidentified American schooner yacht. Oil. 21¹/₄ x
 29¹/₂ in. Attributed to Clement Drew. Source: Capt.
Marion Eppley. 56.1054

Ege, Ove C.
Danish (1882–)

131. *Georg Stage.* Oil. 17¹/₂ x 23³/₈ in. Attributed to Ove
 C. Ege. Danish auxiliary ship, built 1882, Copen-
hagen, Denmark. 212 tons. 111′ x 25′2″ x 13′2″. Later
became the *Joseph Conrad.* (Not illustrated.) Source: Bendt
C. Ege. 59.1357

Ewen, John, Jr.
American

132. *Signals belonging to the, Port of New-London.* Oil. 17 x 24
 in. Signed and dated on reverse: John Ewen, Jr. Oct.
1844, Painter. Fifteen signal flags. Source: Savings Bank
of New London. 39.1563

Ewen, Theodore C. (or G.)
American

133. [Main Street, Mystic Seaport.] Oil. 15¹/₂ x 29¹/₂ in.
 Signed and dated: Theodore C. [or G.] Ewen, 1954.
(Not illustrated.) Source: Wall Rope Works. 56.176

Fagans, Lester

134. Unidentified auxiliary ketch yacht. Watercolor,
 gouache. 14¹/₂ x 18³/₈ in. Signed: Lester Fagans.
Source: Anonymous. 65.238

Feldman, Hilda
American

135. *Emma C. Berry.* Watercolor. 14¹/₈ x 21¹/₂ in. Signed:
 Hilda Feldman. American fishing smack, built 1866,
Noank, Connecticut. 15 tons. Source: Mrs. N. S.
Dickinson. 69.820

134

135

136

138

142

143

Fischer, Anton Otto
German-American (1882–1962)

136. *Aloha*. Oil. 31¹/₂ x 32¹/₄ in. Signed and dated: Anton Otto Fischer., 1938. American auxiliary steel bark yacht, built 1910 by the Fore River Shipbuilding Company, Quincy, Massachusetts. 659 tons. 180'1" x 35'6" x 17'. Yacht of Arthur Curtiss James. Source: The James Foundation of New York, Inc. 65.53

Floherty
American

137. *Constitution*. Watercolor. 18 x 28¹/₂ in. Signed and dated: Floherty, [19]33. American frigate, launched 1797, Boston, Massachusetts. 175' x 43'6" x 14'3". (Not illustrated.) Source: Mrs. John J. Floherty. 65.414

138. *Edward Sewall*. Watercolor. 15 x 23 in. Signed: Floherty. American four-masted ship, built 1899, Bath, Maine. 3206 tons. 332' x 45'3" x 28'3". Sold to Alaska 1929; sold to Japan 1936. Source: Mrs. John J. Floherty. 65.410

139. Unidentified American steamship. Watercolor, gouache. 16 x 24 in. Signed and dated: Floherty, Mar. 8 [19]33. (Not illustrated.) Source: Mrs. John J. Floherty. 65.409

140. Unidentified bark. Watercolor. 17 x 25 in. Attributed to Floherty. (Not illustrated.) Source: Mrs. John J. Floherty. 65.413

141. Unidentified sailing vessel. Watercolor. 16 x 25¹/₂ in. Signed: Floherty. (Not illustrated.) Source: Mrs. John J. Floherty. 65.411

Foster, R. W.

142. *Hopestill*. Watercolor, gouache. 16 x 22¹/₁₆ in. Signed: R. W. Foster. American armed ship. Source: Capt. Marion Eppley. 56.1052

Fowles, A. W.
English (1815–after 1875)

143. *America*. Oil. 19¹/₂ x 29³/₄ in. Signed and dated: A. Fowles, Ryde, 1852. American schooner yacht, built 1851 by W. H. Brown, New York. 108' x 22' x 9'. Source: Rudolph J. Schaefer. 75.188.2

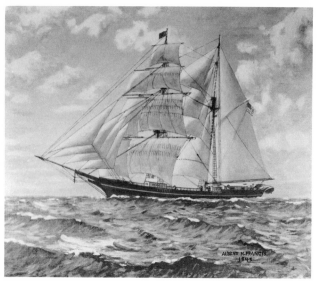

144

146

Francis, Albert N.
American

144. *Scotland*. Oil. 19⁹/₁₆ x 23¹/₂ in. Signed and dated:
 Albert N. Francis, 1945. American brigantine, built
1859, East Haddam, Connecticut. 183 tons. 106′ x 26′ x
8′2″. Source: Albert N. Francis Estate. 51.3997

Freitag, Conrad
German-American (died 1894)

145. *David Carll*. Oil. 22⁵/₈ x 34¹/₂ in. Signed: Conrad
 Freitag. American pilot schooner, built 1876, City
Island, New York. 125 tons. 103′ x 27′ x 8′5″. Source:
Anonymous. 54.1605
See color illustration opposite p. 56.

148

French, C. P.

146. *The 'Era.'* Oil. 14³/₄ x 19 in. Signed and dated:
 C. P. French 1903. American schooner, built 1847,
Boston, Massachusetts. Source: Savings Bank of New
London. 39.1275

147. *The 'Era.'* Oil. 15 x 19 in. Signed and dated: C. P.
 French 1903. American schooner, built 1847,
Boston, Massachusetts. (Not illustrated.) Source: Savings
Bank of New London. 39.1273

Gale, George Albert
American (1893–1951)

148. *Heaving Down—Ship 'California.'* Watercolor. 17⁵/₈ x
 25³/₈ in. Signed and dated: Geo. Gale [19]42.
American ship. Source: George H. Reynolds. 46.680

149. [Sperm whaling—wrenching out the lower jaw.]
 Oil. 28³/₄ x 20¹/₄ in. Signed and dated: Geo. Gale,
[19]41. Source: George H. Reynolds. 49.180

Gavarrone, Domenico
Italian (active 1843–1874)

150. *Ship 'Eastern Star' Captⁿ. A. Curtis Leaving Malta, 1868.*
 Watercolor. 20¹/₂ x 28¹/₂ in. Attributed to Domenico
Gavarrone. American ship, built 1856, Bath, Maine. 1132
tons. 180′ x 35′9″ x 24′. Source: Laurence J. Brengle, Jr.,
William C. Brengle, Mrs. Thomas S. Gates, Jr. 53.4563

149

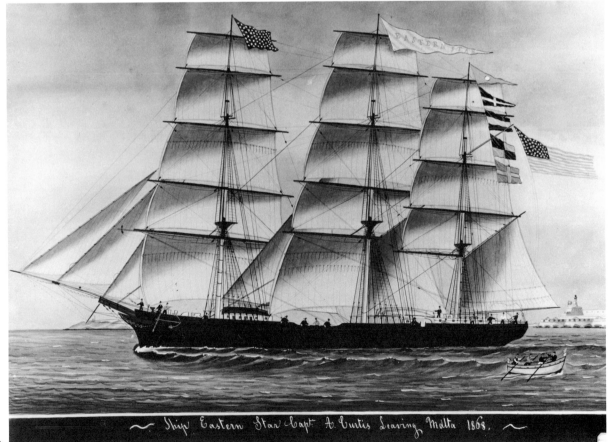

150

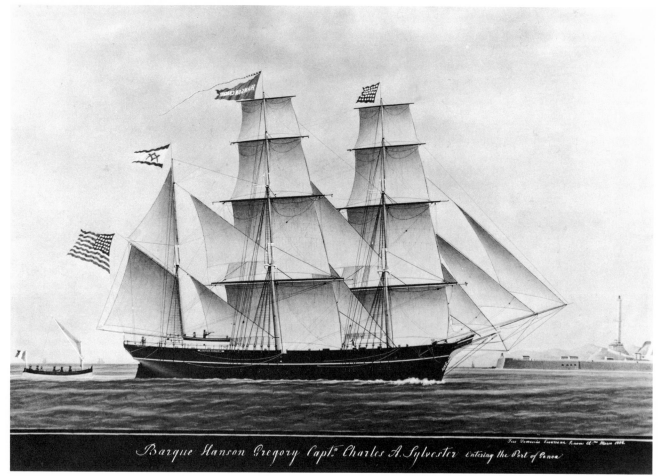

Barque Hanson Gregory Captⁿ Charles A. Sylvester Entering the Port of Genoa

151

153

151. *Barque 'Hanson Gregory' Captⁿ Charles A. Sylvester
 Entering the Port of Genoa.* Watercolor, gouache. 19½
x 27¾ in. Signed: Fece Domenico Gavarrone Genova,
U^{mo}. Marso 1856. American bark. Source: Mrs. Thomas
S. Gates, Jr. 53.4556

154

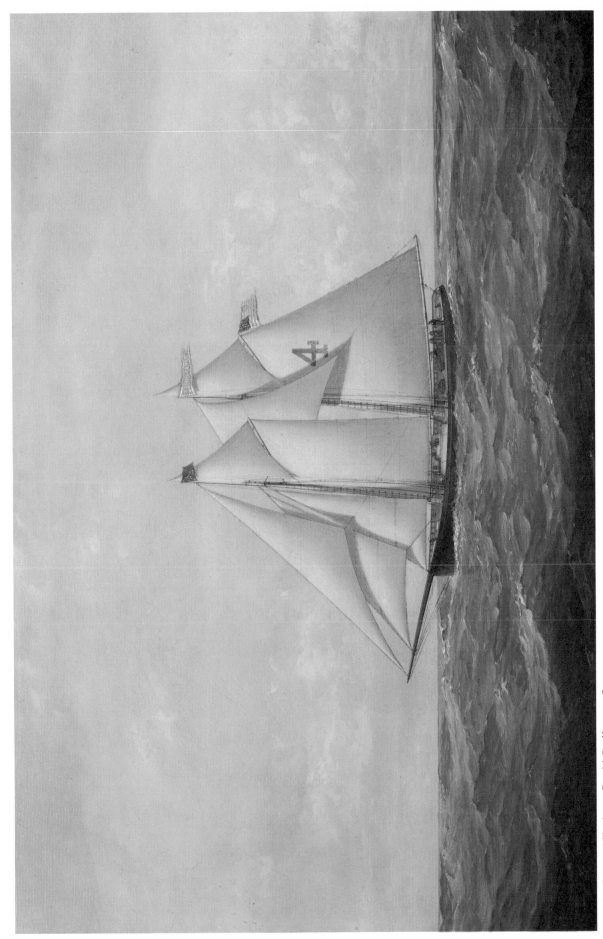

145. Conrad Freitag, *David Carll* 54.1605

Geissman, Robert

152. [*Charles W. Morgan* tied up at Mystic Seaport.]
Watercolor. 16 x 22¹/₂ in. Attributed to Robert
Geissman, 1963. American ship, built 1841, New Bedford,
Massachusetts. 351 tons. 113′11″ x 27′2¹/₂″ x 13′7¹/₄″.
(Not illustrated.) Source: Kirk Wilkinson. 72.486

153. *Leucothea.* Watercolor, gouache. 8¹/₂ x 6¹/₂ in.
Attributed to Robert Geissman, 1963. Figurehead.
Source: Kirk Wilkinson. 72.490

154. [Mystic Seaport street.] Watercolor. 8 x 9 in.
Attributed to Robert Geissman, 1963. Source: Kirk
Wilkinson. 72.491

Gervèse, H.
French

155, 156. Caricatures of life in the French navy. Water-
color, ink. 5¹⁵/₁₆ x 17¹¹/₁₆ in. Signed: H.
Gervèse. (Illustrated: 53.2931.4,5.) Source: Lt. Comdr.
Duncan I. Selfridge. 53.2931.1–6

Gleason, Joe Duncan
American (1881–1959)

157. *85′ Patrol Rescue Boat.* Oil. 24¹/₂ x 29¹/₂ in. Signed:
Duncan Gleason. American army vessel. (Not illus-
trated.) Source: R. F. Haffenreffer. 55.388

158. *Jack of All Trades.* Oil. 24¹/₂ x 29⁵/₁₆ in. Signed:
Duncan Gleason. American Navy coastal cargo
transport, built by Herreshoff, Bristol, Rhode Island.
Source: R. F. Haffenreffer. 55.389

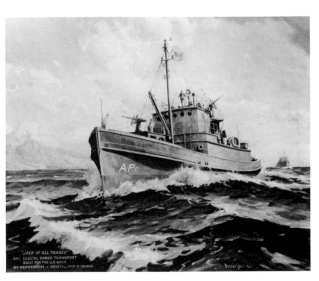

158

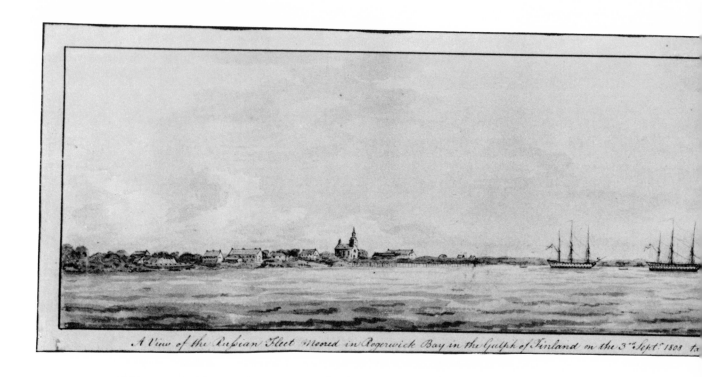

A View of the Russian Fleet moored in Rogerwick Bay in the Gulph of Finland on the 3ᵈ Sept.ᵗ 1808 ta...

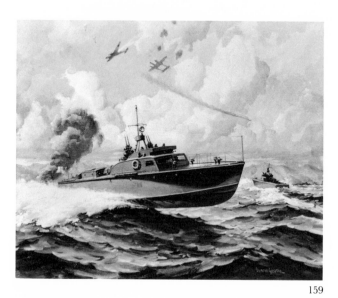

159

[GLEASON]

159. *Patrol Rescue Boat.* Oil. 24¹/2 x 29⁹/16 in. Signed: Duncan Gleason. American army vessel. Source: R. F. Haffenreffer. 55.387

Gordon, L.

160. *A View of the Russian Fleet moored in Rogerwick Bay in the Gulph of Finland on the 3ʳᵈ of Sept.ᵗ 1808 taken from His Majesty's Ship the 'Mars' the advanced Ship of the English and Swedish Fleets.* Watercolor. 5¹/2 x 21⁷/8 in. Signed: L. Gordon Fecit. Source: Paul Hammond. 54.1327

Grant, Gordon
American (1875–1962)

161. Fifty-nine pen, ink drawings. Used as illustrations for Henry B. Culver and Gordon Grant, *The Book of Old Ships*, Garden City Publishing Company: Garden City, New York, 1935. (Not illustrated.) Source: Gordon Grant. 59.738–59.796

Gray, E. H.

162. *Sagamore.* Pastel. 24⁷/8 x 30 in. Signed: E. H. Gray. American freighter. Source: Walter E. Linden.
 49.2865

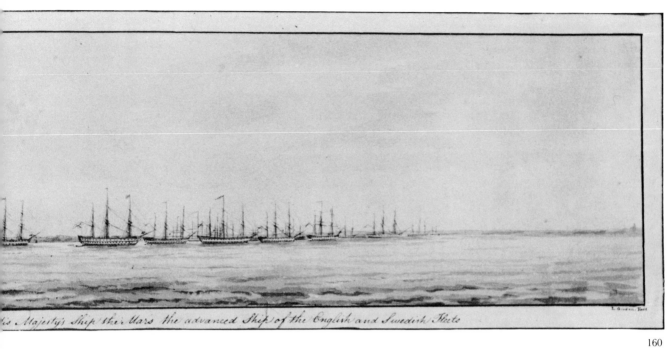

is Majesty's Ship the Mars the advanced Ship of the English and Swedish Fleets

160

162

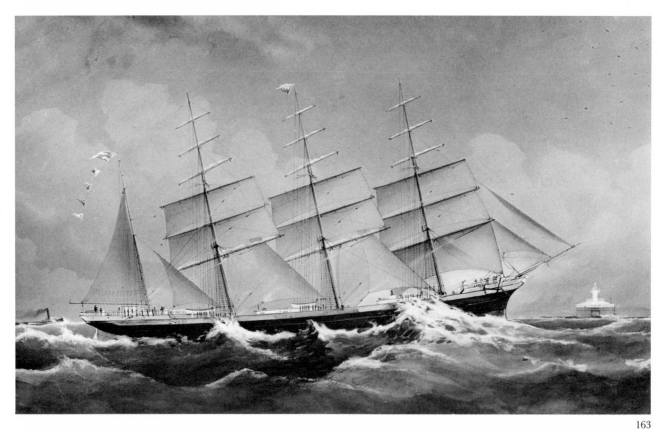

163

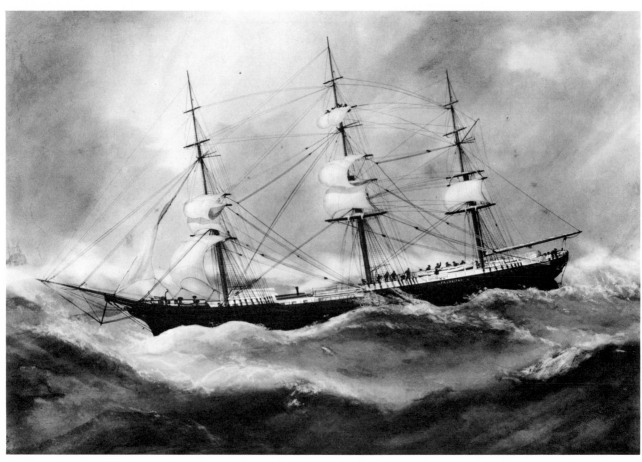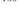

164

166

Gregory, Arthur V.
Australian (1867–1957)

163. *Hawaiian Isles.* Watercolor. 21 1/2 x 34 3/4 in. Signed
 and dated: A V Gregory [18]99. American bark,
built 1892, Glasgow, Scotland, for Hawaiian Construc-
tion Co. of San Francisco. 2097 tons. 270' x 43' 1" x 23' 6".
Source: Laurence J. Brengle, Jr., William C. Brengle,
Mrs. Thomas S. Gates, Jr. 76.22

Gregory, George F.
Anglo-Australian (1818–1885?)

164. *Favorita.* Watercolor. 21 1/4 x 31 1/2 in. Signed and
 dated: G. F. Gregory, Melbourne, 1876. American
ship, built 1862, Mystic, Connecticut. 1194 tons. 188' x
37' x 24'. Sold to Germany 1878. Source: Museum
purchase. 73.21

Hallett, Hendricks A.
American (1847–1921)

165. [Boston Harbor at low tide.] Watercolor. 19 1/4 x
 28 5/8 in. Signed: Hendricks A. Hallett. Source:
Museum purchase. 78.10
See color illustration opposite p. 72.

166. [Lumber schooner in Boston Harbor ca. 1890.] Oil.
 19 9/16 x 15 1/2 in. Signed: Hendricks A. Hallett.
Source: Museum purchase. 79.100

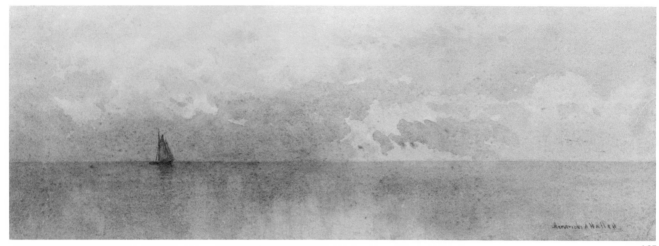

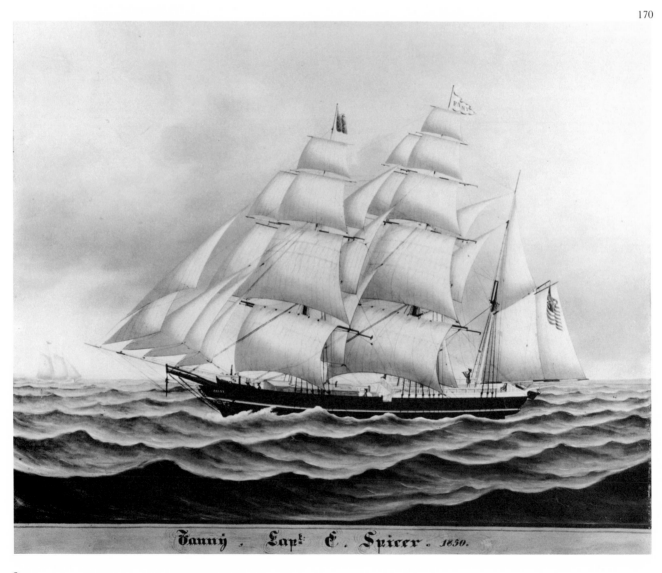

Fanny. Capt. E. Spicer. 1850.

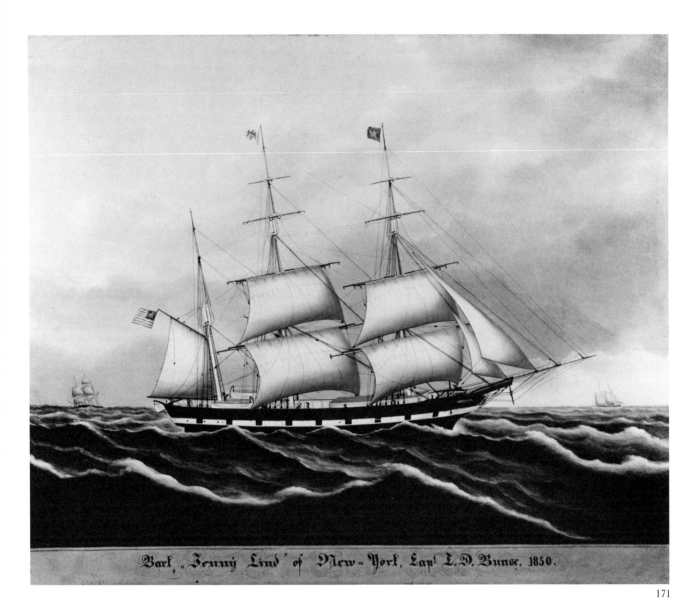

Bark "Jenny Lind" of New-York, Capt L.D. Bunce. 1850.

[HALLETT]

167. Unidentified schooner. Watercolor on cardboard.
6⁵/₈ x 19¹/₂ in. Signed: Hendricks A. Hallett. Source:
Museum purchase. 79.154

Hansen, Harry

168. *Joseph Conrad. Outward Bound.* Pastel. 21³/₄ x 29¹/₂ in.
British auxiliary ship, built 1882, Copenhagen, Den-
mark. 212 tons. 111' x 25'2" x 13'2". (Not illustrated.)
Source: Harry Hansen. 57.393

Hansen, J.
American

169. *'Eliza Mallory' of Mystic Capt. J. E. Williams.* Oil.
24¹/₂ x 35¹/₈ in. Attributed to J. Hansen. American
ship, built 1851 by Charles Mallory, Mystic, Connecticut.
(Not illustrated.) Source: C. D. Mallory Estates. 45.333

170. *'Fanny,' Capt. E. Spicer 1850.* Oil. 24¹/₂ x 29⁵/₈ in.
Attributed to J. Hansen. Signed: illegible, possibly J.
Hansen. American bark, built 1849, by Charles Mallory,
Mystic, Connecticut. 341 tons. 113' x 29'4" x 11'2". Sold
1860. Source: W. I. Spicer Estate. 37.105

171. *Bark 'Jenny Lind' of New-York Capt. L. D. Bunce, 1850.*
Oil. 24⁵/₈ x 29³/₄ in. Signed on label on reverse: J.
Hansen. American bark. Source: Museum purchase.
 62.1287

173

Hartt

172. [New London harbor scene.] Watercolor. 5⅝ x
 22¼ in. Signed and dated: Hartt, Aug! 29th [18]97.
Source: Museum purchase. 75.292

Holt, Charles Jeremiah
American (1794–1831)

173. Unidentified ship. Wool embroidery. 11½ x 17 in.
 Label on back giving history of work. Source:
Museum purchase. 67.136

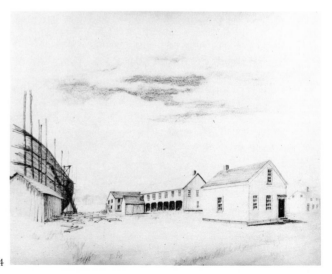

174

172

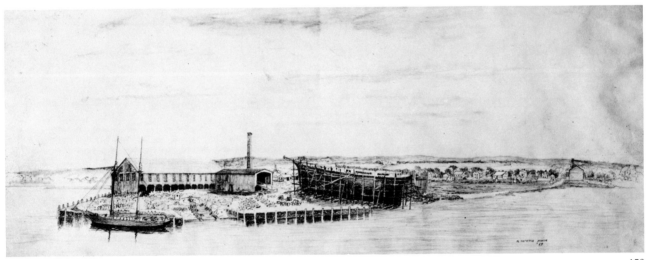

176

Hoxie, Stanley Jerome
American (1895–1981)

174. Eleven drawings for Mystic Seaport diorama.
 Source : Museum purchase. 67.209–67.219. 67.215
signed and dated: S. Jerome Hoxie, [19]59.
Mallory Shipyard. Pencil. 11 x 13⁵/₈ in. 67.218

175. Fourteen drawings for Mystic Seaport diorama.
 Pencil. Ca. 4¹/₄ x 6 in. – 10 x 14 in. (Not illustrated.)
Source: Museum purchase. 68.34.1–14

176. [Greenman shipyard.] Pencil. 7⁷/₈ x 20¹/₄ in. Signed
 and dated: S. Jerome Hoxie [19]59. Source: Mu-
seum purchase. 69.359

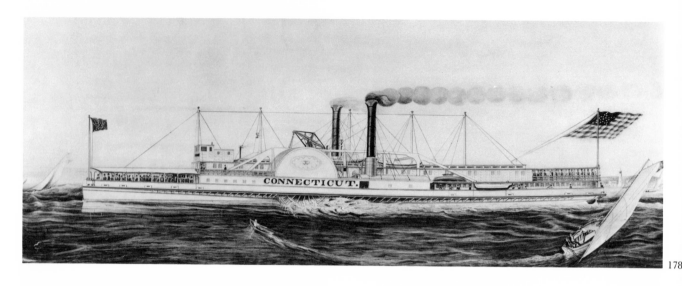

178

178. *Connecticut*. Watercolor. 15¹/₁₆ x 38³/₄ in. Attributed
 to Jurgen Frederick Huge. American steamboat,
built 1848, for Connecticut Steamboat Co.; became a
towboat on the Hudson River. Source: Everett Barns.
 38.246

179. *Henry A. Deming*. Watercolor. 29⁵/₈ x 39³/₈ in.
 Attributed to Jurgen Frederick Huge. American
two-masted schooner, built 1864, East Haddam, Con-
necticut. 190 tons. (Not illustrated.) Source: Miss Alice B.
Williams. 71.36

Hunter, Fred Leo
American (active 1878–1927)

180. *Twilight*. Oil. 21⁵/₈ x 15³/₄ in. Signed and dated:
 F. Leo Hunter, 1927. American ten-meter yacht,
built 1927, Lemwerder, Germany, for Clifford D.
Mallory, Sr. 58′10″x 10′6″ x 7′6″. Source: C. D. Mallory
Estates. 45.342

181. *Wall Street, N.Y. South Street. At the foot of Wall Street,
 1878, New York, N.Y.* Watercolor, pencil. 23⁵/₈ x 27¹/₂
in. Signed and dated: F. Leo Hunter, 1878. Source: C. D.
Mallory Estates. 49.1438

Jacobsen, Antonio Nicolo Gasparo
Danish-American (1850–1921)

182. *Alamo*. Oil. 21¹/₂ x 35³/₄ in. Signed and dated:
 A. Jacobsen, 705 Palisade Av. W. Hoboken, N.J.,
1885. American auxiliary steamship, built 1883, Chester,
Pennsylvania. 2237 tons. 329′ x 40′5″ x 21′5″. Source:
Philip R. Mallory. 75.401

180

Huge, Jurgen Frederick
German-American (1809–1878)

177. *New-York Clipper Schooner 'Carlos C. Colgate' Of Bently
 Miller & Thomas Line*. Watercolor. 28¹/₄ x 40¹/₄ in.
Signed and dated: J. F. Huge, Bridgeport, Conn. 1869.
American three-masted schooner, built 1867, West
Haven, Connecticut. 592.17 tons. 141′8″ x 33′ x 18′.
Source: Museum purchase. 67.98
See color illustration opposite p. 80.

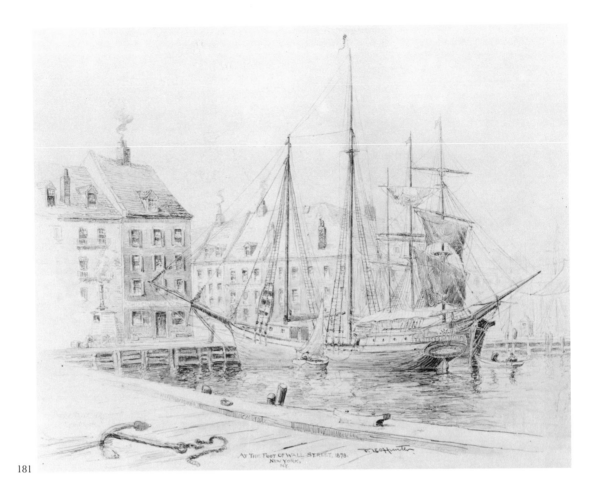

181

182

183

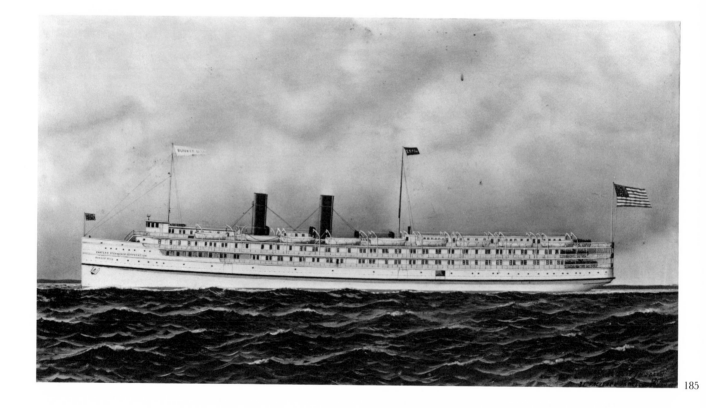

185

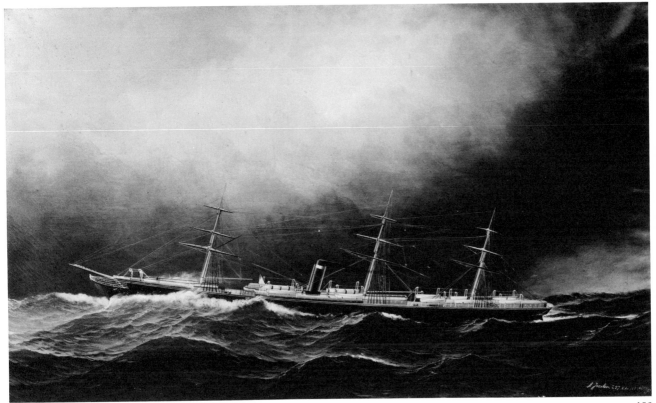

186

183. *Aryan*. Oil. 9⁷/₈ x 17¹/₂ in. Signed and dated:
A. Jacobsen, 1908. American ship, built 1893,
Phippsburg, Maine. 2124 tons. 248′6″ x 42′2″ x 26′3″.
Source: Laurence J. Brengle, Jr. 53.4540

184. *Brazos*. Oil. 25⁹/₁₆ x 45¹/₄ in. Signed and dated:
Antonio Jacobsen 31 Palisade Av. West Hoboken,
N.J., 1910. American steamship, built 1907, Newport
News Shipbuilding Co., Virginia. 3980 tons. 401′ x 54′ x
26′3″. (Not illustrated.) Source: Ward Line. 52.2254

185. *Bunker Hill*. Oil. 19¹/₂ x 35¹/₂ in. Signed and dated:
Antonio Jacobsen, 31 Palisade Av. West Hoboken,
N.J., 1914. American steamship, built 1907, Philadelphia,
Pennsylvania. 1724 tons. 375′ x 52′2″ x 31′6″. Source:
Museum purchase. 65.966

186. *City of Berlin*. Oil. 29¹/₂ x 49¹/₂ in. Signed and dated:
A. Jacobsen, 257 8th Av. N.Y., 1880 or 1888. British
auxiliary steamship, built 1874, Greenock, Scotland.
Source: James A. Lyles. 69.47

187. *City of Paris*. Oil. 21³/₈ x 35¹/₂ in. Signed and dated:
A. Jacobsen., 1889. British auxiliary steamship,
built 1889, Glasgow, Scotland. 5581 tons. 527′6″ x 63′6″
x 22′. Source: Louis H. C. Huntoon. 63.466

188. *City of Rio de Janeiro*. Oil. 21¹/₂ x 35¹/₄ in. Signed and
dated: Antonio Jacobsen, N.Y. 257 8 Av. cor. 23ʳᵈ,
1878. American auxiliary steamship, built 1878, Chester,
Pennsylvania. 3548 tons. 340′ x 38′ x 28′9″. (Not illus-
trated.) Source: C. D. Mallory Estates. 45.335

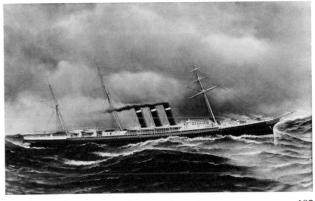

187

189. *Colorado*. Oil. 23³/₄ x 41⁷/₈ in. Signed and dated:
A. Jacobsen 1876 [*sic*]. American auxiliary steam-
ship, built 1879, Chester, Pennsylvania. 2765 tons. 306′ x
39′6″ x 21′6″. (Not illustrated.) Source: C. D. Mallory
Estates. 45.339

190. *Columbia*. Oil. 13³/₄ x 23³/₈ in. Signed and dated:
Antonio Jacobsen, 1908. American Black Ball Line
packet ship, built 1847 by William H. Webb, New York.
1051 tons. (Not illustrated.) Source: Wendell P. Colton,
Jr. 65.971

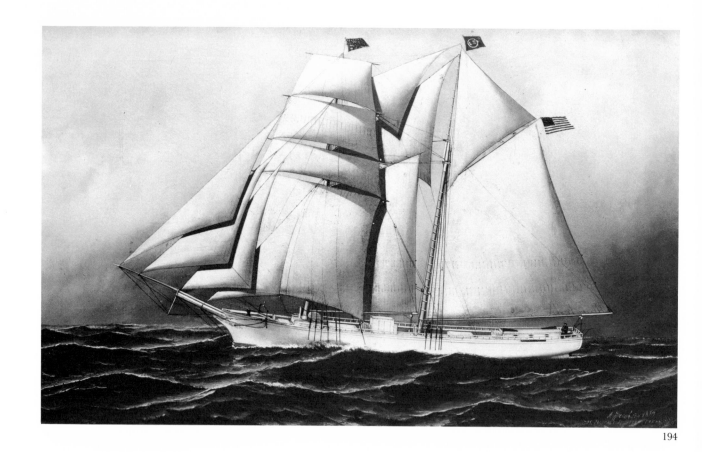

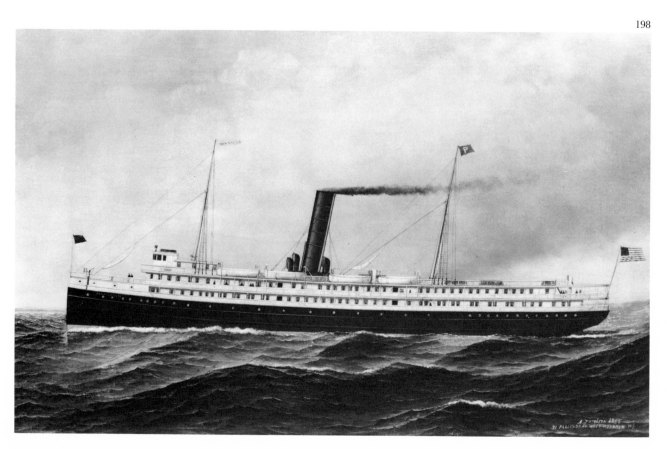

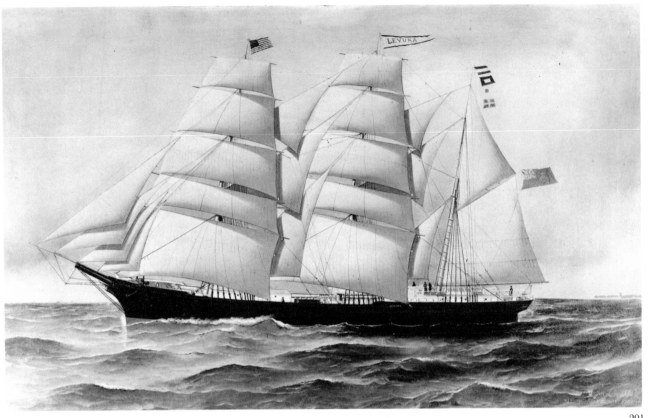

201

191. *Columbia*. Oil. 21¹/₂ x 35¹/₂ in. Signed and dated: Antonio Jacobsen, 1908. American Black Ball Line packet ship, built 1847 by William H. Webb, New York. 1051 tons. (Not illustrated.) Source: Wendell P. Colton, Jr. 65.974

192. *Dauntless*. Oil on board. 13³/₄ x 21³/₄ in. Signed and dated: Antonio Jacobsen, 1908. American schooner yacht, launched 1866, built by Forsyth & Morgan, Mystic, Connecticut; formerly *L'Hirondelle*. (Not illustrated.) Source: Museum purchase. 68.31

193. *Electra*. Oil. 21¹/₂ x 35¹/₂ in. Signed and dated: A. Jacobsen, 1885. American auxiliary steam yacht, built 1884 by Harlan & Hollingsworth, Wilmington, Delaware. 173' x 23' x 10'. (Not illustrated.) Source: Jules L. Devantoy. 77.175

194. *Fredericka Schepp*. Oil. 21¹/₄ x 35¹/₈ in. Signed and dated: A. Jacobsen, 705 Palisade Av West Hoboken, N.J., 1889. American topsail schooner, built 1877, Northport, N.Y. 111'7" x 28' x 14'; formerly *Emma Ritch*. Source: Miss Florence L. Schepp. 58.1318

195. *Henry R. Mallory*. Oil. 29¹/₂ x 59¹/₂ in. Signed and dated: Antonio Jacobsen, 1917. American steamship, built 1916, Newport News, Virginia. 424'3" x 54'5" x 23'8". (Not illustrated.) Source: Ward Line. 52.2248

196. *Horatio*. Oil. 28³/₄ x 49¹/₄ in. Signed and dated: Antonio Jacobsen, 1889. American ship, built 1877, Port Jefferson, New York. 332 tons. 117'5" x 28'6" x 17'. (Not illustrated.) Source: Carl C. Cutler. 40.502

197. *James S. Whitney*. Oil on cardboard. 19⁵/₈ x 34⁵/₈ in. Signed and dated: Antonio Jacobsen 31 Palisade Av West Hoboken, N.J., 1914. American steamship, built 1900, Wilmington, Delaware. 1926 tons. 278'5" x 43' x 29'. (Not illustrated.) Source: Laurence J. Brengle, Jr., William C. Brengle, Mrs. Thomas S. Gates, Jr. 53.109

198. *John Englis*. Oil on board. 22¹/₁₆ x 35³/₄ in. Signed and dated: A. Jacobsen 31 Palisade Av. West Hoboken, N.J., 1896. American steamship, built 1896, Chester, Pennsylvania. 3094 tons. 290'8" x 46' x 21'. Source: Anonymous. 73.144

199. *John Trucks*. Oil. 17¹/₂ x 29⁵/₁₆ in. Signed and dated: Antonio Jacobsen. 1916. American ship, built 1856, by William Cramp, Philadelphia, Pennsylvania. (Not illustrated.) Source: Miss Margaret P. Mallory. 61.177

200. *Lenape*. Oil. 29¹/₂ x 59¹/₂ in. Signed and dated: Antonio Jacobsen 31 Palisade Av., West Hoboken, N.J., 1912. American steamship, built 1904, Camden, New Jersey. 637 tons. 157'7" x 29'9" x 17'2". (Not illustrated.) Source: Ward Line. 52.2249

201. *Levuka*. Oil. 21¹/₂ x 35³/₄ in. Signed and dated: A. Jacobsen 705 Palisade Av West Hoboken. 1890. British bark, built 1884, St. John, New Brunswick. 1426 tons. 199'6" x 39'7" x 24'3". Source: Laurence J. Brengle, Jr. 53.3961

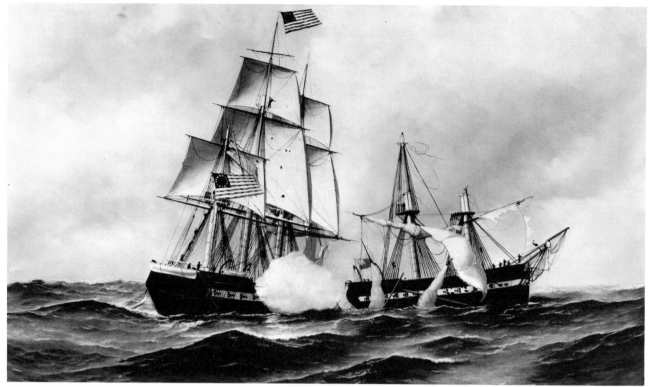

202

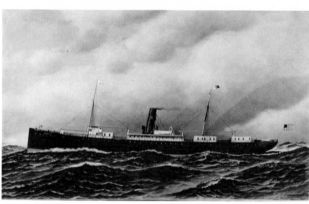

205

[J A C O B S E N]

202. *Capture of British Frigate 'Macedonian' in the War of 1812 by the U.S. Frigate 'United States.'* Oil. 29¼ x 38 in. Signed and dated: Antonio Jacobsen. 1892. Source: Carl C. Cutler. 40.503

203. *Mohawk*. Oil. 25½ x 45½ in. Signed and dated: Jacobsen, Palisade Av West Hoboken, N.J. 1910. American steamship, built 1908, William Cramp & Sons, Philadelphia, Pennsylvania. 4623 tons. 367' x 48'3" x 20'4". (Not illustrated.) Source: Ward Line. 52.2253

204. *New York*. Oil. 29½ x 49⅝ in. Signed and dated: A. Jacobsen 31 Palisade Av. West Hoboken, N.J. 1895. American steamship, built 1875, Wilmington, Delaware. 1805 tons. 281' x 38'1" x 20'2". (Not illustrated.) Source: Ward Line. 52.2251

205. *Nueces*. Oil on cardboard. 21¹⁵/₁₆ x 36 in. Signed and dated: Antonio Jacobsen 31 Palisade Av. West Hoboken, N.J. 1915. American steamship, built 1887, Chester, Pennsylvania. 2465 tons. 328' x 44' x 21'2". Source: Lieut. Col. George S. Deeming. 62.912

206. *Old Dominion*. Oil. 21³/₁₆ x 35½ in. Signed and dated: Antonio Jacobsen, N.Y. 1876. American paddlewheel steamship, built 1872, Wilmington, Delaware. Source: Museum purchase. 59.650

207. [*Old Dominion* and Joy Line vessels.] Oil on board. 29¼ x 59 in. Signed and dated: Antonio Jacobsen. 1908. American steamships. Source: J. B. Dunbaugh. 49.183

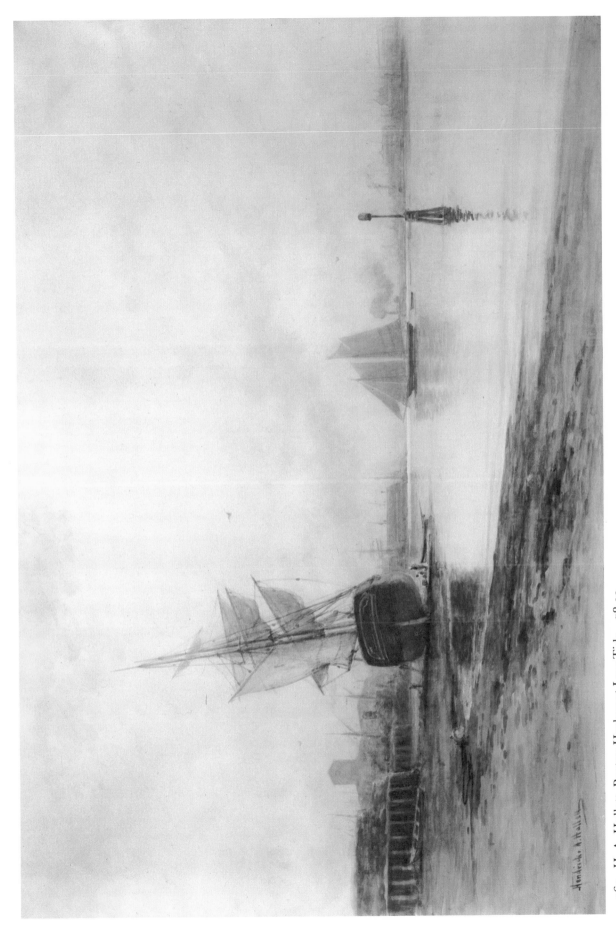

165. H. A. Hallett, Boston Harbor at Low Tide 78.10

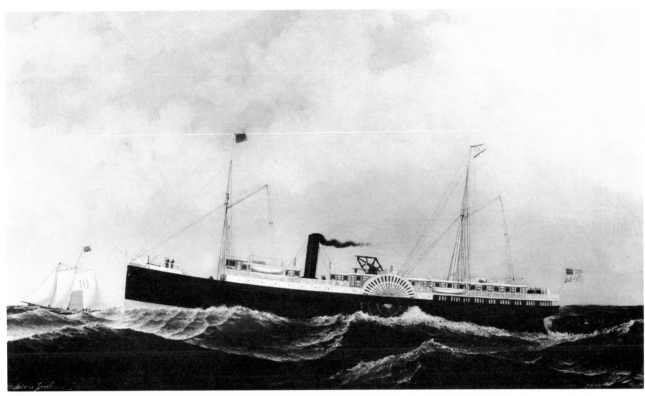

206

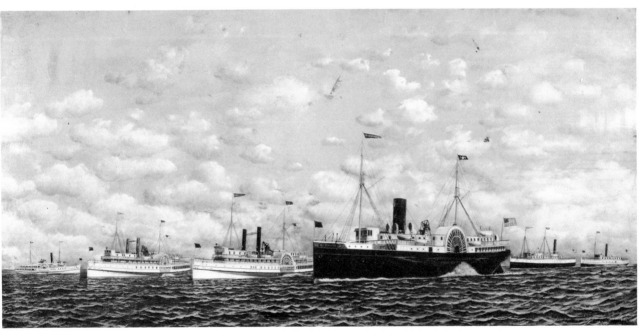

207

73

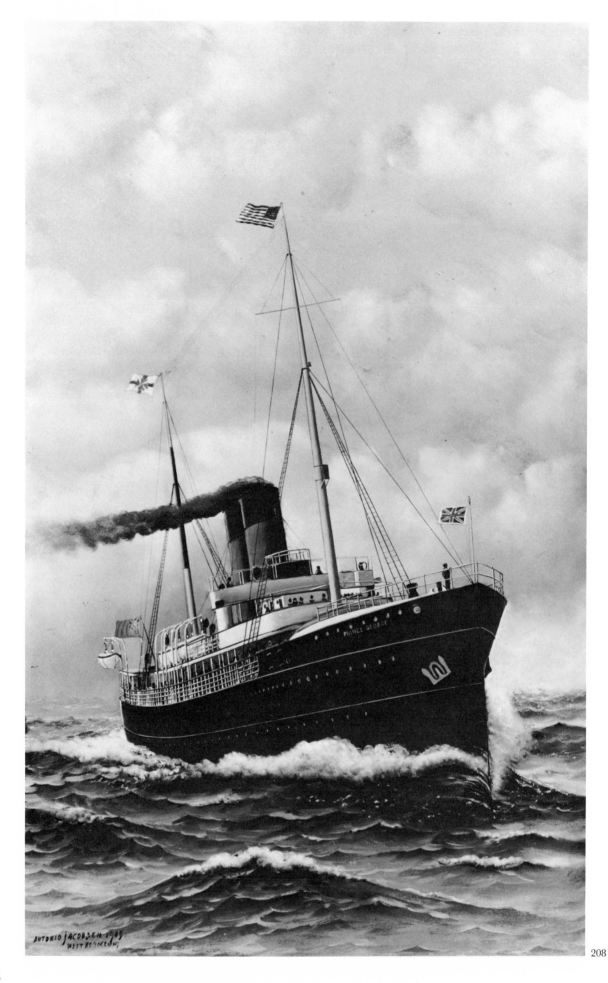

ANTONIO JACOBSEN 1905
WEST HOBOKEN NJ

208

214

212

[J A C O B S E N]

208. *Prince George*. Oil. 35 x 21¼ in. Signed and dated:
Antonio Jacobsen West Hoboken, N.J. 1909. British
steamship, built 1898, Hull, England. 1990 tons. 290' x
38' x 16'5". Source: Ward Line. 52.2250

209. *Prince George*. Oil on board. 27½ x 48 in. Signed and
dated: Antonio Jacobsen 31 Palisade Av West Ho-
boken, N.J. 1909. British steamship, built 1898, Hull,
England. 1990 tons. 290' x 38' x 16'5". (Not illustrated.)
Source: Ward Line. 52.2252

210. *Rio Grande*. Oil. 21¼ x 35½ in. Signed and dated:
Antonio Jacobsen N.Y. 257 8th Av. 1877. American
auxiliary steamship, built 1876, Chester, Pennsylvania.
(Not illustrated.) Source: Museum purchase. 71.66

211. *Riviera*. Oil. 21 x 35⅛ in. Signed: Antonio Jacobsen
31 Palisade Av West Hoboken, N.J. American
auxiliary steam yacht, built 1898, Troon, Scotland. (Not
illustrated.) Source: A. Ciliberti. 59.647

212. *State of Texas*. Oil. 21⅜ x 35⅜ in. Signed and dated:
A. Jacobsen 31 Palisade Av West Hoboken, N.J.
1894. American auxiliary steamship, built 1874 by John
Roach, Chester, Pennsylvania. 1548 tons. 250' x 36' x 20'.
Source: Museum purchase. 69.525

213. *Villamette* [*sic*]. Oil. 29½ x 49½ in. Signed and
dated: A. Jacobsen 705 Pal . . . N.J., 1882. Ameri-
can auxiliary steamship, built 1881, Chester, Pennsyl-
vania. 335'9" x 39'1" x 24'; correct name *Willamette*. (Not
illustrated.) Source: B. Donald Smith, Jr. 73.403

214. *Water Witch*. Oil. 23½ x 35½ in. Signed and dated:
A. Jacobsen. American schooner yacht, built 1880
by D. O. Richmond, Mystic, Connecticut. 168 tons. 85' x
22'5" x 9'. Source: Col. David Banks. 46.202

215. *Yankee Doodle*. Oil. 21½ x 35½ in. Attributed to
Antonio Nicolo Gasparo Jacobsen. American steel
ship. (Not illustrated.) Source: Anonymous. 62.1329

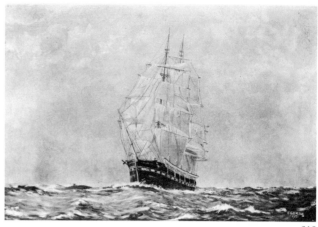

218

Johnson, A. Geary
American

216. [Diamond lightship.] Oil. 12 x 15⅞ in. Attributed
to A. Geary Johnson. (Not illustrated.) Source: A.
Geary Johnson. 57.102

217. [Latimer Reef Light, Fisher's Island Sound.] Oil.
16 x 12 in. Attributed to A. Geary Johnson. Source:
A. Geary Johnson. 57.103

217

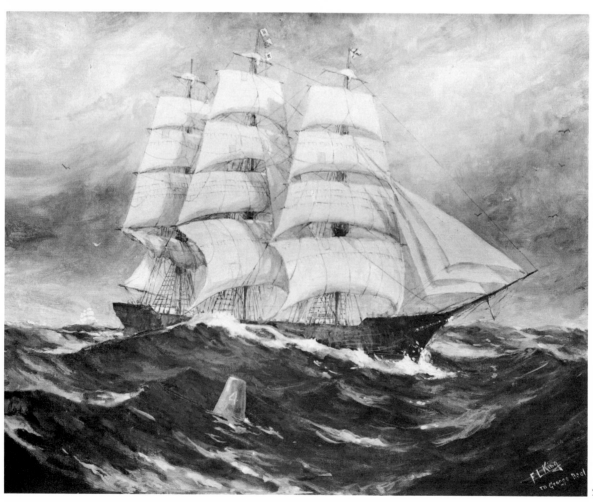

219

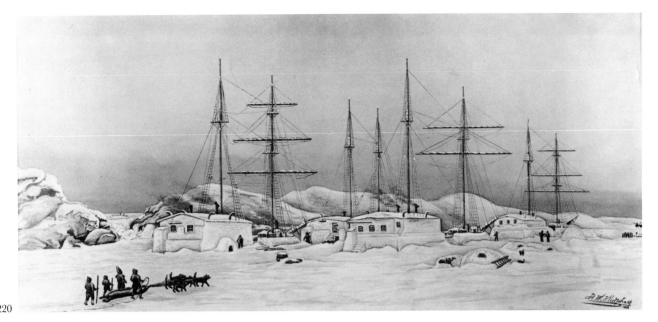

220

221

King, C. G. Y.

218. Unidentified whaleship. Oil. 19½ x 29½ in. Signed and dated: C. G. Y. King, 1931. Source: Savings Bank of New London. 39.1560

King, Frederic Leonard
American (1879–1947)

219. Unidentified ship. Oil. 26¾ x 33½ in. Signed: F. L. King to George Beal. Source: Bequest of George Brinton Beal. 58.1092

Klutschak, Henry W.
Bohemian

220. *Franklin Arctic Search Party in Winterquarters Hudson Bay 1878–79.* Watercolor, gouache. 14⅞ x 25 in. Signed and dated: H. W. Klutschak, 1882. Source: Museum purchase. 62.71

Labell, T.

221. *San Jacinto.* Oil. 19½ x 35¾ in. Signed and dated: T. Labell, 1907. American steamship, built 1903, Chester, Pennsylvania. 3870 tons. 380' x 53' x 24'7". Source: C. D. Mallory Estates. 45.880

223

Langseth-Christiansen, Richard

222. *Charles W. Morgan.* Oil. 21¼ x 32¼ in. Signed: R. Langseth-Christiansen. American ship, built 1841, New Bedford, Massachusetts. 351 tons. 113'11" x 27'2½" x 13'7¼". (Not illustrated.) Source: Richard Langseth-Christiansen. 66.245

Leavitt, John Faunce
American (1905–1974)

223. *Abbie S. Walker.* Pen, pencil. 11 x 13⅜ in. Signed: John F. Leavitt. American three-masted schooner, built 1883, Jonesboro, Maine. 190 tons. 103'7" x 28'7" x 8'5". Source: Gerald Gordon. 78.70

224

224. *Alice S. Wentworth.* Watercolor. 15 x 21¾ in. Signed: John F. Leavitt. American two-masted schooner, built as the *Lizzie A. Tolles*, 1863, Norwalk, Connecticut. 69 tons. Source: Museum purchase. 70.158

225. *America.* Watercolor. 14⅞ x 21⅞ in. Signed: John F. Leavitt. American schooner yacht, built 1967, East Boothbay, Maine. 104'x 22'. Source: Rudolph J. Schaefer. 75.187.14

225

78

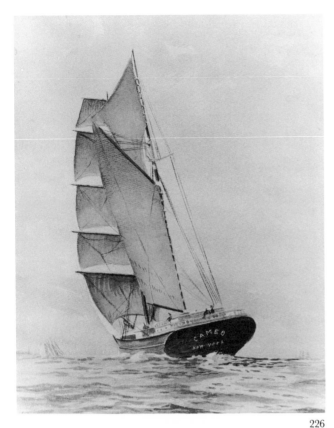

226

227

226. *'Cameo,' New York*. Watercolor. 12½ x 9½ in.
 Attributed to John F. Leavitt. American brigantine, built 1878 by Goss & Sawyer, Bath, Maine. 244 tons. 111'5" x 27'1" x 10'5". Source: Museum purchase by Pilots. 76.1.5

227. *Cutty Sark*. Oil. 17¾ x 23⅝ in. Signed and dated:
 J. F. Leavitt [19]25. British clipper ship. Source: Museum purchase. 77.47

228. *David Crockett*. Watercolor. 18 x 23¹⁵/₁₆ in. Signed:
 John F. Leavitt. American clipper ship, built 1853, Mystic, Connecticut. 1547 tons. 218'8" x 41' x 27'. Later rigged as a bark. In 1890 cut down to a towing barge carrying coal. Source: John F. Leavitt. 74.60

229. *Dorothy A. Parsons*. Pen, ink. 10¾ x 15 in. Signed:
 John F. Leavitt. Chesapeake Bay bugeye. Source: Museum purchase. 75.94

228

229 —

230

231

232

233

234

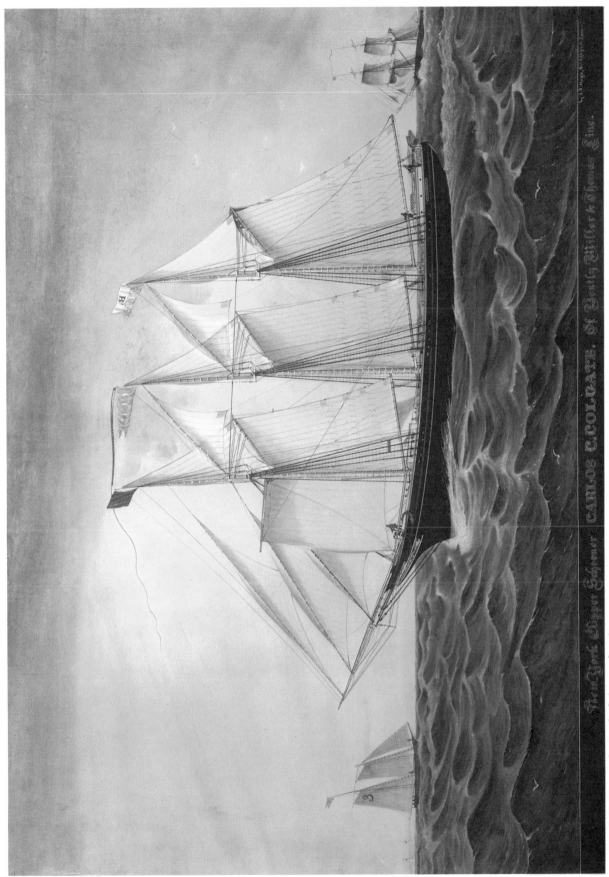

177. J. F. Huge, *Carlos C. Colgate* 67.98

230. *'Eliza Mallory,' Mystic*. Watercolor. 10½ x 14½ in. Signed: John F. Leavitt. American ship, built 1851 by Charles Mallory, Mystic, Connecticut. Source: Philip R. Mallory. 70.664

231. *Ella Eudora*. Pen, ink. 10 x 14 in. Signed and dated: J.F.L. [19]43. American two-masted schooner. Source: Museum purchase by Pilots. 76.1.117

232. *Emma C. Berry*. Watercolor. 10¾ x 14¾ in. Signed: John F. Leavitt. American smack, built 1866, Noank, Connecticut. Source: Museum purchase. 78.139

233. *'Escort.' Wooden Sidewheel Steamer Built by Geo. Greenman & Co. at Mystic 1862*. Pen, ink. 7¼ x 9⁵⁄₁₆ in. Signed: J.F.L. American steamship. Source: Museum purchase. 75.109

234. [Fair Haven oyster dugout canoe.] Pen, ink. 10⁷⁄₁₆ x 13½ in. Signed: John F. Leavitt. Source: Museum purchase. 75.102

235. [Figurehead on bow of the *Seminole*.] Pen, ink. 14½ x 11⁹⁄₁₆ in. Signed: John F. Leavitt. Drawn from the figurehead in the Seaport's collection. Source: Museum purchase. 75.144

236. *Gill Netting*. Pen, ink. 12 x 23¾ in. Attributed to John F. Leavitt. Source: Museum purchase. 75.339

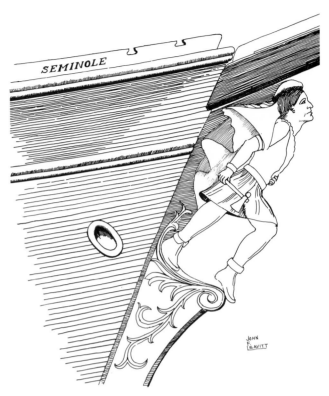

235

GILL NETTING

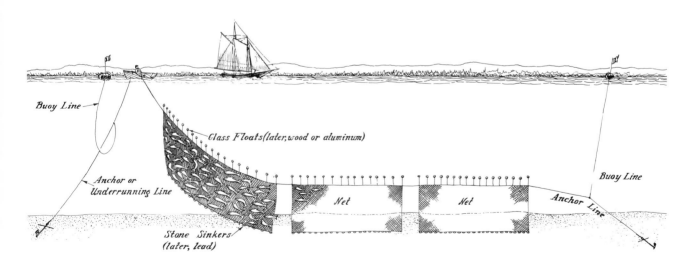

236

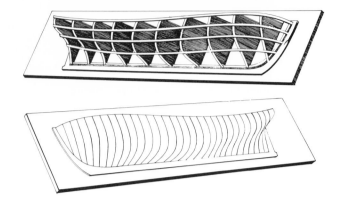

237. *Hawk's nest model. Vertical section model.* Pen, ink. 11 x 14 in. Attributed to John F. Leavitt. Source: Museum purchase. 75.178

238. *L. A. Dunton.* Watercolor. 15 x 21 ¹³/₁₆ in. Signed: John F. Leavitt. American two-masted schooner, built 1921, Essex, Massachusetts. 124' x 25' x 11'6". Source: John F. Leavitt. 65.522

239. *Barkentine 'Mannie Swan' the last square-rigged vessel built at Camden, Me.* Watercolor. 7⁷/₈ x 14⁷/₁₆ in. Signed: Leavitt. American barkentine, built 1891, Camden, Maine. 648 tons. 166' x 36'1" x 18'5". Source: Museum purchase by Pilots. 76.1.22

Top: Hawks nest model
Below: Vertical section model

237

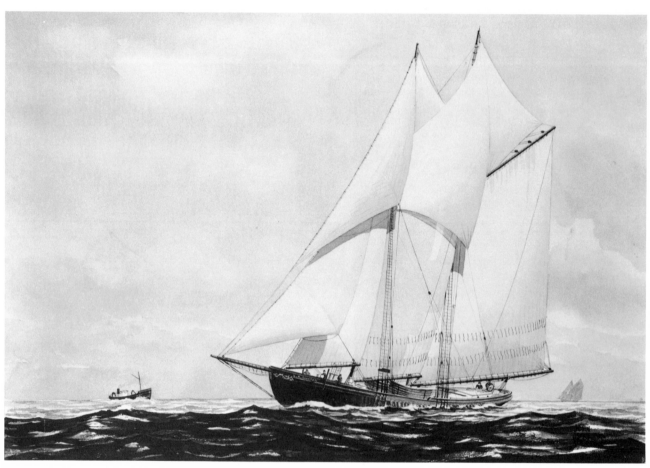

238

239

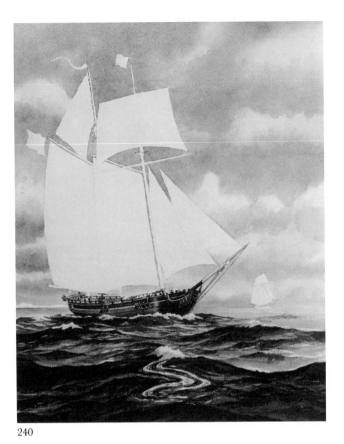

240

241

240. *Massachusetts.* Unfinished watercolor. 25⅞ x
21¾ in. Attributed to John F. Leavitt. American
two-masted topsail schooner. Source: Museum purchase
by Pilots. 76.1.159

241. *'Nellie' ex-'Glory B.'* Pen, ink. 10⁷/₁₆ x 13½ in.
Signed: John F. Leavitt. American steam launch.
Source: Museum purchase. 75.79

242. *Penobscot Bay Salmon Fishery.* Pen, ink. 13¼ x 23⅛ in.
Attributed to John F. Leavitt. Source: Museum
purchase. 75.338

PENOBSCOT BAY
SALMON FISHERY

242

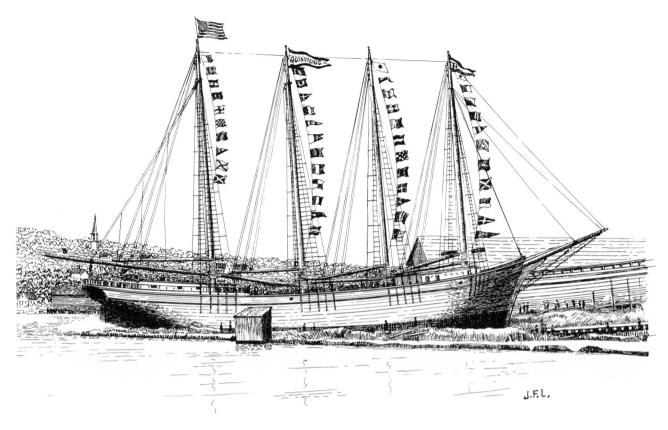

J.F.L.

243

READY WITH THE HARPOON

244

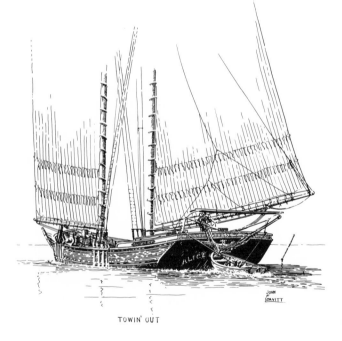

TOWIN' OUT

246

245

84

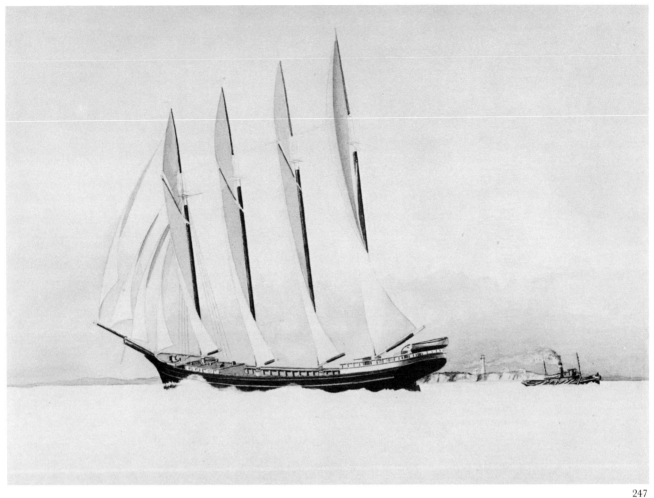

[LEAVITT]

243. *'Quinnebaug,' Launching the 4-masted schooner*. Pen, ink. 11 x 14¼ in. Signed: J.F.L. American four-masted schooner, built 1903, Mystic, Connecticut. 474 tons. 171'6" x 35'7" x 13'3". Source: Museum purchase.
75.84

244. *Ready with the harpoon*. Pen, ink. 8½ x 10¹¹/₁₆ in. Attributed to John F. Leavitt. Source: Museum purchase.
75.134

245. *Rocks & Surf*. Watercolor. 12 x 15⁷/₈ in. Signed: John F. Leavitt. Source: Museum purchase by Pilots.
76.1.138

246. *Towin' Out*. Pen, ink. 13¹¹/₁₆ x 10⁷/₈ in. Signed: John F. Leavitt. Source: Museum purchase by Pilots.
76.1.89

247. Unidentified American four-masted schooner. Unfinished watercolor. 13¹⁵/₁₆ x 21⁷/₈ in. Attributed to John F. Leavitt. Source: Museum purchase by Pilots.
76.1.153

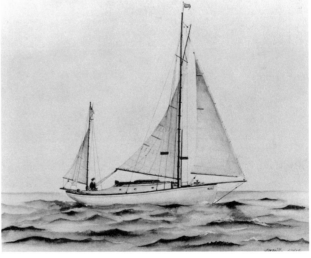

248. Unidentified American yawl yacht. Watercolor. 8 x 10 in. Signed and dated: J. F. Leavitt 5/11/25. Source: Mrs. Alfred F. Loomis.
79.167

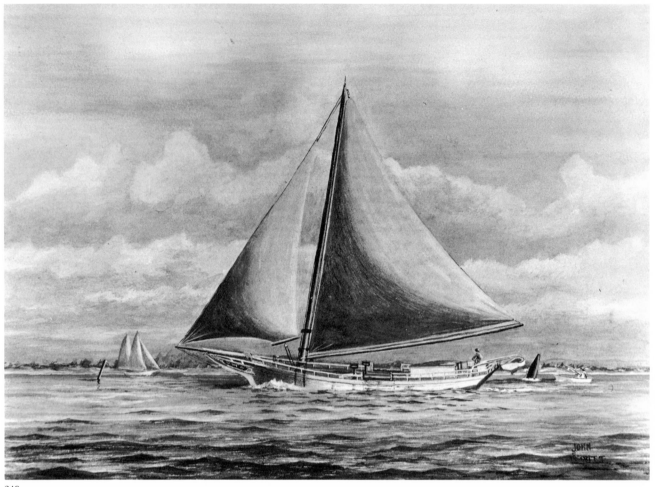

249

250

251

[L E A V I T T]

249. Unidentified Chesapeake Bay skipjack. Watercolor. 10^{15}/16 x 14^7/8 in. Signed: John F. Leavitt. Source: Museum purchase by Pilots. 76.1.143

250. Unidentified harbor. Watercolor. 15 x 20^7/8 in. Signed: John F. Leavitt. Source: Museum purchase by Pilots. 76.1.130

251. Unidentified peapod. Pen, ink. 10^3/16 x 13^3/16 in. Signed: John F. Leavitt. Maine peapod for lobstering, fishing, and general use. Source: Museum purchase. 75.82

Approximately 350 oils, watercolors, pen, ink, and pencil works available for use by students, researchers, etc.

Loomis, C. R.

252. [Boathouse.] Watercolor. 5^3/4 x 13^3/8 in. Signed: C. R. Loomis. (Not illustrated.) Source: Anonymous. 73.116

Loos, J. F. (or John)
Belgian (active 1861–1887)

253. *'Charlotte W. White,' Captain B. F. Pendleton.* Oil. 25½ x 37 in. Signed and dated: J. F. Loos, Antwerp, 1864. American ship, built 1858, Belfast, Maine. 1411 tons. 190' x 37' x 23'6". Missing on voyage from Liverpool 1880. Source: Laurence J. Brengle, Jr. 53.4530

254. *Gov. Goodwin.* Oil. 24⁹/₁₆ x 36⅛ in. Signed and dated: John Loos, Antwerp, 1886. American ship, built 1877, East Boston, Massachusetts. 1414 tons. 212' x 40' x 23'. Source: Cameron I. Cutler. 72.493

255. *Jacob S. Winslow.* Oil. 19¹⁵/₁₆ x 29¾ in. Signed and dated: John Loos, Antwerp, 1871. American bark, built 1869, Westbrook, Maine. 524 tons. (Not illustrated.) Source: C. D. Mallory Estates. 45.341

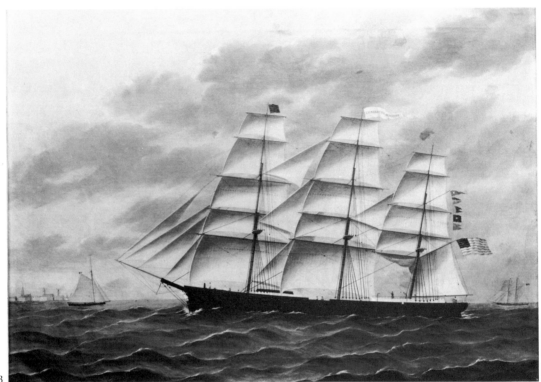

253

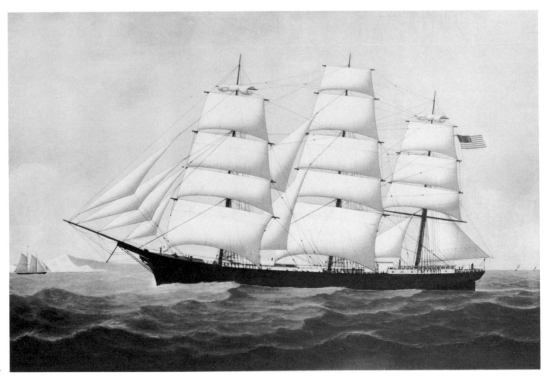

254

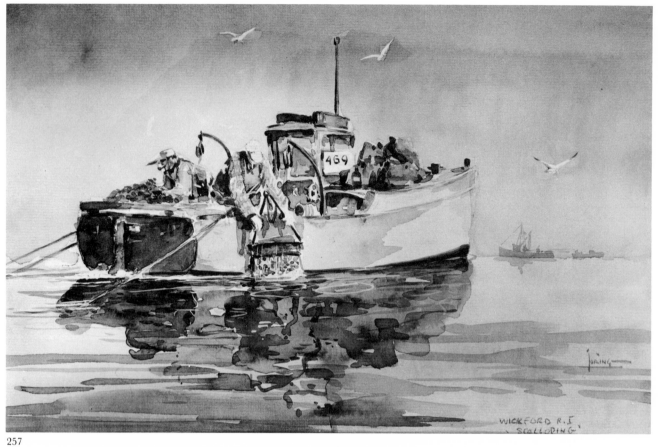

257

258

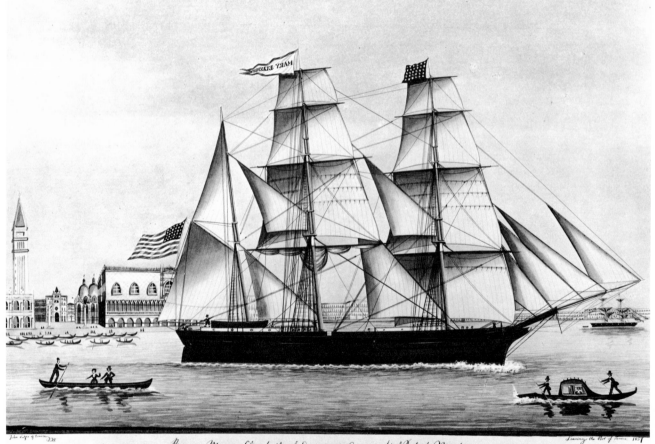

Barque Mary Elizabeth of Searsport Cyrus & Nichols Master

259

260

Loring, Paule Stetson
American (1899–1968)

256. *Quoddy Boat; Carry-Away Boat (Lubec); Hampton Whaler; Isle of Shoals Shay; Chebacco.* Pen, ink. 13½ x 16 in. Attributed to Paule S. Loring. Illustrations for David Cabot, *"New England Double Enders," The American Neptune,* 12 (1952). (Not illustrated.) Source: David Cabot. 70.832

257. *Wickford, R.I., Scalloping.* Watercolor. 9¾ x 15 in. Signed: Loring. Source: Bequest of Thomas P. Horgan. 64.444

Luzro, Giovanni (or John)
Italian (active 1850–1877)

258. *Barque 'Mary Elizabeth' of Searsport Cyrus A. Nichols Master Leaving the Port of Venice 1857.* Watercolor. 16⁵/₁₆ x 23³/₁₆ in. Signed: John Luzro of Venice. American bark, built 1850, Searsport, Maine. Source: William C. Brengle. 53.3948

McBey, James
Scottish-American (1883–1959)

259. *Bonnie Dundee* [III?]. Watercolor. 9 x 14⁵/₁₆ in. Signed and dated: James McBey, 1941. American auxiliary ketch yacht. Source: Philip R. Mallory. 67.260

260. *Cat Cay 6 March 1958.* Watercolor. 14³/₁₆ x 20¼ in. Signed and dated: James McBey, Cat Cay 6 March 1958. Source: Philip R. Mallory. 67.256

261. *Charles W. Morgan.* Watercolor. 14 x 24½ in. Signed and dated: James McBey, Mystic, 31 October 1942. American ship, built 1841, New Bedford, Massachusetts. 351 tons. 113′11″ x 27′2½″ x 13′7¼″. (Not illustrated.) Source: Philip R. Mallory. 67.258

262. *Charles W. Morgan.* Watercolor. 13½ x 23 in. Signed and dated: James McBey, Mystic, Conn. 31 October 1942. American ship, built 1841, New Bedford, Massachusetts. 351 tons. 113′11″ x 27′2½″ x 13′7¼″. (Not illustrated.) Source: Philip R. Mallory. 67.254

266

267

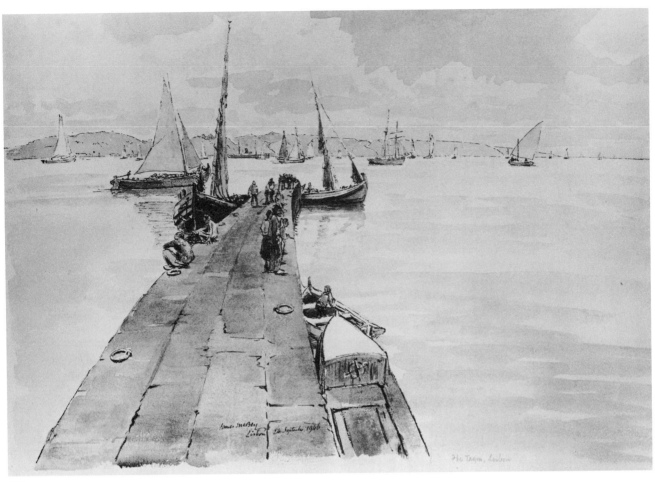

268

[M C B E Y]

263. *Cutty Sark*. Watercolor. 12⁵/₈ x 18⁵/₈ in. Signed and
 dated: James McBey East India Dock, London, 11,
13 September 1954. British clipper ship. (Not illustrated.)
Source: Philip R. Mallory. 55.544

264. [Dock-side at Oase, Kent, England.] Watercolor.
 12¹/₄ x 19³/₈ in. Signed: James McBey Oase Kent.
(Not illustrated.) Source: Philip R. Mallory. 67.261

265. [Mystic Seaport.] Watercolor. 14⁹/₁₆ x 22 in. Signed
 and dated: James McBey Mystic, Conn. September
1945. (Not illustrated.) Source: Philip R. Mallory. 67.253

266. [Tangier.] Watercolor. 11¹/₂ x 18¹/₂ in. Signed and
 dated: James McBey Tangier 3 March 1951. Source:
Philip R. Mallory. 67.257

267. [Tangier.] Watercolor. 12¹/₄ x 19 in. Signed and
 dated: James McBey Tangier March 1948. Source:
Philip R. Mallory. 67.259

268. *The Tagus, Lisbon*. Watercolor. 13³/₄ x 19¹/₄ in.
 Signed and dated: James McBey Lisbon 24 Sep-
tember 1946. Source: Philip R. Mallory. 67.255

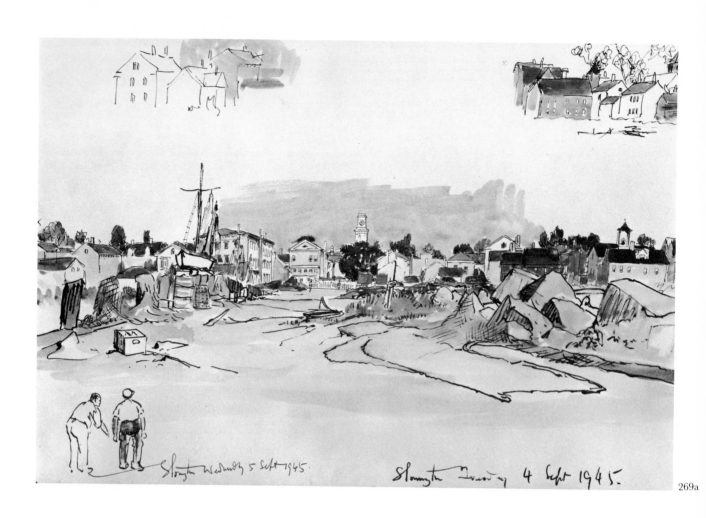

Stonington Wednesday 5 Sept 1945. Stonington Tuesday 4 Sept 1945.

269a

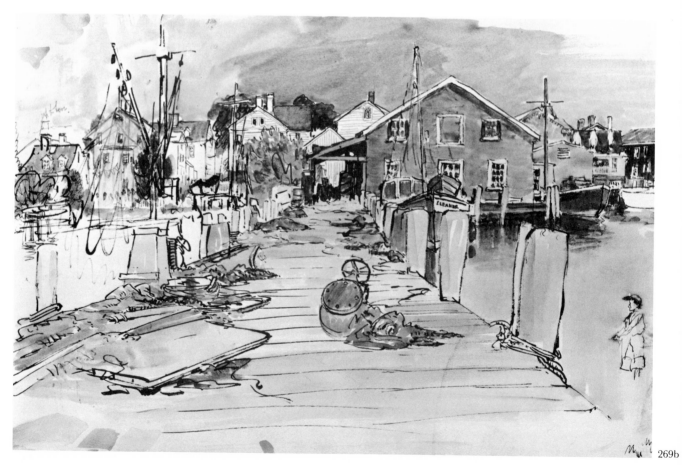

269b

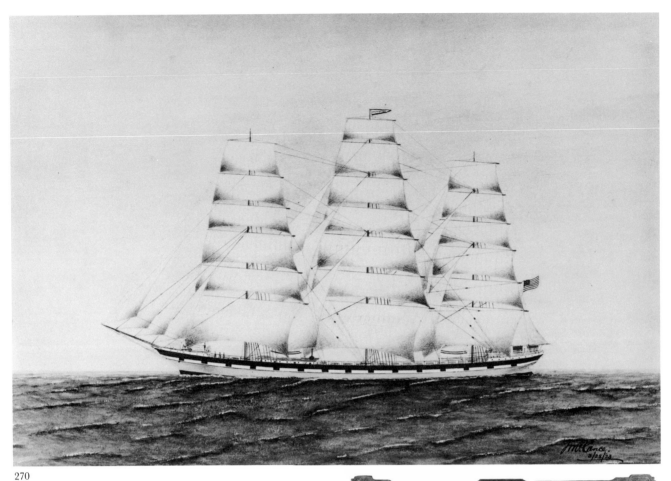

270

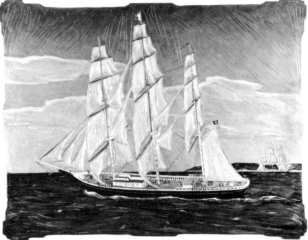

271

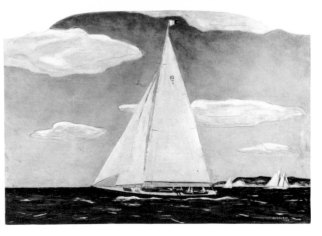

272

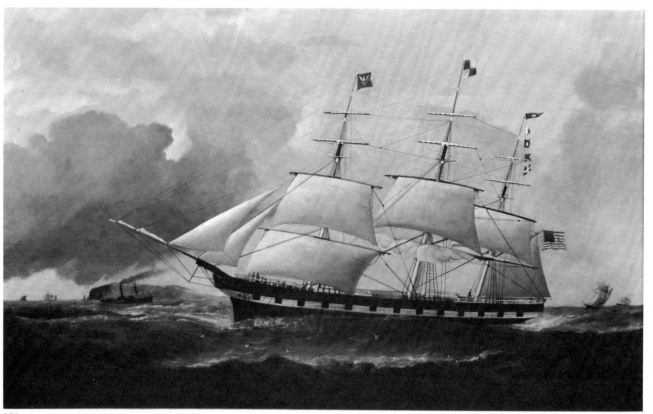

273

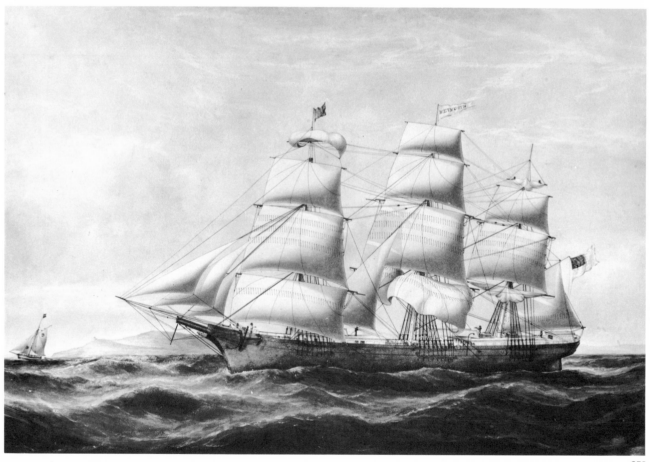

275

McFarlane, Duncan
Scottish (active 1834–1871)

273. *Fort William* [?] Oil. 25 x 41 1/8 in. Attributed to
 Duncan McFarlane. American ship, built 1854,
Sunderland, England. Source: Mrs. Thomas S. Gates, Jr.
 53.4533

274. *H. M. Hayes.* Watercolor. 19 x 27 1/4 in. Attributed to
 Duncan McFarlane. American ship, built 1853,
Kennebunk, Maine. 1370 tons. Source: William C.
Brengle. 53.3950
See color illustration opposite p. 96.

275. *Weymouth.* Watercolor. 19 5/16 x 27 3/4 in. Attributed
 to Duncan McFarlane. American ship, built 1854,
East Boston, Massachusetts. 1396 tons. 200' x 38' x 24'.
Source: Laurence J. Brengle, Jr. 53.3945

Manton, John

276. *Pell-Mell. A terrific Squall on the Atlantic (no joke) not half
 way across.* Watercolor. 7 3/8 x 9 in. Signed: J. M.
Page from logbook 448 kept by John Manton on board the
ship *Isabella* of Leith, Scotland. British ship. (Not
illustrated.) Source: Museum purchase. 79.166

Martens, John W.
(active 1836–1846)

277. [Wallabout Bay, East River, New York.]
 Watercolor. 20 3/4 x 30 in. Signed and dated: J. W.
Martens, 1836. Source: Harold H. Kynett. 58.1303

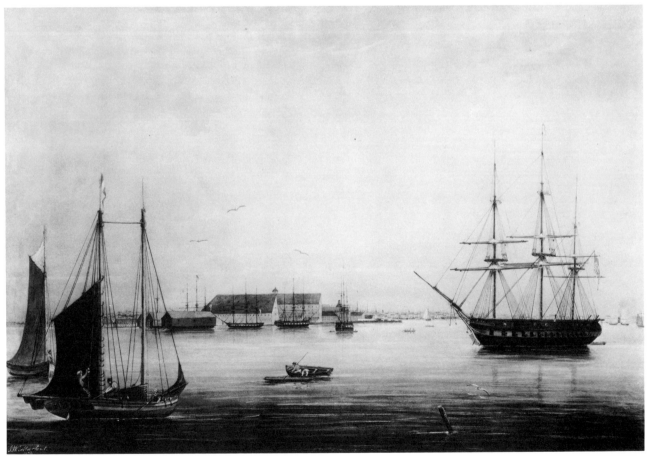

277

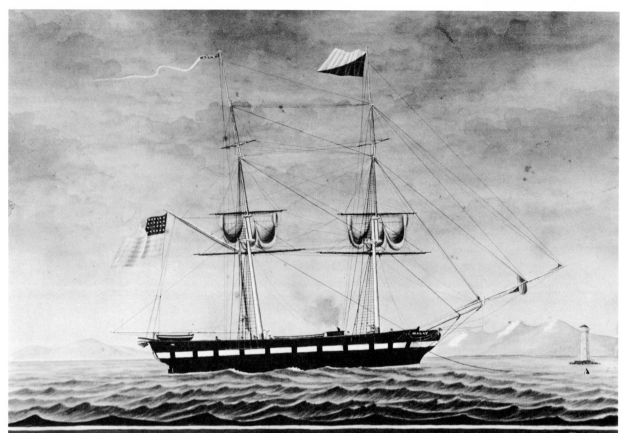

BRIG MALAY IN LEGHORN ROADS JOHN NICHOLS JR. MASTER OCTOBER 16TH 1833

278

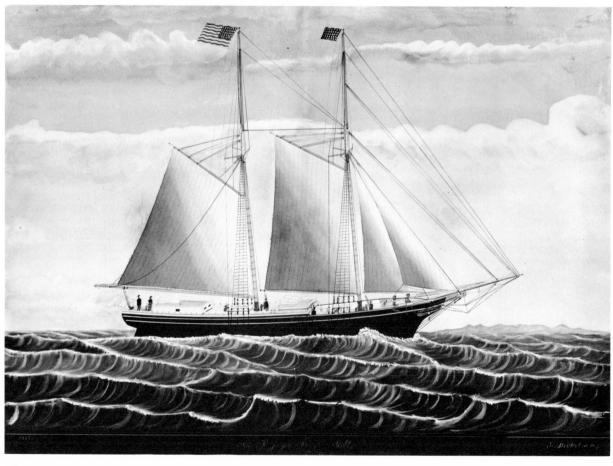

279

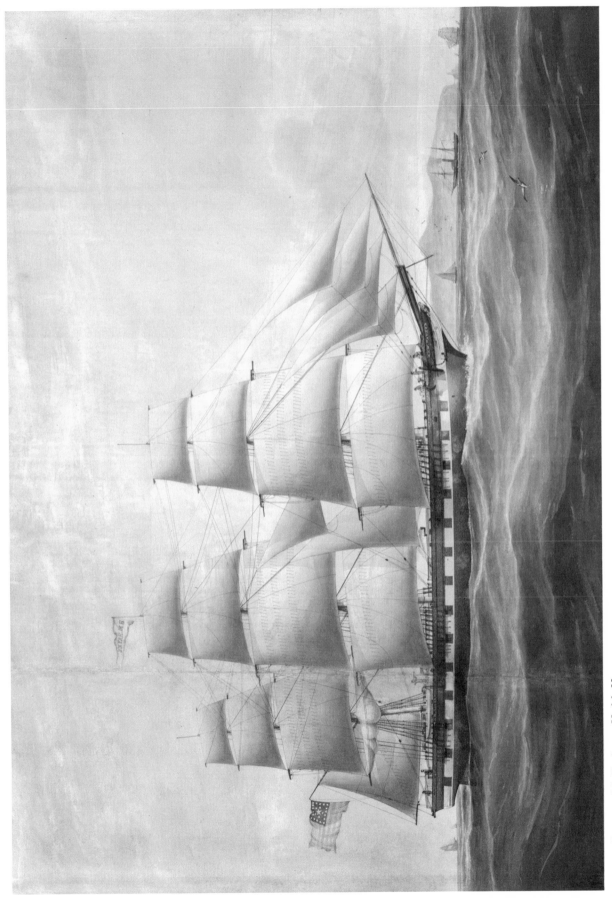

274. Duncan McFarlane, *H. M. Hayes* 53-3950

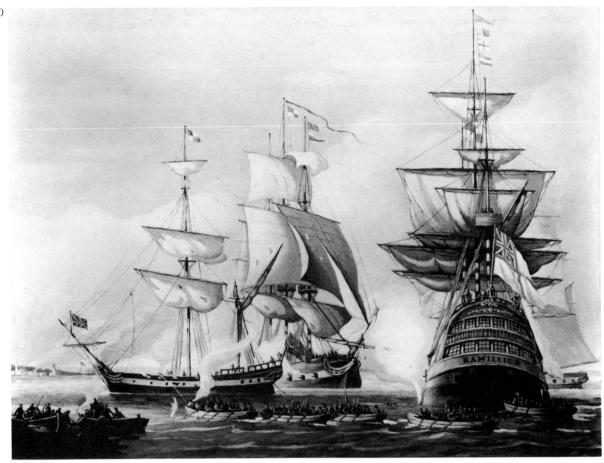

Mazzinghi, Pietro
Italian (active 1831–1836)

278. *Brig 'Malay' in Leghorn Roads John Nichols Jr. Master October 16th 1833*. Watercolor, gouache. 15³/8 x 21³/8 in. Signed: Peter Mazzinghi facit Leghorn. American brig, built 1818, Salem, Massachusetts. Source: Mrs. Mary Stillman Harkness. 33.9

Mikkelsen, E.

279. *'Ida A. Jayne,' Capt. Mills*. Watercolor, gouache. 20 x 27⁷/8 in. Signed and dated: E. Mikkelsen, 1884. American two-masted schooner, built 1863, Port Jefferson, New York. 207 tons. 99'5" x 28'7" x 8'5". Source: Mrs. Walter Parsons. 66.176

Mitchell, George B.
American (1874–1966)

280. [Stonington, Connecticut, attacked by the British fleet, 9 and 10 August 1814.] Oil. 29¹/2 x 35 in. Signed: G. B. Mitchell. Source: G. B. Mitchell Estate. 44.285

Mixter, Felicie Howell
American (1897–)

281. *Following the Winner August 2nd 1937*. Watercolor. 8 x 11³/4 in. Signed and dated: F.H.M. [19]37. (Not illustrated.) Source: Mrs. Henry Galpin. 70.385

282. *'Ranger' August 2nd 1937*. Watercolor. 8¹/4 x 11³/4 in. Signed and dated: F.H.M. [19]37. American J-boat. (Not illustrated.) Source: Mrs. Henry Galpin. 70.383

283. *Spectators August 2nd 1937*. Watercolor. 8 x 11⁵/8 in. Signed and dated: F.H.M. [19]37. (Not illustrated.) Source: Mrs. Henry Galpin. 70.384

284. *The Fleet August 2nd, 1937. Newport August 2, 1937*. Watercolor. 7¹/2 x 11¹/2 in. Signed and dated: F.H.M. [19]37. Source: Mrs. Henry Galpin. 70.382

284

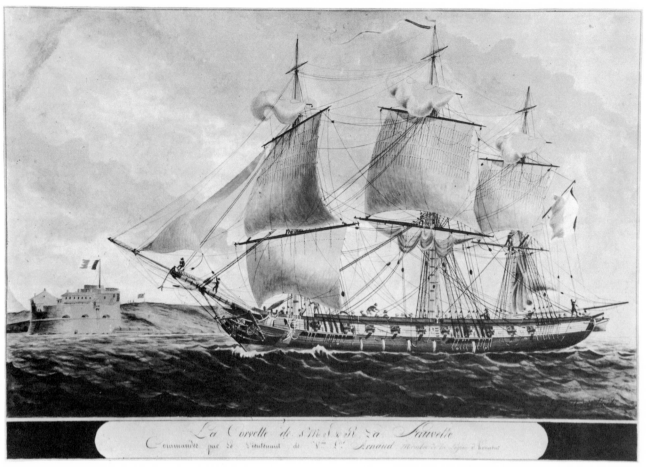

285

Morety, Andrès
French (active 1797–1817)

285. *La Corvette de S. M. I. & R. 'La Fauvette' Commandée par
le Lieutenant de V^an L. Arnaud Membre de la Légion
d'honneur.* Watercolor. 19¼ x 27¼ in. Signed and dated:
Fait par Andrès Morety, Toulon le 2 Aout 1812. Source:
Mrs. Thomas S. Gates, Jr. 53.4562

Morrill, George
American

286. *Nantucket Whale Ship Signals 1840.* Oil on panel. 23½ x
13½ in. Signed: George Morrill Sign and Fancy
Painter New Bedford Mass. Source: Museum purchase.
 37.89

Neiman, LeRoy
American (1926–)

287. [*Constellation*—Oyster Bay—*Sovereign.*] Oil and
enamel on board. 71½ x 47½ in. Signed and dated:
LeRoy Neiman [19]64. American and British twelve-
meter yachts. Source: Arthur W. Herrington. 67.61

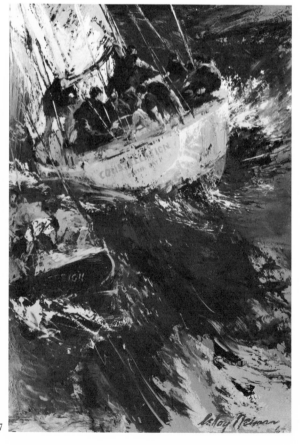

287

98

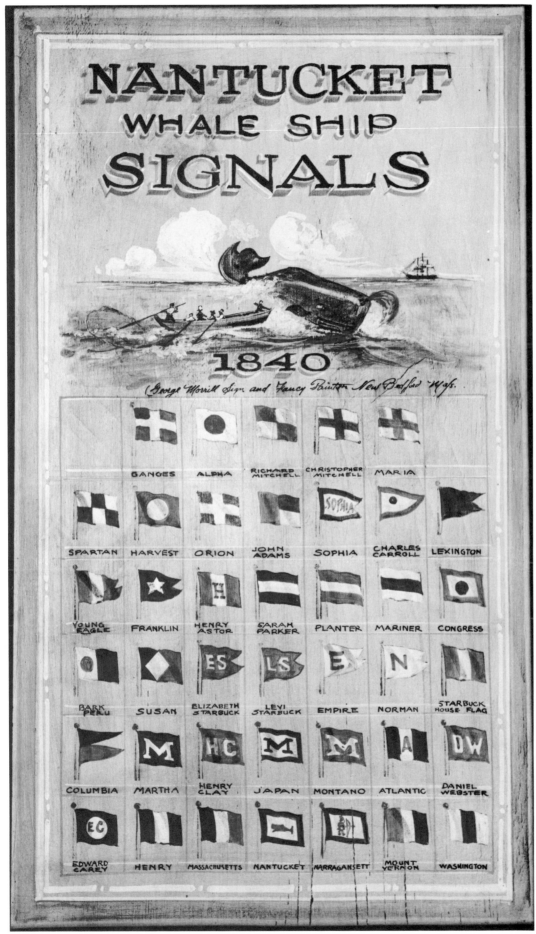

286

99

Newell, Robert R.
American

288. *The Private Signals of Nantucket Whaling Merchants.*
Watercolor, pen. 18¼ x 15 in. Signed and dated: R. R. Newell [19]70. (Not illustrated.) Source: Robert R. Newell. 71.5

Neyland, Harry
American (1877–1958)

289. *Charles W. Morgan.* Oil. 25½ x 31½ in. Signed: Harry Neyland. American bark, built 1841, New Bedford, Massachusetts. 351 tons. 113'11" x 27'2½" x 13'7¼". (Not illustrated.) Source: George L. Miner. 66.223

290. [*Charles W. Morgan* in a snowstorm.] Oil. 19½ x 17½ in. Signed: Harry Neyland. American bark, built 1841, New Bedford, Massachusetts. 351 tons. 113'11" x 27'2½" x 13'7¼". Source: Museum purchase. 78.238

290

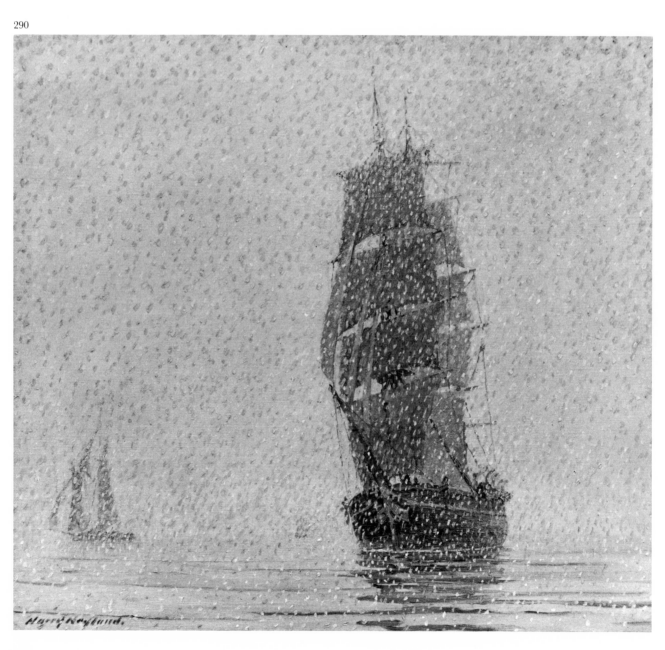

291

291. *'Charles W. Morgan' lying at her berth at Fairhaven.* Oil.
17³/₄ x 23⁵/₈ in. Signed and dated: Harry Neyland
South Dartmouth Mass. August 22, 1925. American bark,
built 1841, New Bedford, Massachusetts. 351 tons.
113′11″ x 27′2¹/₂″ x 13′7¹/₄″. Source: Museum purchase.

74.7

Nichols, H. D.

292. *The schooner smack, 'Maria.'* Watercolor. 10 x 7 in.
Signed: H. D. Nichols. American schooner smack.
Source: Capt. Horace Allen Arnold. 32.88

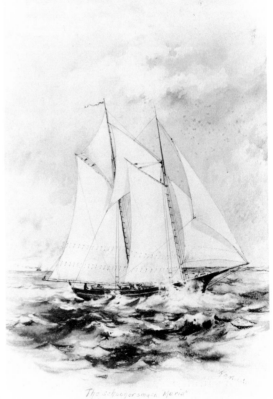

292

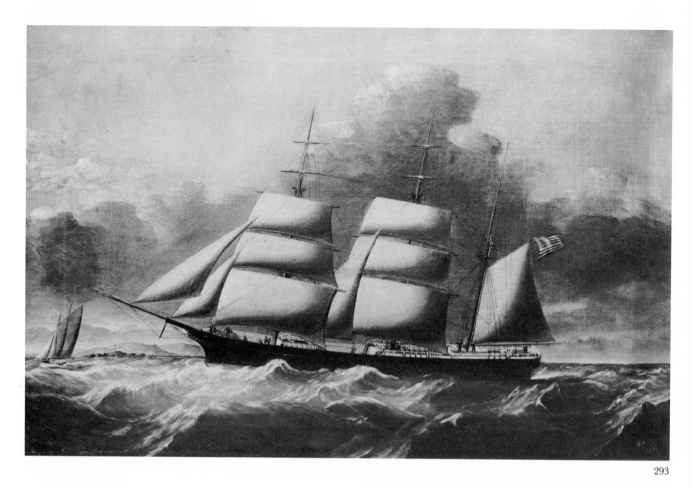

293

Ogilvy, Clinton
American (1838–1900)

293. *Sappho*. Oil. 19³/4 x 29³/8 in. Signed and dated:
 C. Ogilvy, 1871. American bark, built 1870, Noank,
Connecticut. 712 tons. Source: Henry B. duPont.

62.1251

Palmer, R. B.

294. *Along the docks New London, Conn*. Charcoal.
 10⁷/8 x 8⁵/8 in. Signed and dated: Palmer, 1904.
Source: Mrs. Harriet Greenman Stillman. 41.272

295. Unidentified hermaphrodite brig on shore.
 Watercolor, gouache. 16 x 21¹/2 in. Signed and
dated: Palmer, [19]05. Source: Gideon O. Manchester.

50.3068

Pansing, Fred
German-American (1844–1912)

296. *City of Chicago*. Oil. 59³/8 x 107³/4 in. Attributed to
 Fred Pansing. British auxiliary steamship, built
1883, Glasgow, Scotland. 3383 tons. 430'6" x 33'6". (Not
illustrated.) Source: Mrs. Laurence J. Brengle, Sr.

51.4008

297. *Priscilla*. Oil. 21⁵/8 x 36¹/2 in. Signed: Fred Pansing.
 American sidewheel steamship, built 1894 for the
Fall River Line. Source: John Bailey. 40.341

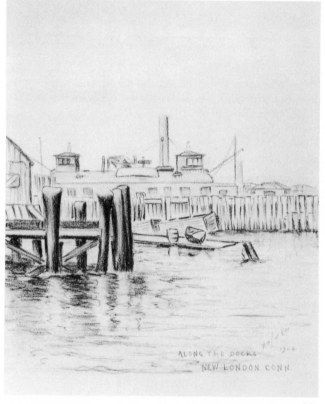

294

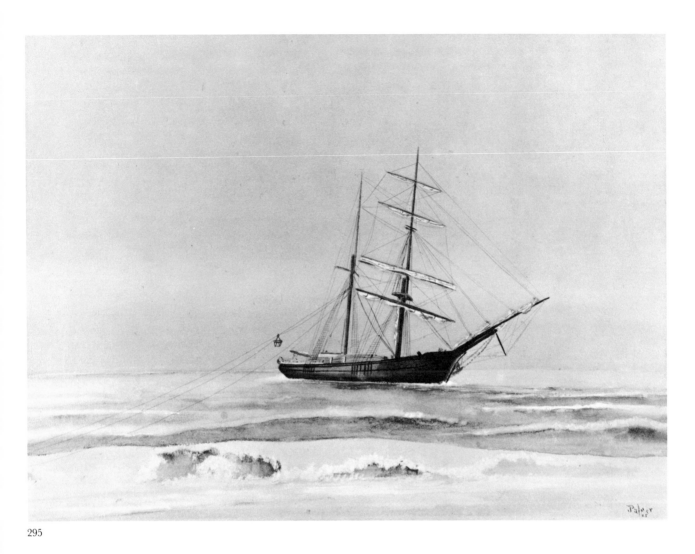

295

297

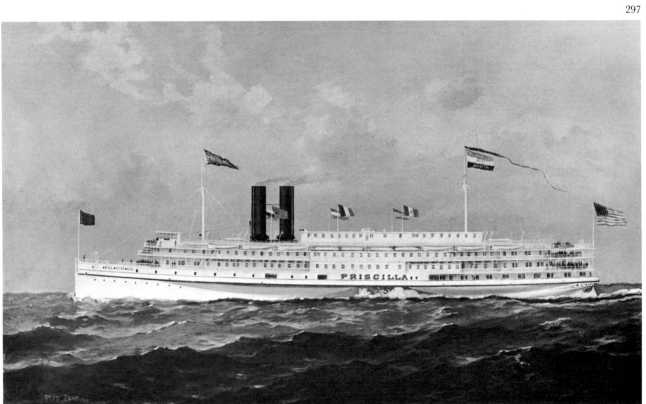

300

Park, Edwin Avery
American

298. [Anchors.] Watercolor. 15¼ x 22 in. Signed and
 dated: E. A. Park, 1945. (Not illustrated.) Source:
Edwin Avery Park. 66.225

299. [Mystic Seaport grounds.] Watercolor. 14⅞ x 22 in.
 Signed and dated: E. A. Park 1944. (Not illustrated.)
Source: Edwin Avery Park. 66.227

300. [Pinky at a wharf.] Watercolor. 15½ x 22 in. Signed
 and dated: E. A. Park [19]45. Source: Edwin Avery
Park. 66.226

Parsons, Charles Richard
American (1844–1915)

301. *Pilgrim.* Watercolor, gouache. 21 x 34½ in. Signed
 and dated: C. R. Parsons, [18]82. American side-
wheel steamboat, built 1882, Chester, Pennsylvania. 3484
tons. 390′ x 50′ x 18′6″. Source: Mrs. Eleanore Hammer
Scherer in memory of Valdemar T. Hammer. 59.1195
See color illustration opposite.

302

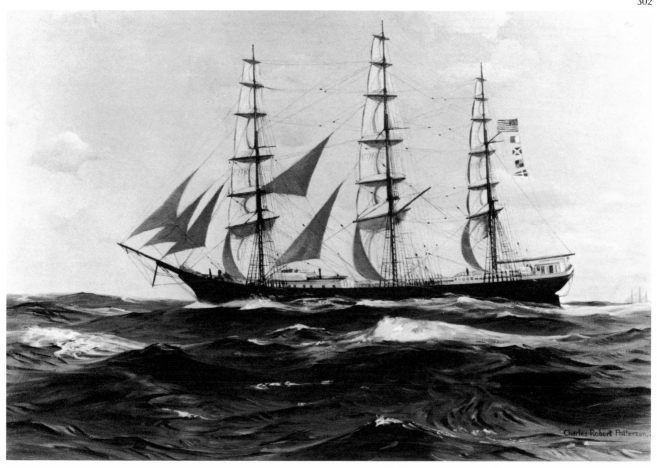

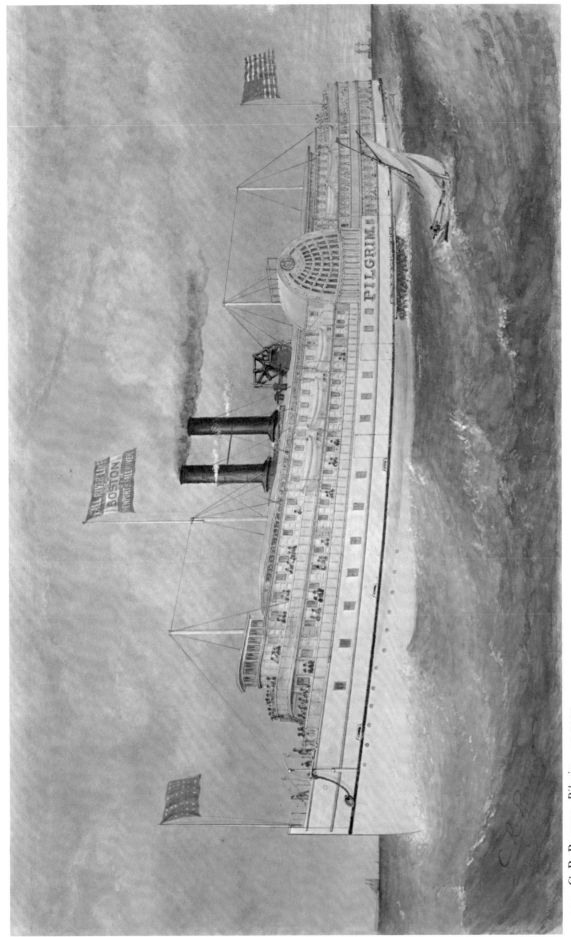

301. C. R. Parsons, *Pilgrim* 59.1195

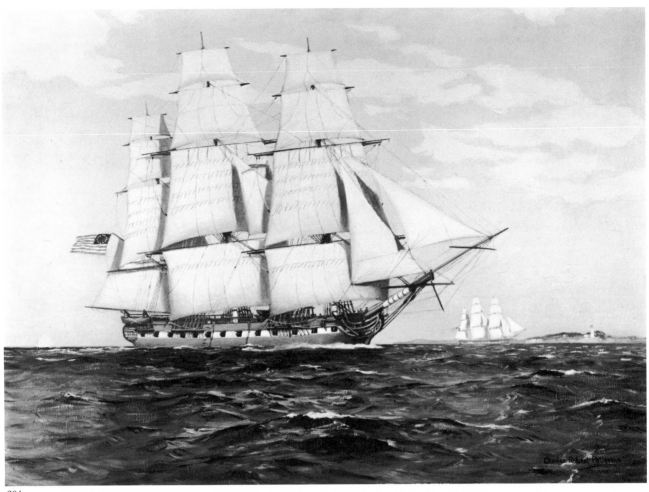

304

Patterson, Charles Robert
Anglo-American (1878–1958)

302. *Benjamin F. Packard*. Oil. 29½ x 44¼ in. Signed and dated: Charles Robert Patterson [19]25. American ship, built 1883, Bath, Maine. 2076 tons. 244'2" x 43'2" x 26'7". Source: C. Porter Schutt. 76.50

303. *Close-Reefing The Main Topsail*. Oil. 11⅝ x 15⅝ in. Signed: Charles R. Patterson. (Not illustrated.) Source: Carl C. Cutler. 76.66

304. *Randolph*. Oil. 29½ x 41¼ in. Signed: Charles Robert Patterson. American frigate, built 1776. Source: William B. Young, Peter C. Young, Mrs. Katherine M. Bicket. 67.223

305. Unidentified ship. Oil. 29½ x 36½ in. Signed: Charles Robert Patterson. (Not illustrated.) Source: W. Gerald Bryant. 73.181

306. *W. R. Grace*. Oil. 173 x 96 in. Signed: Charles Robert Patterson. Ca. 1931. American ship, built 1873, Bath, Maine. (Not illustrated.) Source: Grace Line. 61.302

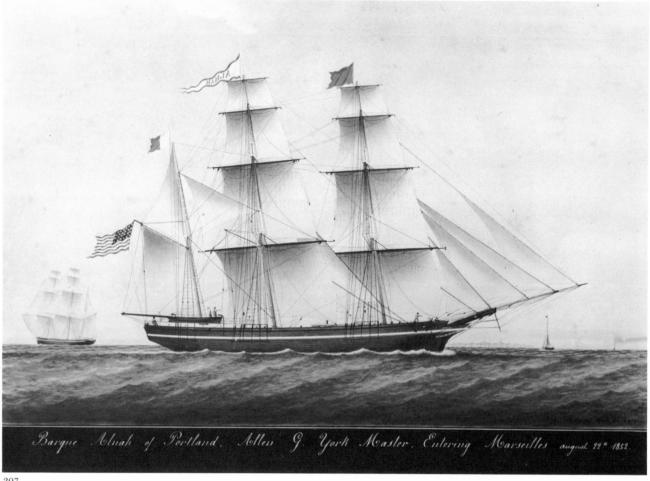

307

Barque Alnah of Portland. Allen G. York Master. Entering Marseilles august 22ᵈ 1852.

Pellegrin, Joseph-Honoré-Maxime
French (1793–1869)

307. *Barque 'Alnah' of Portland. Allen G. York Master.*
Entering Marseilles august 22ᵗʰ 1852. Watercolor. 18¹/8
x 24⁷/8 in. Signed and dated: Hʳᵉ Pellegrin Marseilles
1852. American bark, built 1852, Portland, Maine. 265
tons. Source: Mrs. Thomas S. Gates, Jr. 53.3946

308. *Barque 'Frank' of New York 1867.* Watercolor,
gouache. 19 x 25¹/2 in. Unfinished, some rigging in
pencil. Attributed to Honoré Pellegrin. American bark,
built 1865, Cherryfield, Maine. 577 tons. 132' x 31' x 18'.
Source: Laurence J. Brengle, Jr. 53.4567

309. *'Nashua' of Providence. George S. Perry Master. Entering*
Marseilles 1842. Watercolor. 17¹/4 x 23³/8 in. Signed:
Honoré Pellegrin à Marseilles 1842. American bark, built
1833, North River, Massachusetts. Source: Mrs. E. A.
Winnette. 72.152

310. *'Iᵉʳ Gavitano'. . 1849.* Watercolor. 17⁹/16 x 22¹³/16 in.
Signed: Hʳᵉ Pellegrin à Marseilles. Spanish
auxiliary steamship. (Not illustrated.) Source: William C.
Brengle. 53.4565

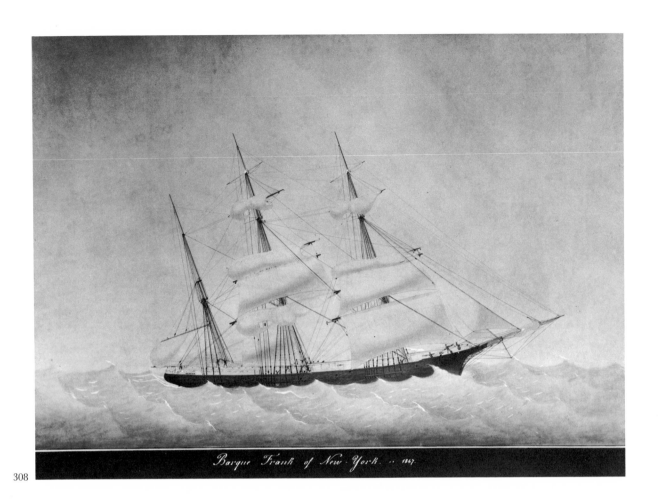

Barque Frank of New-York. 1867.

308

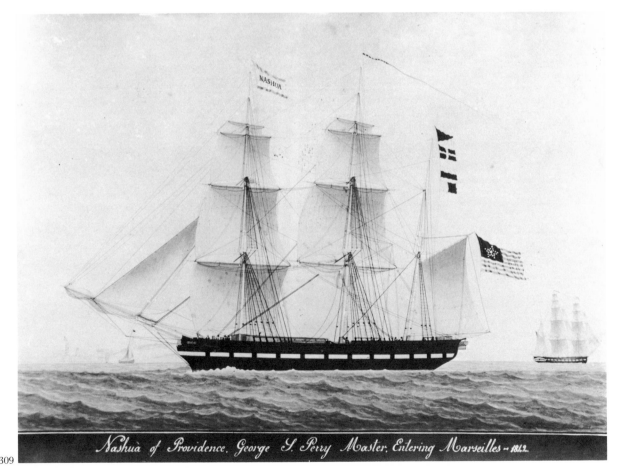

NASHUA

Nashua of Providence. George S. Perry Master. Entering Marseilles - 1842.

309

107

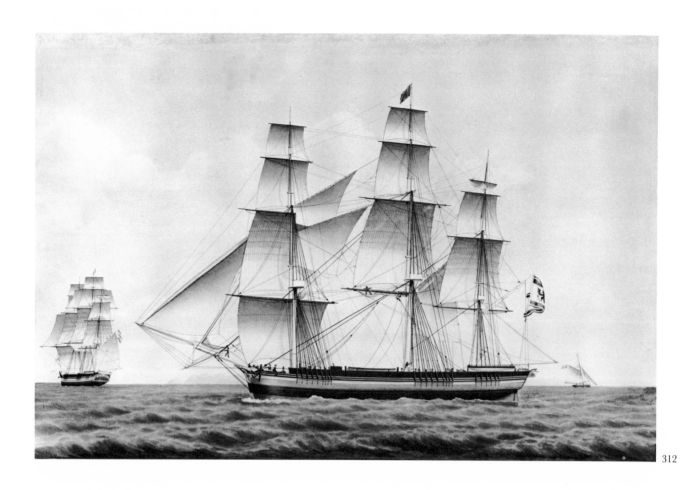

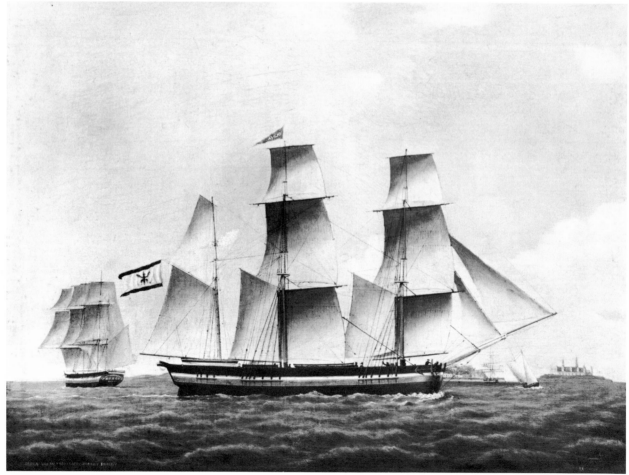

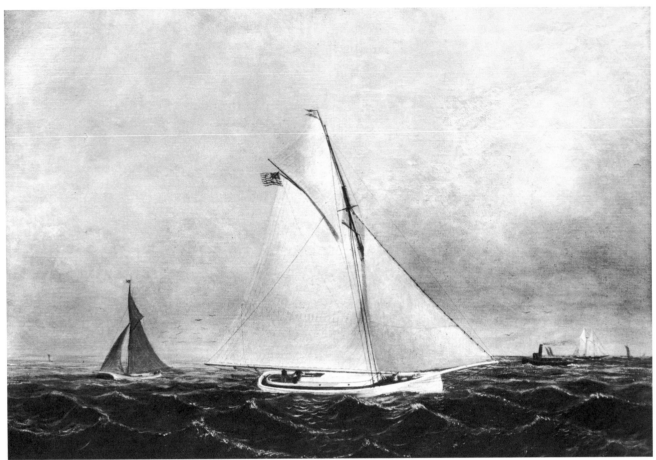

315

Petersen, Jacob
Danish (1774–1855)

311. *Ship 'Aeronaut' of Boston Captn John Eldridge.*
Watercolor. 16^{3}/8 x 19^{7}/16 in. Attributed to Jacob
Petersen. American ship. Source: Philip R. Mallory.
See color illustration opposite p. 112. 59.1177

312. *'Enterprize.' von Dantzig geführt von Captn William
Klÿne.* Watercolor. 17^{1}/4 x 25^{1}/4 in. Signed and
dated: . . . Petersen, 1844. Prussian bark. Source: Mrs.
Mary Stillman Harkness. 33.6

313. *'Oliva' von Dantzig, Captn Robert Fussey.* Oil. 21 x 28^{1}/4
in. Signed and dated: I. P. 1839. Prussian bark.
Source: Laurence J. Brengle, Jr. 53.4532

Petersen (or Peterson), John (or Johan Eric Christian)
Danish-American (1839–1874)

314. [*Neptune,* New York, sailing through the fishing fleet,
Grand Banks.] Oil. 37 x 57 in. Signed and dated:
John E. C. Peterson Boston 1866. American ship, built
1855, New York. Source: Sanborn Griffin. 58.626
See color illustration opposite p. 120.

Pirsson, James W.
American (1833–1888)

315. *Bunsby.* Oil. 13^{3}/8 x 19^{1}/4 in. Signed and dated: J. W.
Pirsson 1871. American sloop yacht, built 1868 by
Herreshoff, Bristol, Rhode Island. Source: Mrs. George
A. Beardsley. 55.1135

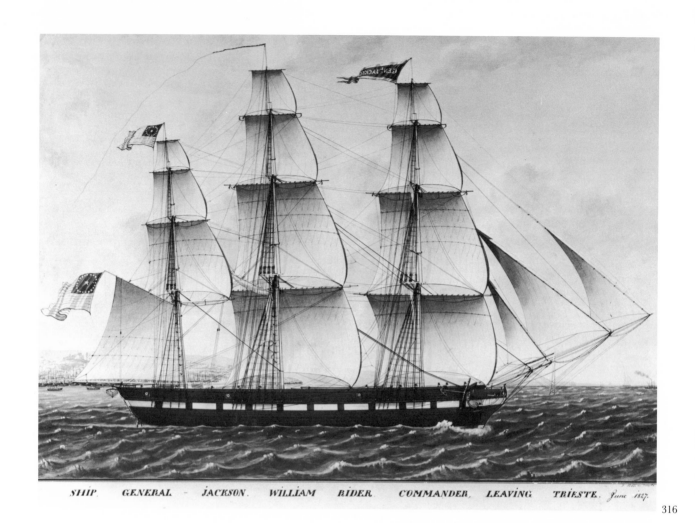

SHIP GENERAL - JACKSON. WILLIAM RIDER. COMMANDER. LEAVING TRIESTE. June 1837.

316

320

Polli, Felice
Italian (1793–1859)

316. *Ship 'General Jackson' William Rider Commander leaving Trieste June 1827.* Watercolor. 17½ x 23⅝ in. Signed: F. Polli in Trieste. American ship. Source: Capt. Marion Eppley. 56.879

Potter, O. E.

317. *Hammonia.* Pastel. 30½ x 23⅜ in. Signed: Potter. German auxiliary steamship. (Not illustrated.) Source: Mrs. George R. Watrous. 48.27

318. *Neptune Car.* Pencil, pastel, pen, ink. 15¾ x 19¾ in. Signed: O. E. Potter. American ship. (Not illustrated.) Source: Mrs. George R. Watrous. 48.28

Pringle, James Fulton
Anglo-American (1788–1847)

319. *North America.* Oil. 24½ x 35½ in. Signed and dated: J. Pringle, 1841. American ship, built 1833, Bath, Maine. 407 tons. (Not illustrated.) Source: Museum purchase. 59.648

320. *Poland.* Oil. 29½ x 45½ in. Signed and dated: J. Pringle, 1835. American packet ship, built 1832, New York. Source: William and Zada Lynch. 55.547

Raleigh, Charles Sidney
American (1831–1925)

321. *Belle of the Sea.* Oil. 26 x 36 in. Signed and dated: C. S. Raleigh, 1892. American ship, built 1857, Marblehead, Massachusetts. 1255 tons. 189'4" x 37'7" x 23'6". Sold to Liverpool 1864. Source: Museum purchase. *See color illustration opposite p. 128.* 74.928

322. [Captain and Mrs. Thomas Crapo crossing the Atlantic in small whaleboat.] Oil. 31 x 49¹⁵⁄₁₆ in. Signed and dated: C. S. Raleigh, 1878. (Not illustrated.) Source: Robert Deeley. 55.965

Rickeman, Fred

323. [*Mystic* and docks.] Oil. 17⅝ x 22⅝ in. Signed: Fred Rickeman. American steamboat. Source: Fred Rickeman. 54.1609

323

325

[RICKEMAN]

324. [Mystic River.] Oil. 17⁵/₈ x 23¹/₂ in. Signed: Fred Rickeman. (Not illustrated.) Source: Fred Rickeman. 54.1608

325. [Mystic bridge.] Oil. 17³/₄ x 23³/₄ in. Signed: Fred Rickeman. Source: Fred Rickeman. 54.1606

Roberto, Luigi
Italian (active ca. 1874 – ca. 1891)

326. *'Governor Robie' or Beth* [of Bath] *Entering teh Bay of Naples 7ᵇᵉʳ the 1886* [*sic*]. Watercolor. 20¹/₄ x 33 in. Signed and dated: L. Roberto Napoli 1886. American ship, built 1883, Bath, Maine. 1712 tons. 224' x 41'x 23'8". Lost with all hands off New Jersey, November 1921. Source: Laurence J. Brengle, Jr., William C. Brengle, Mrs. Thomas S. Gates, Jr. 62.1152

327. *Brig 'Penobscot.' R. Edgerly Master Entering the Harbor of Naples October 30ᵗʰ 1861*. Watercolor, gouache. 20¹³/₁₆ x 30⁵/₈ in. Attributed to Luigi Roberto. American hermaphrodite brig. Source: Laurence J. Brengle, Jr., William C. Brengle, Mrs. Thomas S. Gates, Jr. 64.259

311. Jacob Petersen, *Aeronaut* 59.1177

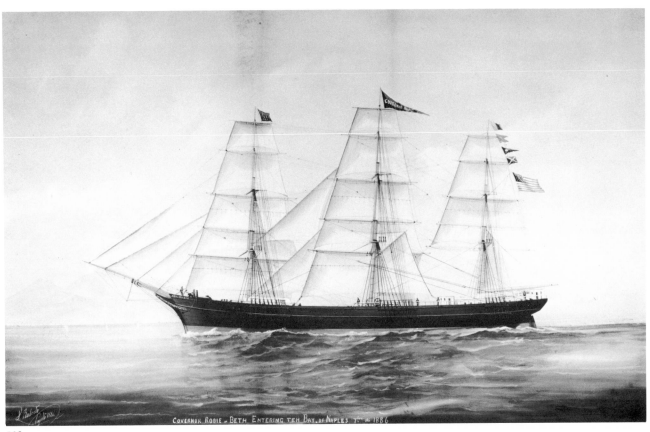

326

GOVERNOR ROBIE or BETH ENTERING TEH BAY OF NAPLES 7.º.º 1886

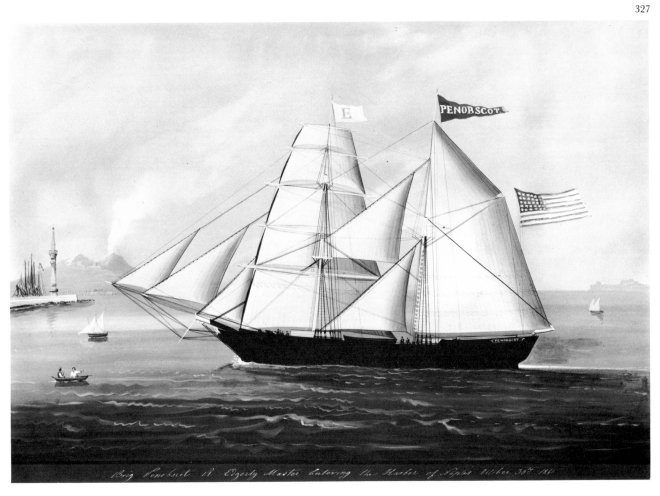

Brig Penobscot R Edgerly Master Entering the Harbor of Naples Weber 30.º 1861

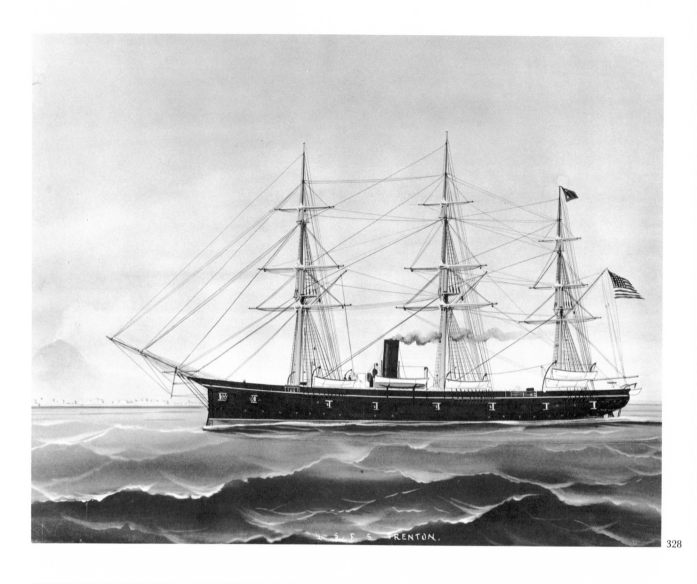

328

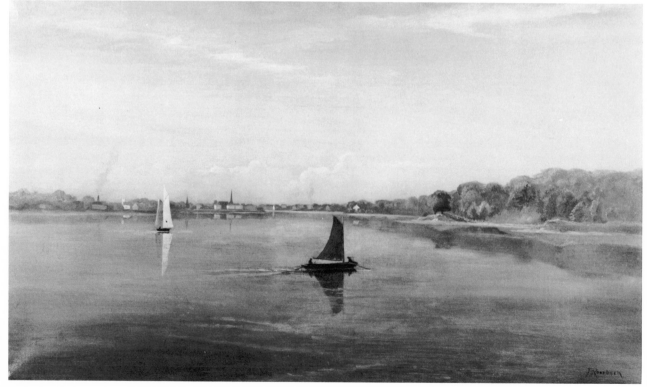

330

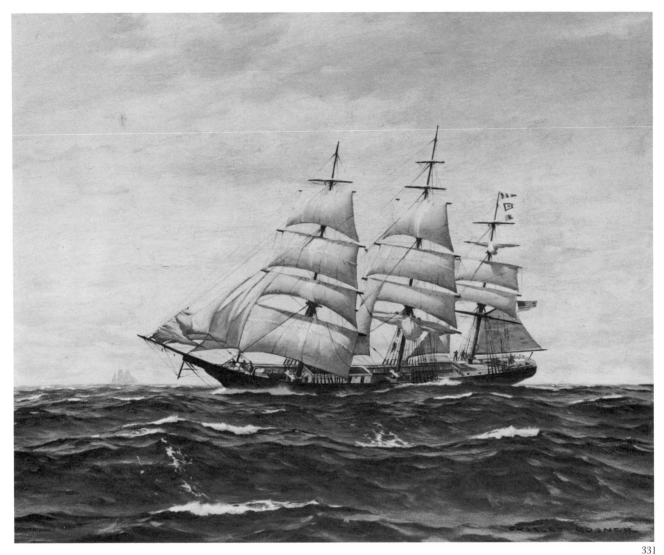

[ROBERTO]

328. *U.S.F.S. 'Trenton.'* Watercolor, gouache. 15¼ x
 19⅛ in. Attributed to Luigi Roberto. American
steam frigate, built 1873–1877, New York. Source:
Frederick A. Darling. 78.32

Roorbach, G. Seldon

329. [Mystic River road.] Oil. 9⅝ x 15¾ in. Signed and
 dated: Roorbach, 1888. (Not illustrated.) Source:
Museum purchase. 69.377

330. [Mystic River scene.] Oil. 13¾ x 23¹¹⁄₁₆ in. Signed:
 Roorbach. Source: Museum purchase. 69.378

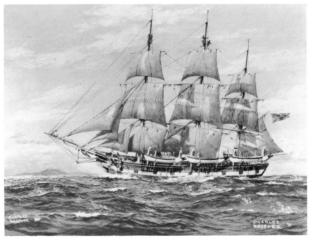

Rosen, see Van Rosen.

Rosner (or Rossner), Charles
German-American (1894–1975)

331. *'Akbar' of Boston.* Oil. 23½ x 29½ in. Signed:
 Charles Rosner. American ship, built 1863 by P.
Curtis, East Boston, Massachusetts. 906 tons. 159'7" x
32'8" x 21'9". Source: Charles E. Rueckert. 78.148

332. *Eliza Adams.* Watercolor. 14 x 19 in. Signed and
 dated twice: Charles Rossner [19]71. American
whaling ship, built 1835, Fairhaven, Massachusetts.
Source: Museum purchase. 71.301.1

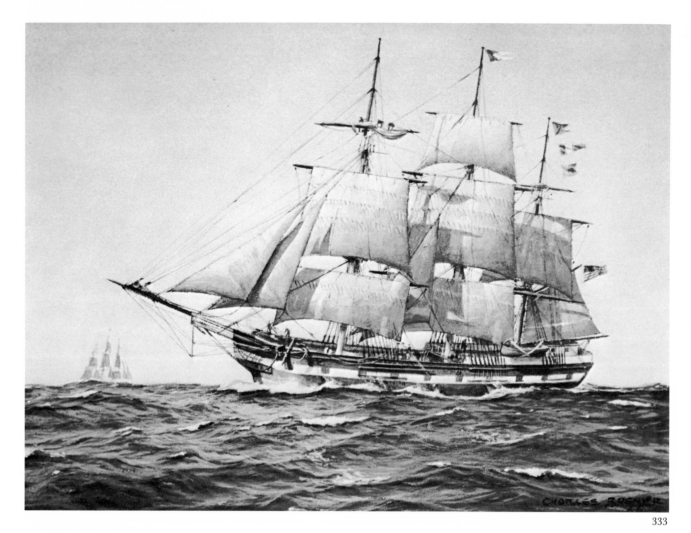

333

[ROSNER]

333. *Queen of the West*. Watercolor, gouache. 10 x 14 in.
 Signed and dated: Charles Rosner [19]65. American
ship, built 1843 by Brown & Bell, New York. 1160 tons.
179'4" x 37'6" x 22'. Source: Museum purchase.

71.301.2

334. Fourteen pen, ink drawings of life on board ship.
 Used by *Yachting*. (Not illustrated.) Source:
Museum purchase, Mr. & Mrs. Charles Rosner.

71.301.3–13, 72.151, 76.153, 76.154

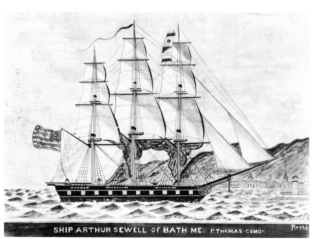

335

Rosso
Italian

335. *Ship 'Arthur Sewell' of Bath Me. P. Thomas Comdʳ.*
 Watercolor. 15 x 21 in. Signed: Rosso. American
ship. This painting does not illustrate the only known
Arthur Sewall, a bark built in 1899 in Bath, Maine. Source:
Laurence J. Brengle, Jr., William C. Brengle, Mrs.
Thomas S. Gates, Jr.

53·79

Roux, Ange-Joseph-Antoine
French (1765–1835)

336. *'American' of New-York Capᵗⁿ. John Hillard.*
 Watercolor. 17½ x 23⅞ in. Signed and dated: Antᵉ
Roux à Marseilles, 1820. American snow brig, built 1816,
Middletown, Connecticut. Source: Mrs. Thomas S.
Gates, Jr.

53·455⁸

337. *'Le Jeune Antoine.' Capⁿᵉ. Pʳᵉ. Oprosy, allant a l'ille de
 France, le 23 7ᵇʳᵉ. 1821.* Watercolor. 17¼ x 23⅞ in.
Signed and dated: Antⁿᶜ. Roux à Marseille, 1821. French
brig. Source: Laurence J. Brengle, Jr.

53·4554

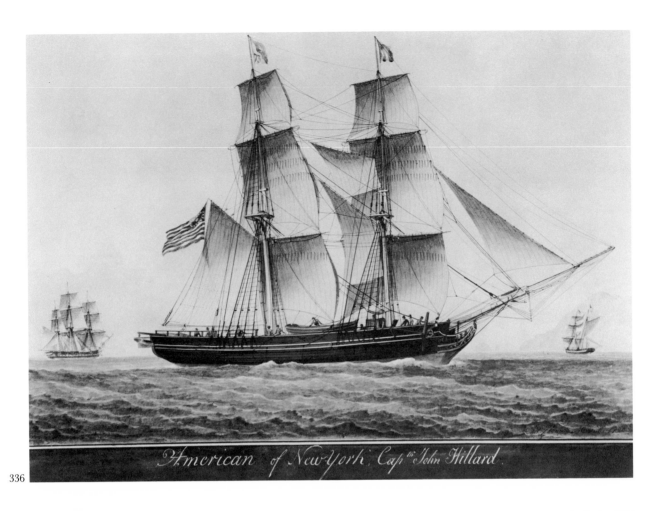

336 *American of New-York, Cap.ᵗⁿ John Hillard.*

337

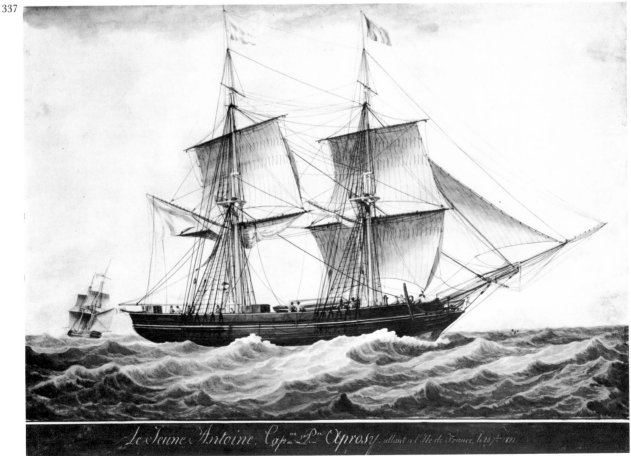

Le Jeune Antoine, Cap.ⁿᵉ P.ⁿ Aprosy, allant a l'Ile de France, le 23 7.ᵇʳᵉ 1811.

117

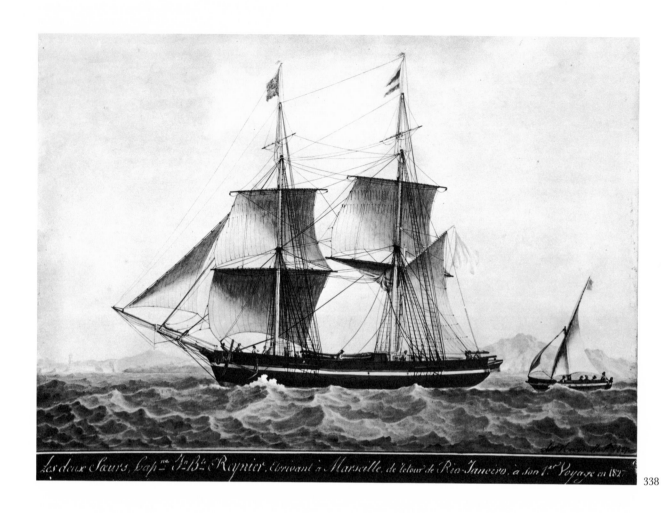

Les deux Sœurs, Cap.ne J.B.te Raynier, arrivant à Marseille, de retour de Rio-Janeiro, a son 1.er Voyage en 1827.

338

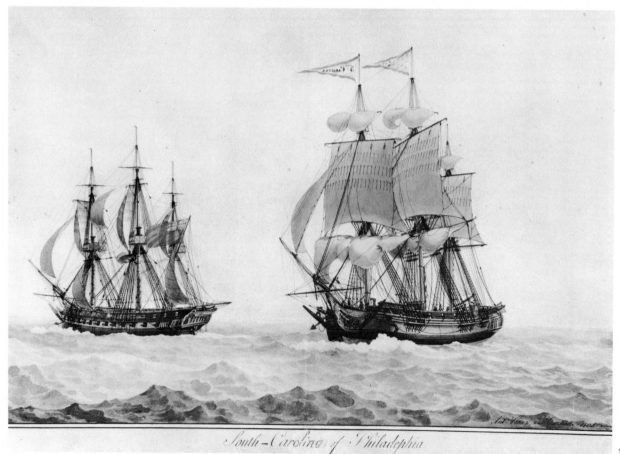

South-Carolina of Philadephia

339

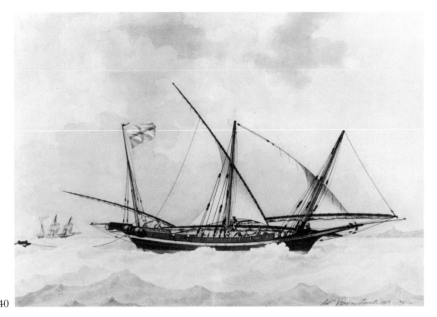

340

341

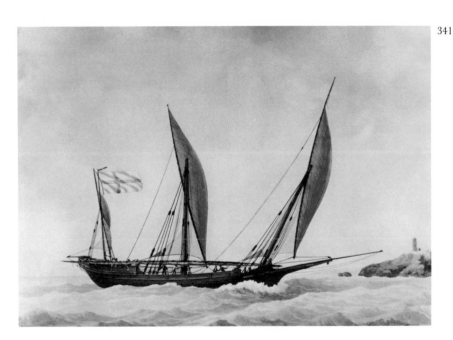

[ROUX, ANGE-JOSEPH-ANTOINE]

338. *'Les deux Soeurs,' Cap^{ne}. J^{n}. B^{te}. Reynier, Ebrivant à Marseille de letour de Rio-Janeiro. à son 1^{er}. Voyage en 1827.* Watercolor. 17½ x 23^{11}/16 in. Signed and dated: Ant^{e} Roux à Mars^{lle}., 1827. French snow brig. Source: Laurence J. Brengle, Jr. 53.4557

339. *'South-Carolina' of Philadelphia.* Watercolor. 18 x 25½ in. Signed and dated: Ant^{e}. Roux à Marseille, 1805. American ship, built 1800, Philadelphia, Pennsylvania. 251 tons. 87'3" x 25'8". Source: Museum purchase. 67.208

340. Unidentified xebec. Watercolor. 15¼ x 21½ in. Signed and dated: Ant^{ne} Roux à Marseille, 1803–38. Source: Mrs. Thomas S. Gates, Jr. 53.4564

341. Unidentified xebec. Watercolor. 15¼ x 21⅝ in. Signed and dated: Ant^{e} Roux à Marseille, 1803–64. Source: William C. Brengle. 53.4568

Roux, François-Geoffroi
French (1811–1882)

342. Sketchbook, thirty-eight drawings on fourteen leaves. Watercolor, pen, pencil. 5⁹/16 x 10^{15}/16 in. Signed and dated: F^{cois} Roux, 1825. Source: William C. Brengle, Laurence J. Brengle, Jr. VFM 964

See illustrations on pp. 120–122.

342a

342b

342c

314. John Petersen (or Peterson), *Neptune* 58.626

342d

342e

342f

342g

342h

342i

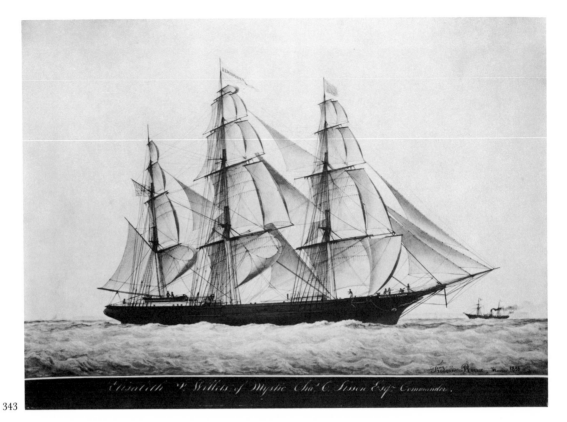

343

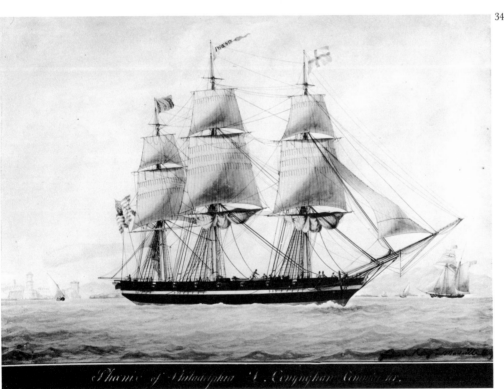

344

Roux, François-Joseph-Frédéric
French (1805–1870)

343. *'Elisabeth F. Willets' of Mystic Chas. C. Sisson Esq.
Commander*. Watercolor. 16⅛ x 22⅜ in. Signed and
dated: Frédéric Roux, Havre, 1855. American clipper
ship, built 1854 by Charles Mallory, Mystic, Connecticut.
825 tons. 156′ x 34′ x 19′. Sold at Shanghai, China, 1864.

At one time there was a label on back: "Frédéric Roux
hydrographe & peintre de marine Havre En Janvier
1855." Source: Museum purchase. 70.799

344. *'Phoenix' of Philadelphia. D. Conyngham Commander*.
Watercolor. 17 x 22¹⁵⁄₁₆ in. Signed and dated:
frédéric Roux a Marseille, 1827. American ship. Source:
Mrs. Thomas S. Gates, Jr. 53.4555

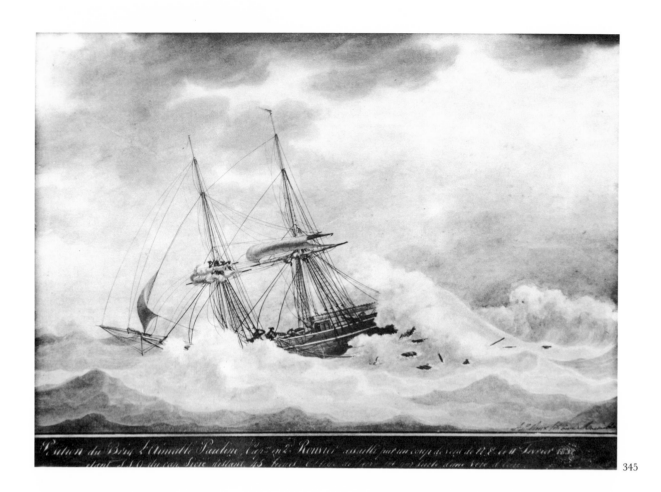

Position du Brig L'Aimable Paulme, Cap.ne n.º Rouxier assailli par un coup de vent de N.E. le 11 Février 183?
étant S.S.O. du cap Sieve distant 45 lieues ...

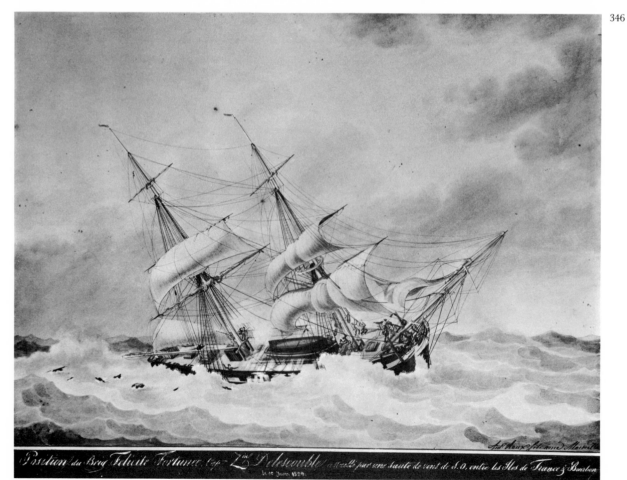

Position du Brig Felicité Fortunée, Cap.ne L.m Pelescouble atteint par une saute de vent de S.O. entre les Iles de France & Bourbon
le 30 Juin 1829.

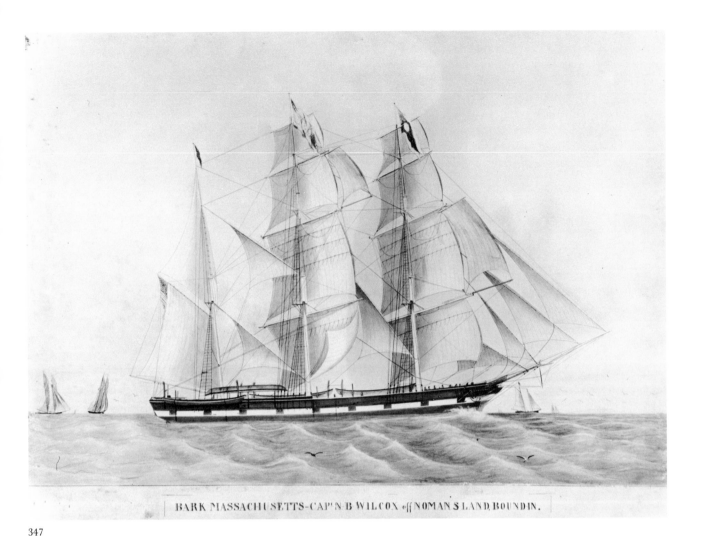

BARK MASSACHUSETTS-CAP'N B WILCOX off NOMAN'S LAND BOUND IN.

347

Roux, Mathieu-Antoine fils
French (1799–1872)

345. *Position du Brig 'L'Aimable Pauline' Cap^ne en 2^d Rouvier*
 assaille par un coup de vent de N. E. le 11 Fevrier 1832; etant
 S.S.O. du cap Sicie distant 45 lieves, Oblige de faire jet par suile
 d'une Voie d'Eau. Watercolor. 13³/₈ x 17³/₄ in. Signed: Ant^e
 Roux fils ainé Marseille. French brig. Source: William C.
 Brengle. 53.4570

346. *Position du Brig 'Felicite Fortunee' Cap^ne Z^in Delescouble*
 assaille par une saute de vent de S. O. entre les Isles de France
 & Bourbon. le 10 Juin 1829. Watercolor. 17⁵/₈ x 22⁷/₈ in.
 Signed on label on reverse: Ant^e Roux fils ainé Marseille.
 Source: Laurence J. Brengle, Jr. 53.4551

Russell, Benjamin
American (1804–1885)

347. *Bark 'Massachusetts'—Cap^t. N.-B.—Wilcox off*
 Noman's-Land-Bound-In. Watercolor. 18⁷/₁₆ x 28 in.
 Attributed to Benjamin Russell. American bark, built
 1836, New Bedford, Massachusetts. 364.5 tons. 108'6³/₄''
 x 27'5'' x 13'8¹/₂''. Abandoned in the Arctic Ocean 1871.
 Source: Westerly [Rhode Island] Sea Scouts. 66.248

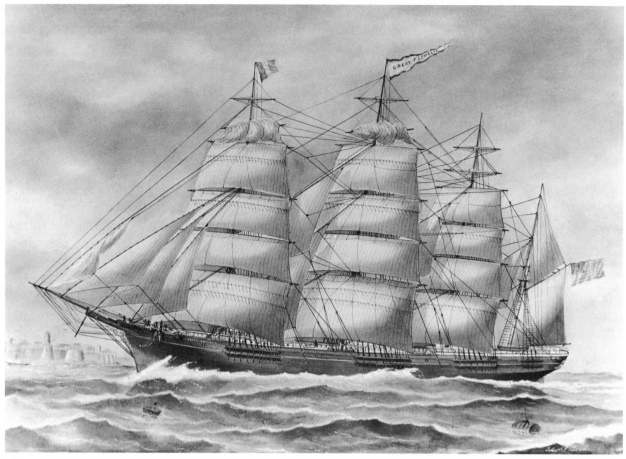

348

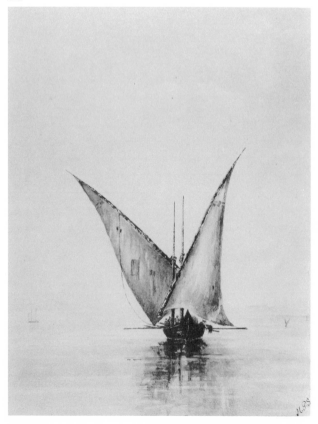

349

Russell, Edward John
Anglo-American (1832–1906)

348. *Great Republic.* Watercolor. 19³/4 x 28³/4 in. Signed: Edw^d J. Russell. American clipper ship, built 1853 by Donald McKay, East Boston, Massachusetts. 4555 tons. 335' x 53'x 38'. Source: Mrs. Mary Stillman Harkness. 33.11

S., M. P.

349. [Nile River dhow.] Watercolor. 14³/4 x 11 in. Signed: M. P. S. Source: Capt. Marion Eppley. 56.878

Salmon, Robert
Anglo-American (active ca. 1800 – ca. 1844)

350. *Fishing Boats Goin [sic] Out.* Oil on panel. 5³/4 x 8³/8 in. Signed and dated on reverse: Painted by R. Salmon N^o 998, 1829. Source: Mrs. Edward B. Watson, Jr. 74.13

Sanborn, Percy A.
American (1849–1929)

351. *Ship 'Seaman's Bride'; A. B. Wyman, Master. Built at Belfast, Me. 1856.* Oil. 22 x 33³/4 in. Signed: Percy Sanborn. American ship. 759 tons. 159' x 32' x 16'. Source: William C. Brengle. 53.3960

350

351

352

353

Schetky, John Christian Scottish (1778–1874)

352. *America*. Watercolor, gouache. 11½ x 23½ in.
 Signed and dated: J. C. Schetky, 1851. American
schooner yacht, built 1851 by W. H. Brown, New York.
108' x 22' x 9'. Source: Rudolph J. Schaefer. 75.188.4

353. [*Chesapeake* and *Shannon*, War of 1812.] Oil. 25½ x
 41¼ in. Attributed to John Christian Schetky.
American and British frigates. *Chesapeake* built 1799,
Norfolk, Virginia. Source: Mrs. Sara C. Chisholm.

64.692

354. [French, British naval battle off L'Orient 22 May
 1812.] Watercolor, gouache. 18 x 27¾ in. Attrib-
uted to John Christian Schetky. Pair with 54.1338.
Source: Paul Hammond. 54.1337

355. [French, British naval battle off L'Orient 22 May
 1812.] Watercolor, gouache. 18 x 27¾ in. Attrib-
uted to John Christian Schetky. Pair with 54.1337.
Source: Paul Hammond. 54.1338

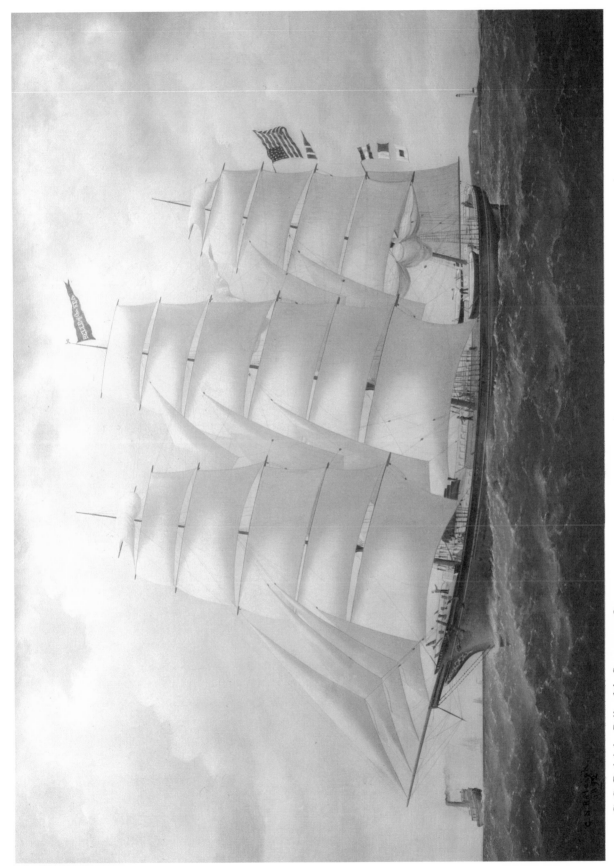

321. C. S. Raleigh, *Belle of the Sea* 74.928

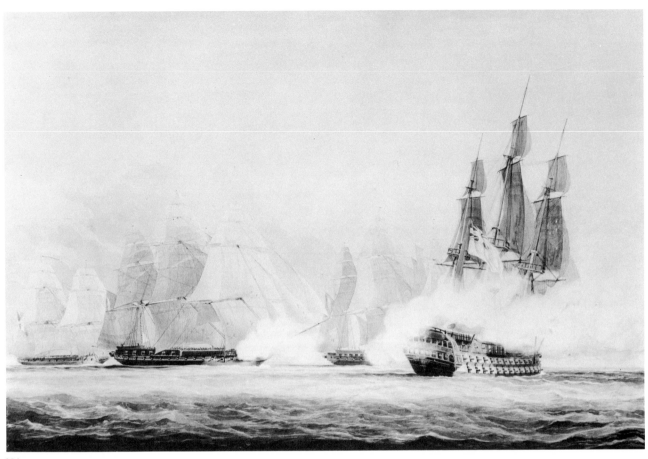

354

355

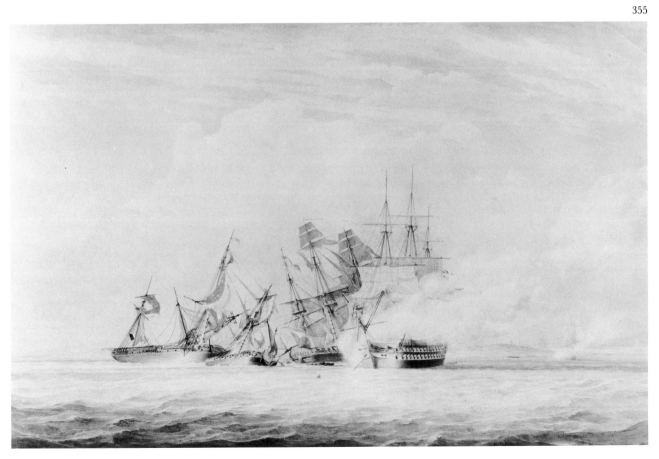

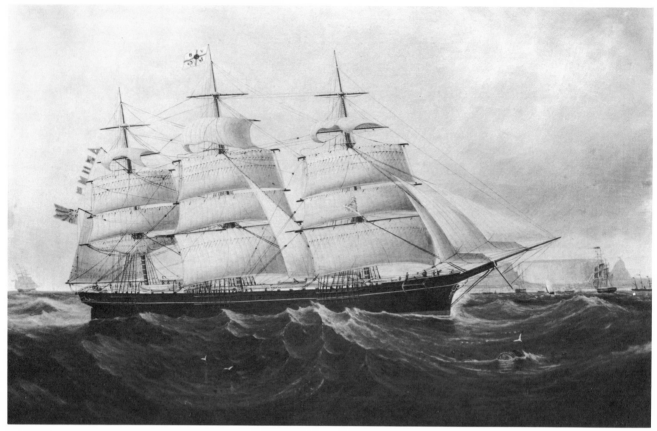

356

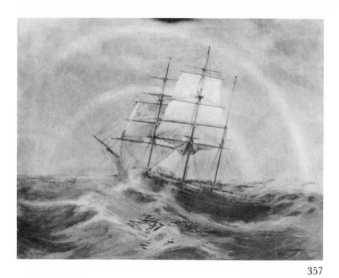

357

Scott, John
British (active ca. 1840 – ca. 1872)

356. *Richard Rylands*. Oil. 27½ x 41¼ in. Signed and
dated: J. Scott, 1870. British ship, built 1863, New
Brunswick. 1390 tons. 203′ x 40′3″ x 24′9″. Employed in
the Liverpool-Indian service. Source: Laurence J.
Brengle, Jr., William C. Brengle, Mrs. Thomas S.
Gates, Jr. 53.497

Sébille, Albert
French

357. *'Apache.' N.Y.Y.C. May 29ᵗᵗᵉ 1905 lat. 48°29,' N. long.
39°52' West*. Oil. 22¼ x 29 in. Signed and dated:
Albert Sebille, 1906. American auxiliary bark yacht, ex-
White Heather, built 1890 by J. Reid & Co., Port Glasgow,
Scotland. 307.16 tons. 178′8″ x 28′3″ x 16′5″. Source:
Mrs. Charles F. Havemeyer. 64.615

Serres, Dominic
French-British (1722–1793)

358. *'Phoenix,' 'Rose,' 'Asia,' and 'Experiment,' British
Squadron on the Hudson River, attacked by fire ships and
galleys, 16 August 1776*. Oil. 24½ x 39⅜ in. Signed and
dated: D. Serres, 1777. Painted by Dominic Serres after a
sketch by Sir James Wallace, commander of the *Experi-
ment*. Source: Harold H. Kynett. 49.804

Sheppard, Warren
American (1858–1937)

359. *Aloha*. Oil. 30¼ x 39 in. Signed: Warren Sheppard.
American auxiliary bark yacht, built 1910, Quincy,
Massachusetts. Source: The James Foundation of New
York, Inc. 65.54

360. *Young America*. Oil. 16¾ x 24¾ in. Signed: Warren
Sheppard. American clipper ship, built 1853 by W.
H. Webb, New York. Source: Mrs. Charles F.
Havemeyer. 64.616

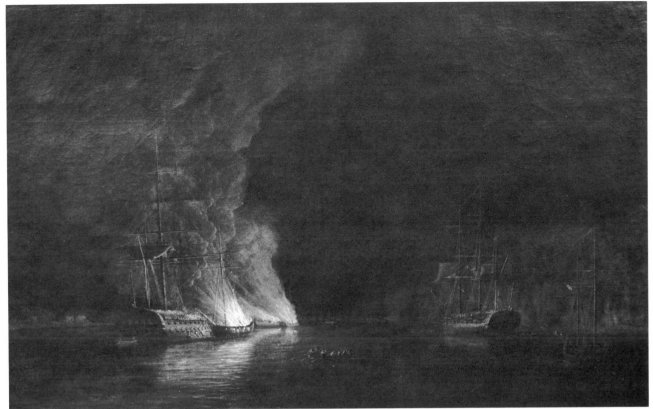

358

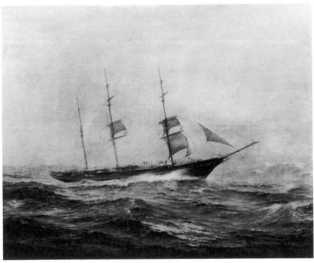

359

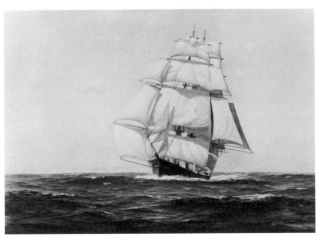

360

Siems, J. H.
American

361. *Pilot's Bride*. Watercolor. 8⁵/₁₆ x 13 in. Signed and
 dated: J. H. Siems, 1881. American two-masted
schooner, built 1856, Rockland, Maine. 193 tons. 90′ x
26′6″ x 9′6″. Lost on Desolation Island 1884. Source:
Museum purchase. 72.53
See color illustration opposite p. 136.

362. *Pilot's Bride*. Watercolor. 8⁷/₈ x 13 in. Attributed to
 J. H. Siems, 1881. American two-masted schooner,
built 1856, Rockland, Maine. 193 tons. 90′ x 26′6″ x 9′6″.
Lost on Desolation Island 1884. Source: Anonymous.
 66.278

362

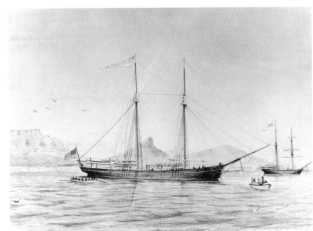

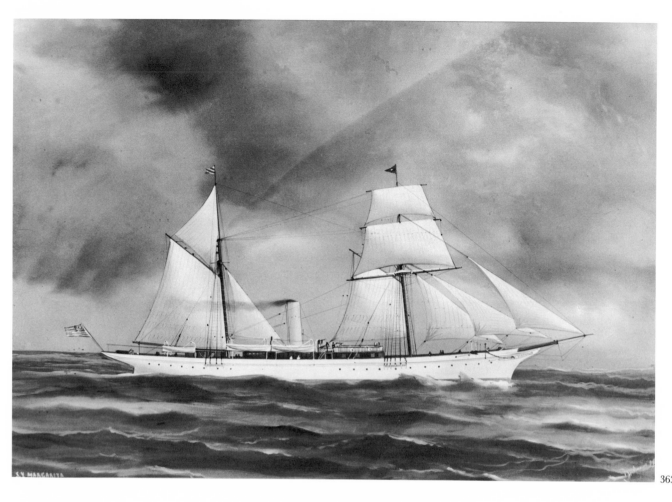

363

364

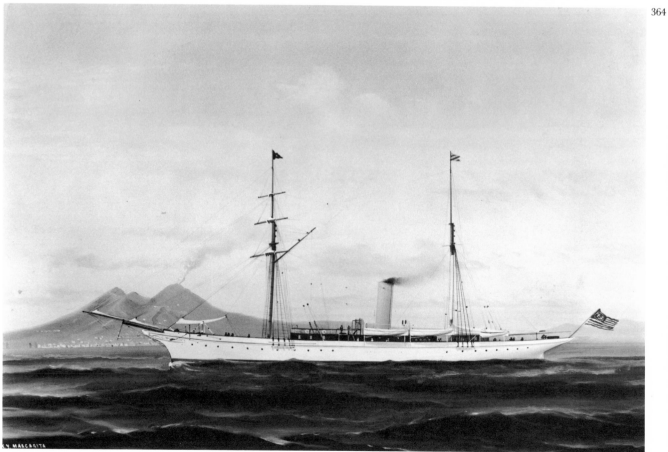

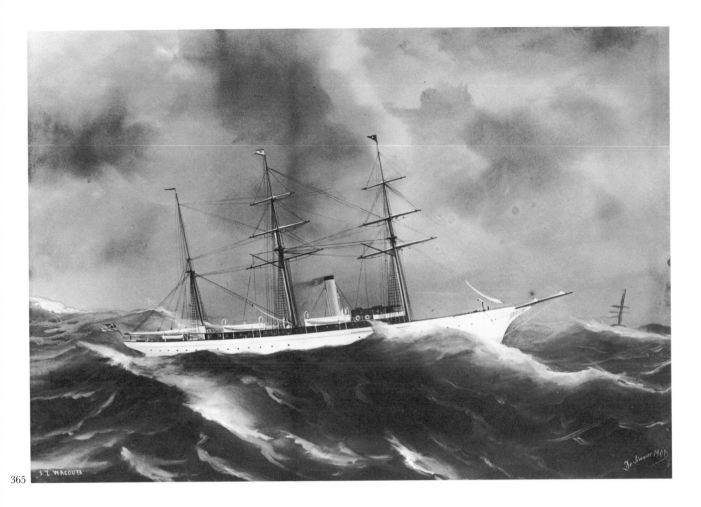

365

Simone, A. (or Tomaso de)
Italian (active 1851–1907)

363. *S. Y. Margarita*. Watercolor, gouache. 16³/₄ x 24⁵/₈ in. Signed and dated: De Simone, [18]95. American auxiliary steam yacht, built as *Semiramis* 1889 by Ramage and Ferguson, Leith, Scotland. 491 tons. 225' x 27'2" x 13'. Source: L. B. Gross. 48.1156

364. *S. Y. Margarita*. Watercolor. 16³/₈ x 24¹/₂ in. Attributed to Tomaso de Simone. American auxiliary steam yacht, built as *Semiramis* 1889 by Ramage and Ferguson, Leith, Scotland. 491 tons. 225' x 27'2" x 13'. Source: Arthur Oldroyd. 72.51

365. *S. Y. Wacouta*. Gouache. 18 x 25³/₈ in. Signed: De Simone, 1905. American auxiliary steam yacht, built 1894 as *Eleanor* by Bath Iron Works, Bath, Maine. 401 tons. 220' x 32' x 17'3". Source: L. B. Gross. 48.1157

Skov, W. P.

366. *George Bancroft*. Oil on paper. 16 x 22¹/₂ in. Signed and dated: W. P. Skov, 1947. American Liberty ship, built 1942, Los Angeles, California. Source: Mrs. M. B. Wallace. 52.839

366

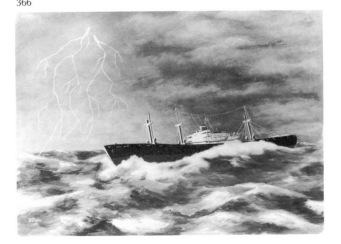

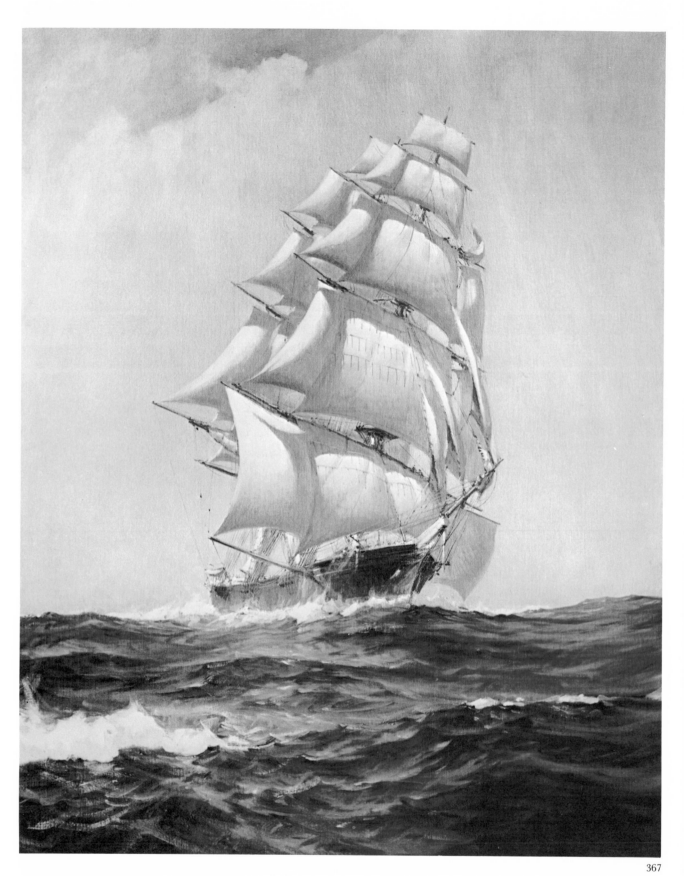

367

Smith, Frank Vining
American (1879–1967)

367. Unidentified ship. Oil on board. 44¼ x 35¼ in.
Signed and dated: Frank Vining Smith, 1929.
Source: Mr. and Mrs. Richard W. Pratt. 76.28

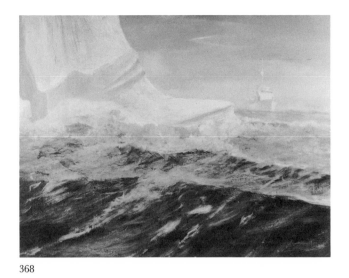

368

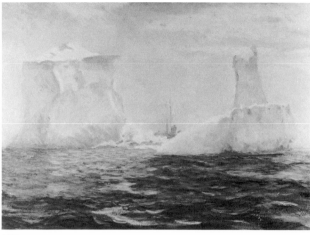

369

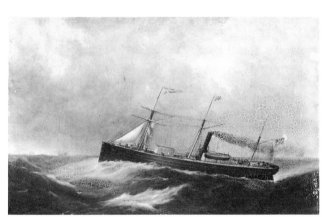

370

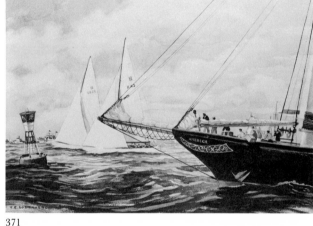

371

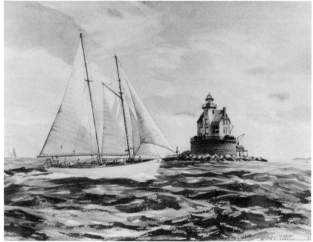

372

Smith, I. B. (Mrs. Edward H. Smith)

368. [U.S. Coast Guard cutter.] Oil. 23¹/₂ x 33¹/₄ in.
 Signed and dated: I. B. Smith [19]38. Source: Mrs.
Edward H. Smith. 65.1088

369. [U.S. ice patrol.] Oil. 17¹/₂ x 23 in. Signed and
 dated: I. B. Smith, 1938. Source: Mrs. Edward H.
Smith. 65.1089

Smith, J. B. and Son
American: Joseph B. (1798–1876); William S. (1821–)

370. *Thomas Swann*. Oil. 26 x 40 in. Label on reverse: J. B.
 Smith & Son. Marine Artists. No 43 Fulton Street.
near Fulton Ferry. Brooklyn. American steam barkentine,
built 1853, Philadelphia, Pennsylvania. 462 tons. 168' x
24' x 11'. Source: Museum purchase. 38.318

Soderberg, Yngve Edward
American (1896–1971)

371. [*America* at the start.] Watercolor. 20¹/₁₆ x 26⁵/₈ in.
 Signed: Y. E. Soderberg. American schooner yacht,
built 1967, East Boothbay, Maine. 104' x 22'. Source:
Rudolph J. Schaefer. 75.187.9

372. *'Brilliant' Passing Race Rock Light*. Watercolor. 18¹/₄ x
 24³/₄ in. Signed: Y. E. Soderberg, 51 Clift St. Mystic.
American schooner yacht, built 1932, City Island, New
York. Source: Miss Kathryn Virginia Allen. 76.81

373. *'Endeavour' Homeward Bound.* Pencil. 4^{15}/16 x 8 in.
 Attributed to Yngve Edward Soderberg. British J-
boat, built 1934, Gosport, England. Source: Mrs. Y. E.
Soderberg. 73.14.9

374. [Men pulling lobster pots.] Pencil. 5 x 8 in.
 Attributed to Yngve Edward Soderberg. (Not
illustrated.) Source: Mrs. Y. E. Soderberg. 73.14.8

375. [Mystic Seaport from the river.] Pencil. 12 x 17^{7}/8 in.
 Attributed to Yngve Edward Soderberg. (Not illus-
trated.) Source: Mrs. Y. E. Soderberg. 73.14.15

376. Thirteen sketches of yacht racing and Mystic
 Seaport scenes. Pencil, pen, ink. One signed: Y. E.
Soderberg. (Not illustrated.) Source: Mrs. Y. E.
Soderberg. 73.14.1–7, 10–14, 16

377. Two pencil sketches of Mystic Seaport. Signed: Y. E.
 Soderberg. (Not illustrated.) Source: Anonymous.
 76.84, 85

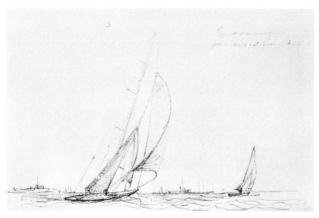

373

Spencer, R. B.
English (active 1840–1874)

378. *Legion of Honnor* [*sic*]. Oil. 19^{1}/2 x 29^{5}/8 in. Signed:
 R. B. Spencer. British ship, built 1863, St. John,
New Brunswick. 1219 tons. Lost on the coast of Tripoli
1876. Source: Wendell P. Colton, Jr. 65.975

378

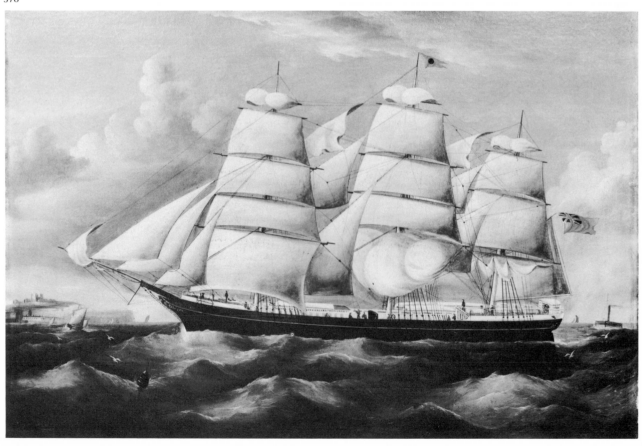

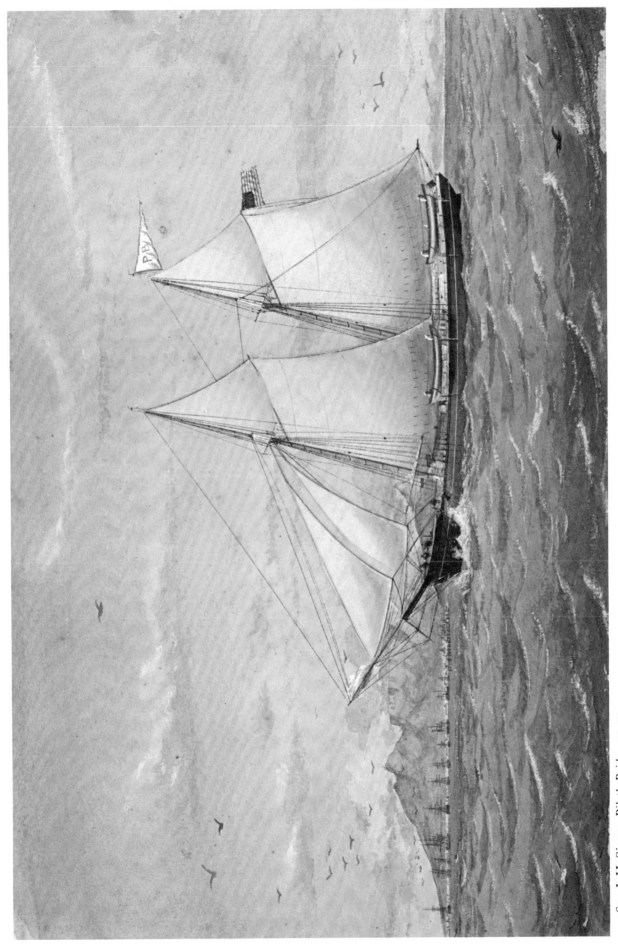

361. J. H. Siems, *Pilot's Bride* 72.53

Stillman, Charles Kirtland
American (1879–1938)

379. [Three shrimp boats.] Oil on board. 16¹/₁₆ x 19¹⁵/₁₆
 in. Signed on reverse: Painted by C. K. Stillman.
Source: C. K. Stillman. 76.163

380. [Two shrimp boats.] Oil on board. 16 x 19⁷/₈ in.
 Signed: Painted by C. K. Stillman. (Not illustrated.)
Source: C. K. Stillman. 76.164

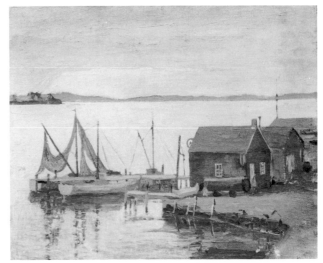
379

Stobart, John
Anglo-American (1929–)

381. [*America* off the Needles in the famous race of 1851.]
 Oil. 27¹/₂ x 39¹/₂ in. Signed: Stobart © 67. American
schooner yacht, built 1851 by W. H. Brown, New York.
Source: Rudolph J. Schaefer. 75.188.1

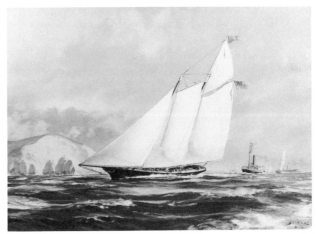
381

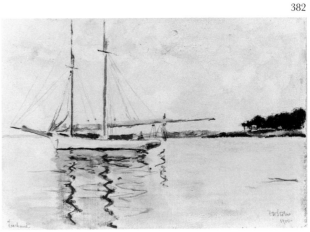
382

Stokes, F. W.

382. Unidentified schooner yacht. Oil. 5¹⁵/₁₆ x 8⁵/₈ in.
 Signed and dated: F. W. Stokes, Larchmont, 1900.
Source: The James Foundation of New York, Inc. 65.79

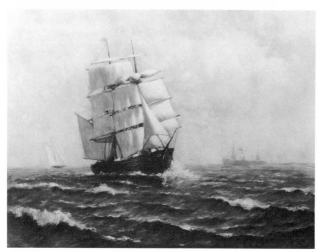

383

Stoopendael, F. v.

383. Unidentified bark. Oil. 29¼ x 39¼ in. Signed: F. v. Stoopendael. Source: Mrs. Patricia N. Sonnenschein and Kenneth S. Niddrie.　71.39

Storck, Abraham
Dutch (1636–1712)

384. [Dutch naval vessels.] Oil. 25⅛ x 30⁹⁄₁₆ in. Signed: A. Storck. Source: Mrs. Carll Tucker.　67.77

384

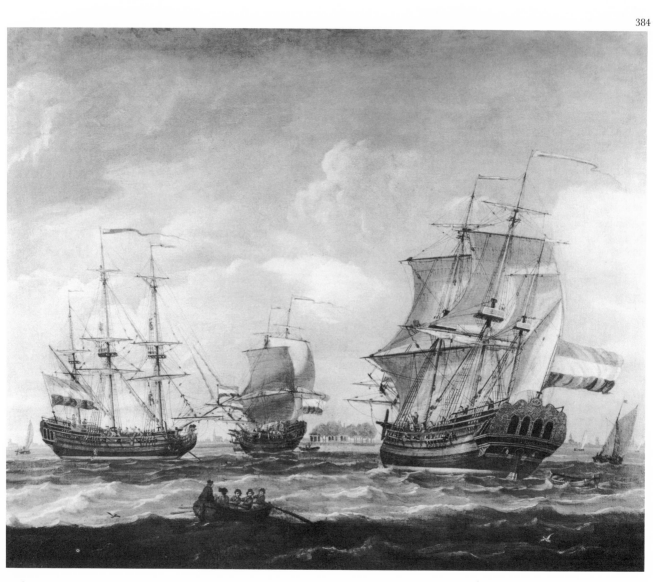

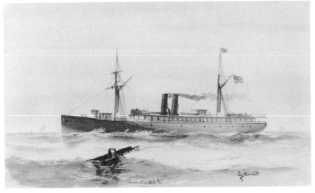

385

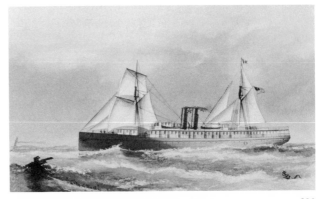

386

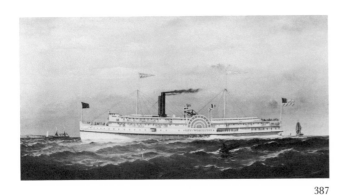

387

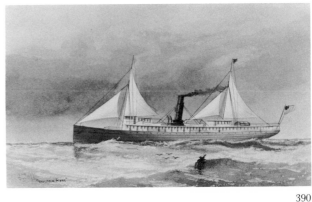

388

389

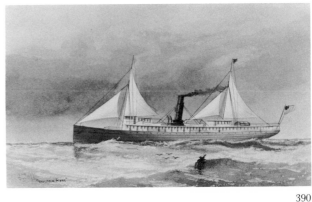

390

Stuart, Alexander Charles
Anglo-American (1831–1898)

385. *City of San Antonio.* Pen, wash. 5³/4 x 9³/4 in. Signed: Stuart. American auxiliary steamship, built 1872, Chester, Pennsylvania. 1415 tons. 235′ x 36′ x 22′. Source: Mrs. George Forbes and Mrs. William C. Sproul. 43.800

386. *City of Waco.* Pen, wash. 5³/4 x 9³/4 in. Signed: S superimposed on an anchor. American auxiliary steamship, built 1873, Chester, Pennsylvania. 240′ x 35′ x 27′. Source: Mrs. George Forbes and Mrs. William C. Sproul. 43.798

387. *City of Worcester.* Oil. 25¹/2 x 49¹/2 in. Signed and dated: Stuart, [18]84. American steamboat, built 1881, Wilmington, Delaware. 328′ x 46′ x 14′5″. Source: Anonymous. 59.1380

388. *Colorado.* Pen, wash. 5³/4 x 9³/4 in. Signed: Stuart. American auxiliary steamship, built 1879, Chester, Pennsylvania. 2765 tons. 306′ x 39′6″ x 21′6″. Source: Mrs. George Forbes and Mrs. William C. Sproul. 43.799

389. *Rio Grande.* Pen, wash. 5³/4 x 9³/4 in. Signed: Stuart. American auxiliary steamship, built 1876, Chester, Pennsylvania. Source: Mrs. George Forbes and Mrs. William C. Sproul. 43.796

390. *Western Texas.* Pen, wash. 5³/4 x 9³/4 in. Signed: Stuart. American auxiliary steamship, built 1877, Chester, Pennsylvania; sold 1884. 1121 tons. 225′ x 34′ x 16′. Source: Mrs. George Forbes and Mrs. William C. Sproul 43.797

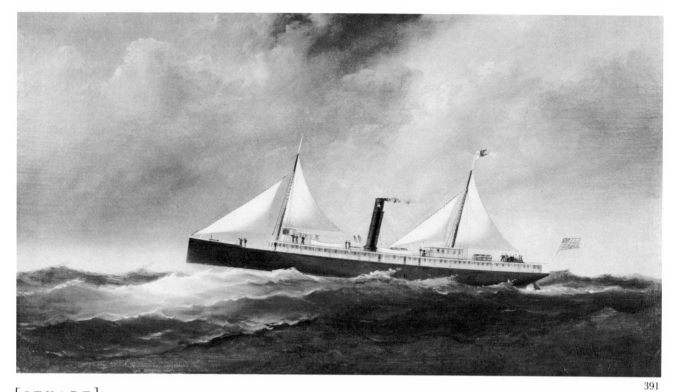

[STUART]

391. *Western Texas.* Oil. 19³/₄ x 35⁷/₈ in. Signed and dated:
 Stuart, 1877 [?]. American auxiliary steamship,
built 1877, Chester, Pennsylvania; sold 1884. 1121 tons.
225′ x 34′ x 16′. Source: C. D. Mallory Estates. 45.330

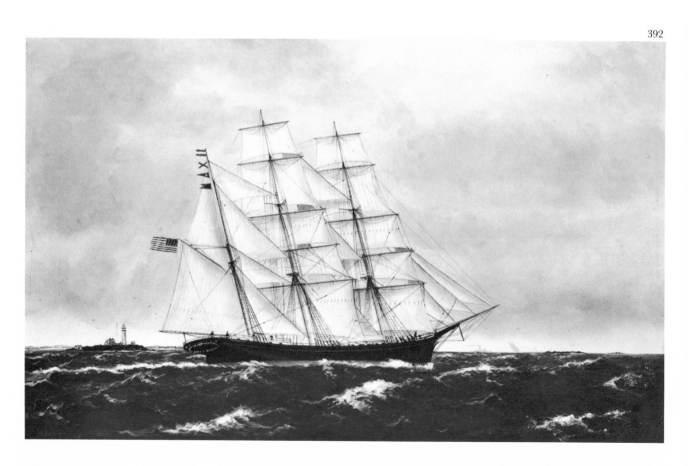

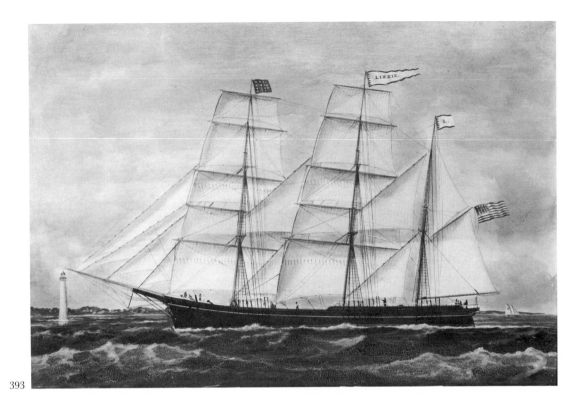

393

Stubbs, William Pierce
American (1842–1909)

392. *'Alice.' Boston*. Oil. 25½ x 41¼ in. Signed:
 W. P. Stubbs. American bark, built 1881,
Weymouth, Massachusetts. Source: Museum purchase.
48.887

393. *Lizzie*. Oil. 19¼ x 29¾ in. Signed and dated:
 Stubbs, 1871. American bark, built 1857, Medford,
Massachusetts. Source: William C. Brengle. 53.3962

394. *Massachusetts* [towing whaleship in a camel]. Oil.
 21 x 35³/₁₆ in. Signed: Stubbs. American paddle-
wheel steamboat, built 1842, New York. Source:
Laurence J. Brengle, Jr., William C. Brengle, Mrs.
Thomas S. Gates, Jr. 53.78
See color illustration opposite p. 144.

395. *Rebecca Goddard*. Oil. 21¼ x 36³/₁₆ in. Signed and
 dated: Stubbs [18]81. American bark, built 1860,
Medford, Massachusetts. 413 tons. Source: Harold H.
Kynett. 49.3179

395

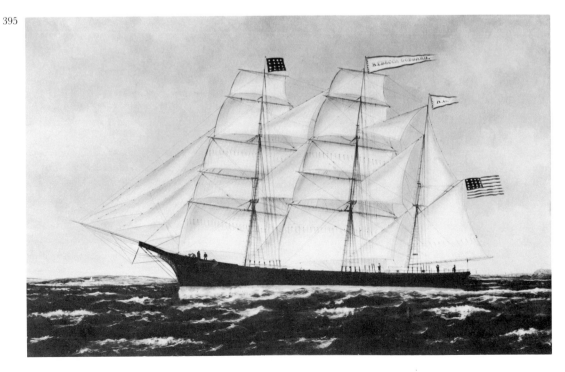

396

Sturence, John

396. [Shipping off the Lanterna, Genoa, Italy.] Oil. Signed and dated: John Sturence, 1889. 65 Jen. . . [illegible]. Source: C. K. Stillman and Mrs. Harriet Greenman Stillman. 38.556

Suller, Joseph C.

397. *Charles W. Morgan.* Pen, ink. 6 x 4¼ in. Signed and dated: J. C. Suller, 1948. American ship, built 1841, New Bedford, Massachusetts. 351 tons. 113′11″ x 27′2½″ x 13′7¼″. Source: Joseph C. Suller. 48.83

Terpning, Howard

398. [*Charles W. Morgan,* Mystic, Connecticut.] Watercolor. 19½ x 13½ in. Signed: Howard Terpning, Graduate Chicago Art Institute. American ship, built 1841, New Bedford, Massachusetts. 351 tons. 113′11″ x 27′2½″ x 13′7¼″. Painted for cover of Esso map May 1961. (Not illustrated.) Source: Esso Standard Division, Humble Oil & Refining Company. 61.501

Thompson, Ellery F.
American (1899–)

399. *Capt. Nathaniel B. Palmer.* Oil. 23½ x 35½ in. Signed: Thompson. American dragger, built 1942, Stonington, Connecticut. Blown up by a dragged-up bomb off Block Island, 1945. Source: Ellery Thompson. 70.378

400. *Charles W. Morgan.* Oil. 29⁵⁄₁₆ x 36 in. Signed: Ellery Thompson. American ship, built 1841, New Bedford, Massachusetts. 351 tons. 113′11″ x 27′2½″ x 13′7¼″. (Not illustrated.) Source: Ellery Thompson. 70.155

401. *Elias F. Wilcox.* Oil. 21¾ x 28 in. Signed: Thompson. American menhaden steamer, built 1923, Palmer's Yard, Noank, Connecticut. 164 tons. 139′1″ x 24′ x 11′6″. Source: Ellery Thompson. 70.377

402. Unidentified American trawler. Oil. 23¾ x 29½ in. Signed and dated: Ellery Thompson, 1956. American dragger. Source: Ellery Thompson. 56.794

THE CHARLES W. MORGAN MYSTIC CONN.

397

399

401

402

404

Thorsen, Lars
Norwegian-American (1876–1952)

403. [*Andrew Jackson* and *David Crockett* rounding Cape
Horn.] Oil. 39½ x 49½ in. Signed: Lars Thorsen.
American clipper ships. *Andrew Jackson* built 1855, Mystic,
Connecticut; *David Crockett* built 1853, Mystic,
Connecticut. (Not illustrated.) Source: Mrs. Clarence
Wimpfheimer. 54.566

404. *Dauntless*. Watercolor. 14½ x 18¼ in. Signed: Lars
Thorsen. American ship, built 1869, Mystic,
Connecticut. 181′ x 35′ x 22′ 9″. Source: John W. Steube.
40.138

405

408

405. *'John McDonald,' in the Trade Winds*. Oil. 39½ x 49½ in. Signed: Lars Thorsen. American ship, built 1882, Bath, Maine. 2172 tons. 249'4" x 43'1" x 28'1". Source: Lars Thorsen. 40.102

406. [Sea elephant hunting.] Oil. 120 x 38½ in. Signed and dated: Lars Thorsen, 1929. (Not illustrated.) Source: Savings Bank of New London. 39.1551

407. [Sealing.] Oil. 120 x 36 in. Signed and dated: Lars Thorsen, 1929. (Not illustrated.) Source: Savings Bank of New London. 39.1550

408. Unidentified ship. Pencil. 13 x 21³/₈ in. Signed: Lars Thorsen, Noank. Source: Jibboom Club. 56.1061

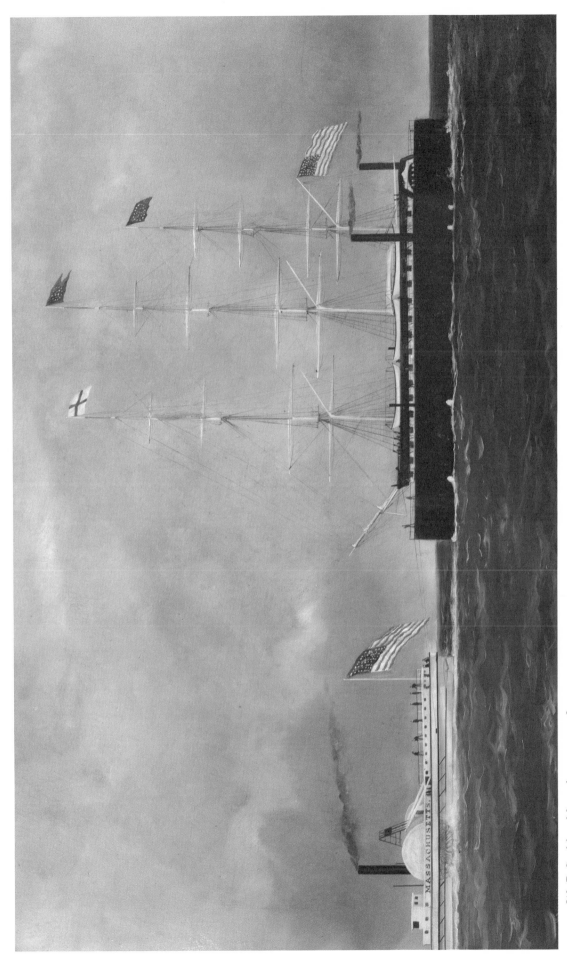

394. W. P. Stubbs, *Massachusetts* 53·78

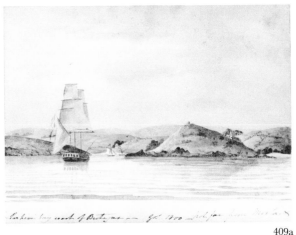

409a

409b

409c

409d

Tobin, George
English (1768–1838)

409. Sketchbook. Watercolor. 6³/₄ x 9⁷/₈ in. Signed and
 dated: G. T. 1794–1827. Seventy-two drawings on
thirty-eight leaves. Each page signed and with the name of
the vessel Tobin was on. Source: Anonymous. VFM 965

Torrey, Charles
American (1859–1921)

410. *Sovereign of the Seas*. Oil. 25¹/₂ x 42 in. Signed and
 dated: Chaˢ Torrey, 1916. American clipper ship,
built 1852, East Boston, Massachusetts. 2420 tons.
258′2″ x 44′7″ x 23′6″. Lost 1859. Source: Mrs. Mary
Stillman Harkness. 33.7

411. *Vesper*. Oil. 19³/₄ x 29³/₄ in. Signed and dated: Chas.
 Torrey 1918. American ship. Copy of unknown
painting. Source: Ralph M. Torrey. 55.967

410

411

412

413

414

Turner, Joseph Mallord William
English (1775–1851)

412. *Minorca Harbor*. Watercolor. 4⁵/₈ x 12¹/₈ in. Dated in
pencil on reverse: 1841. Artist unknown; arrow
drawn in by John Anderson, Jr., who attributed drawing
to J. M. W. Turner, to indicate hidden signature. Source:
Philip R. Mallory. 67.279

415

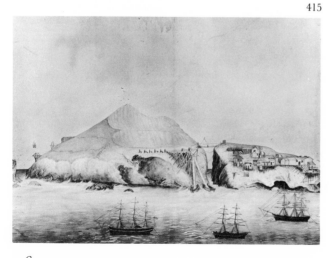

413. Unidentified small sailing boats. Pen, ink. 7³/₈ x
10³/₄ in. Dated: 1802. Artist unknown; arrows
drawn in by John Anderson, Jr., who attributed drawing
to J. M. W. Turner, to indicate hidden signature. Source:
Philip R. Mallory. 67.289

Van Rosen, Captain Gunnar

414. [U.S. army transport *Charles A. Stafford*
rescuing the crew of the Portuguese schooner *Maria
Carlotta*.] Oil. 24 x 36 in. Signed: G van Rosen. Source:
Captain Gunnar van Rosen. 51.419

W., P. (or R.)

415. [Loading guano at Chincha Islands.] Watercolor.
14⁵/₈ x 21³/₁₆ in. Signed: P. [or R.] W. Source:
Museum purchase. 69.228

Wade

416. *Charles Mallory's Shipyard, Mystic, Connecticut*. Pen,
ink. 6¹/₂ x 12 in. Signed and dated: Wade, 1950.
Source: Philip R. Mallory. 67.263

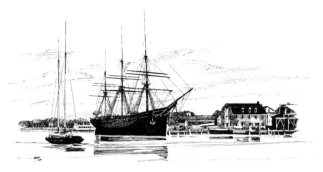

416

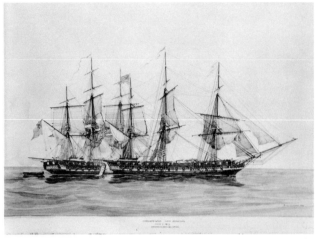

421

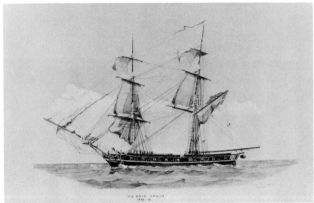

417

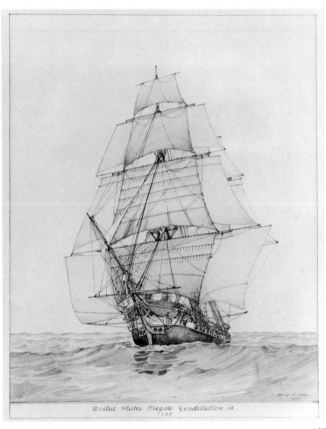

423

Wales, George Canning
American (1868–1940)

417. *U.S. Brig 'Argus,' 1803–13*. Watercolor. 9¼ x 14¾ in.
 Signed and dated: George C. Wales, 1934. American
naval brig, built 1803, Boston, Massachusetts. 298 tons.
Captured by *H.M.S. Pelican*, 14 August 1813. Source:
Anonymous. 32.274

418. *'Argus' and 'Pelican.'* Watercolor. 11¾ x 17¼ in.
 Signed and dated: George C. Wales, 1931. American
and British naval brigs. *Argus* built 1803, Boston,
Massachusetts. (Not illustrated.) Source:
Harold H. Kynett. 43.1116

419. *'Boxer' and 'Enterprise,' September 5, 1813*. Watercolor.
 11¾ x 17⅛ in. Signed and dated: George C. Wales,
1931. American and British naval brigs. *Enterprise* built
1799, Baltimore, Maryland. (Not illustrated.) Source:
Harold H. Kynett. 43.1124

420. *'Cherub,' 'Essex,' 'Phoebe,' off Valparaiso, March 28,
 1814*. Watercolor. 12 x 17¼ in. Signed and dated:
George C. Wales, 1931. British and American warships.
Essex, American frigate, launched 1799, Salem,
Massachusetts. (Not illustrated.) Source: Harold H.
Kynett. 43.1126

421. *'Chesapeake' and 'Shannon,' June 1, 1813*. Watercolor.
 7¼ x 11¾ in. Signed and dated: George C. Wales,
1933. American and British frigates. *Chesapeake* built 1799,
Norfolk, Virginia. Source: Harold H. Kynett. 43.1119

422. *'Chesapeake' and 'Shannon,' off Boston Light June 1, 1813*.
 Watercolor. 7¼ x 11¾ in. Signed and dated:
George C. Wales, 1931. American and British frigates.
Chesapeake built 1799, Norfolk, Virginia. (Not illustrated.)
Source: Harold H. Kynett. 43.1127

423. *United States Frigate 'Constellation,' 38. 1797*. Watercolor.
 12¾ x 10 in. Signed and dated: George C. Wales,
1927. American frigate, launched 1797, Baltimore,
Maryland. Source: Anonymous. 32.270

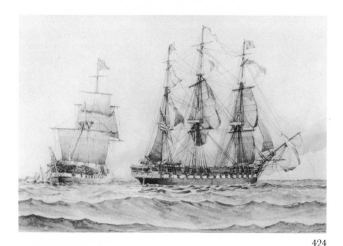

424

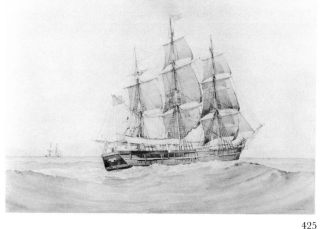

425

426

427

431

[WALES]

424. *'Constitution' and 'Java.'* Watercolor. 11½ x 17½ in.
Signed and dated: George C. Wales, 1930. American
and British frigates. *Constitution* launched 1797, Boston,
Massachusetts. Source: Harold H. Kynett. 43.1123

425. *Whaleship 'Desdemona' of New Bedford.* Watercolor.
14⁷/₈ x 19³/₈ in. Signed and dated: George C. Wales,
1930. American whaleship, built 1823, Middletown,
Connecticut. Source: Harold H. Kynett. 43.1133

426. *U.S. Frigate 'Essex,' 32—1799.* Watercolor. 12⁵/₈ x 18
in. Signed and dated: George C. Wales, 1937.
American frigate, launched 1799, Salem, Massachusetts.
850 tons. Source: Anonymous. 32.267

427. *'Guerrière' and 'Constitution.'* Watercolor. 11¹/₈ x
16⁹/₁₆ in. Signed and dated: George C. Wales, 1930.
British and American frigates. *Constitution* launched 1797,
Boston, Massachusetts. 1728 tons. Source: Harold H.
Kynett. 43.1118

428. *Revolutionary Frigate 'Hancock'—32.* Watercolor. 11³/₄
x 17¹/₈ in. Signed and dated: George C. Wales, 1934.
American frigate, built 1776, Newburyport, Massachu-
setts. (Not illustrated.) Source: Anonymous. 32.271

429. *'Hornet' and 'Peacock' Feb. 24, 1813.* Watercolor. 11³/₄
x 17¹/₄ in. Signed and dated: George C. Wales, 1931.
British and American warships. *Hornet*, sloop of war, built
1805, Baltimore, Maryland. (Not illustrated.) Source:
Harold H. Kynett. 43.1117

430. *'Hornet' and 'Penguin,' March 23, 1815.* Watercolor.
12¹/₁₆ x 17¹/₄ in. Signed and dated: George C.
Wales, 1932. American and British warships. *Hornet*,
sloop of war, built 1805, Baltimore, Maryland. 440 tons.
(Not illustrated.) Source: Harold H. Kynett. 43.1120

431. *McDonough's Victory—Lake Champlain—Sept. 11, 1814.*
Watercolor. 11³/₄ x 17 in. Signed and dated: George
C. Wales, 1932. Source: Harold H. Kynett. 43.1128

433

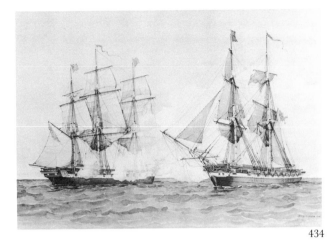

434

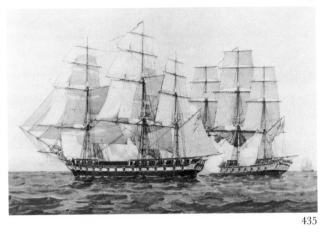

435

436

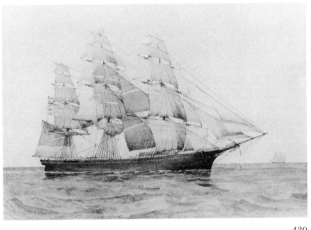

439

432. *'Niagara,' Breaking the British line—Lake Erie—Sept. 10, 1813.* Watercolor. 11⁷/₈ x 18 in. Signed and dated: George C. Wales, 1931. American brig, built 1813, Presque Isle, Pennsylvania. (Not illustrated.) Source: Harold H. Kynett. 43.1131

433. *Clipper Ship 'Nightingale' of Boston 1851.* Watercolor. 10⁷/₁₆ x 14¹⁵/₁₆ in. Signed and dated: George C. Wales, 1927. American clipper ship, built 1851, Portsmouth, New Hampshire. 1066 tons. 165' x 36' x 20'. Foundered 1893. Source: Anonymous. 32.275

434. *'Peacock' and 'Epervier.' April 28, 1814, First Broadsides.* Watercolor. 11³/₄ x 17¹/₂ in. Signed and dated: George C. Wales, 1931. American and British warships. *Peacock*, sloop of war, built 1813, New York. 509 tons. Source: Harold H. Kynett. 43.1121

435. *'President' and 'Endymion' January 15, 1815.* Watercolor. 12³/₁₆ x 18³/₁₆ in. Signed and dated: George C. Wales, 1932. American and British frigates. *President* built 1800, New York. 1576 tons. Source: Harold H. Kynett. 43.1115

436. *'President' in chase of 'Belvidera'—June 23, 1812.* Watercolor. 11³/₄ x 17 in. Signed and dated: George C. Wales, 1932. American and British frigates. *President* built 1800, New York. 1576 tons. (Not illustrated.) Source: Harold H. Kynett. 43.1134

437. *American Privateer 'Prince de Neufchatel' Captain Ordronaux 1813–1814.* Watercolor. 8¹/₂ x 13 in. Signed and dated: George C. Wales, 1935. American armed topsail schooner. Source: Anonymous. 32.272

438. *Revolutionary Frigate 'Raleigh,' 32.* Watercolor. 11³/₄ x 17 in. Signed and dated: George C. Wales, 1927. American frigate, built 1776, Portsmouth, New Hampshire. (Not illustrated.) Source: Harold H. Kynett. 43.1125

439. *Red Jacket.* Watercolor. 12³/₄ x 18 in. Signed and dated: George C. Wales, 1930. American clipper ship, built 1853, Rockland, Maine. 2305 tons. 251' x 44' x 31'. Source: Harold H. Kynett. 43.1132

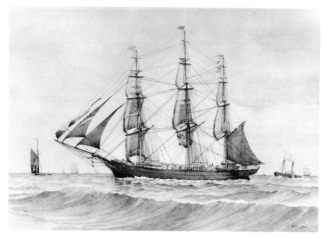

440

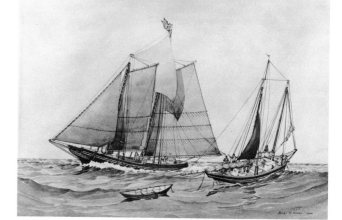

441

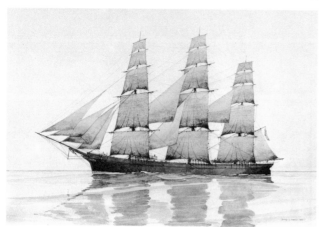

445

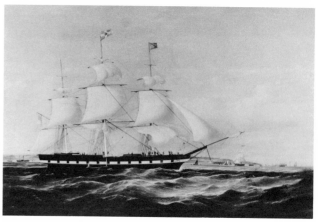

446

[W A L E S]

440. *Surprise*. Watercolor. 14 x 18 in. Signed and dated:
 George C. Wales, 1930. American clipper ship, built
1850, East Boston, Massachusetts. 1261 tons. 183′3″ x
38′8″ x 25′. Source: Harold H. Kynett. 43.1130

441. Unidentified Essex-built schooner and pinky.
 Watercolor. 12½ x 17 in. Signed and dated: George
C. Wales, 1938. American two-masted schooners. Source:
Harold H. Kynett. 43.1129

442. *'United States' and 'Argus.'* Watercolor. 12¾ x 18 in.
 Signed and dated: George C. Wales, 1937. American
warships. *Argus* built 1803, Boston, Massachusetts. 298
tons. (Not illustrated.) Source: Anonymous. 32.268

443. *U.S. Gunboat Number 5—1803. From contemporary data
 collected by H. I. Chapelle.* Watercolor. 13¾ x 11⅝ in.
Signed and dated: George C. Wales, 1935. American
gondola. (Not illustrated.) Source: Anonymous. 32.273

444. *U.S.S. 'Wasp,' 1813.* Watercolor. 8½ x 11 in. Signed
 and dated: George C. Wales, 1931. American sloop
of war. (Not illustrated.) Source: Anonymous. 32.269

445. *Young America*. Watercolor. 12¾ x 18 in. Signed and
 dated: George C. Wales, 1930. American clipper
ship, built 1853 by W. H. Webb, New York. 1961 tons.
235′ x 40′2″ x 25′9″. Foundered 1888, raised, name
changed to *Miroslav*. Source: Harold H. Kynett. 43.1122

Walters, Samuel
English (1811–1882)

446. *Caleb Grimshaw*. Oil. 23½ x 35¼ in. Attributed to
 Samuel Walters. American ship, built 1848 by W.
H. Webb, New York. 987 tons. Source: Wendell P.
Colton, Jr. 65.967

447. *Samoset*. Oil. 23¼ x 35½ in. Attributed to Samuel
 Walters. American ship, built 1847 by Fernald &
Pettigrew, Portsmouth, New Hampshire. 563 tons. 136′ x
30′ x 17′6″. Source: Museum purchase. 70.800
See color illustration opposite p. 152.

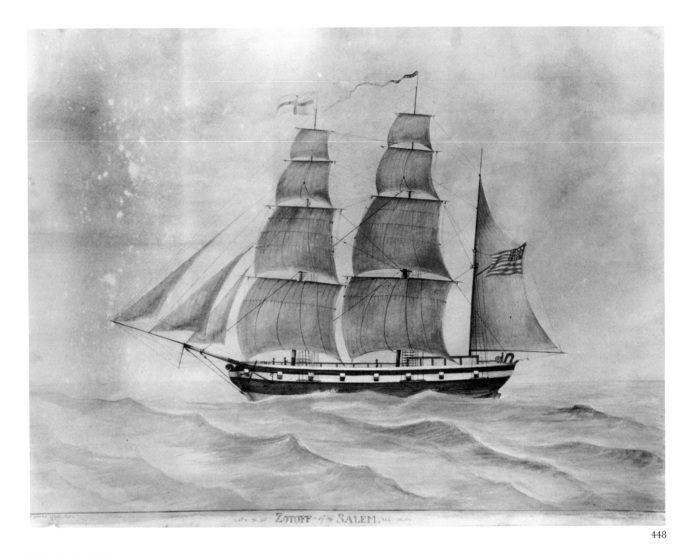

448

Ward, William
English (1761–1802)

448. *'Zotoff' of Salem*. Watercolor. 19½ x 24½ in. Signed and dated: William Ward Delin, Anno 1795. American bark. Source: Laurence J. Brengle, Jr., William C. Brengle, Mrs. Thomas S. Gates, Jr. 53.4559

Wasson, George Savary
American (1855–1932)

449. Four sketchbooks. Pencil sketches. New England coast, small local vessels. Source: Anonymous.

VFM 966

449a

449b

151

450

Wendell, G. E.

450. *America*. Watercolor. 6³/₄ x 21¹/₄ in. Signed
 and dated: G. E. Wendell, 1868. American schooner
yacht, built 1851 by W. H. Brown, New York. 108′ x 22′ x
9′. Source: Rudolph J. Schaefer. 75.187.10

Weyts, Carolus Ludovicus
Belgian (1828–1876)

451. *'Caledonia' of Bath, Cap! S. S. Horton Passing Flushing.*
 Oil on glass. 21¹/₂ x 28¹/₈ in. Signed; now washed off.
American ship, built 1860 by Houghton Bro., Bath,
Maine. 999 tons. 181′6″ x 34′8″ x 23′4″. (Not
illustrated.) Source: Mrs. Laurence J. Brengle, Sr.
 51.3351

452. *'M. R. Ludwig' of Warren, passing Dover Castle, 1862.*
 Oil. 23 x 30 in. Signed: C. L. Weyts D'Anvers.
American ship, built 1856 by Kennedy & Vinal, Warren,
Maine. 1046 tons. Source: Laurence J. Brengle, Jr.
 53.4529

453. *Schooner [sic] 'Sirocco' of Aberdeen command by A. Buyers,*
 1st off' J. S. Scorbie passing South Foreland 1872. Oil. 23 x
31¹/₄ in. Signed: C. L. Weyts. British barkentine, built
1867, Aberdeen, Scotland. 233 tons. 120′9″ x 24′6″ x
12′7″. Source: Harold H. Kynett. 61.2

454. *'Vulture' of New York. Gurden L. Smith Com! passing*
 Flushing 1857. Oil on glass. 22 x 28³/₄ in. Attributed
to Carolus Ludovicus Weyts. American ship, built 1853,
Essex, Connecticut. (Not illustrated.) Source: George R.
Goddard. 66.194

452

447. Samuel Walters, *Samoset* 70.800

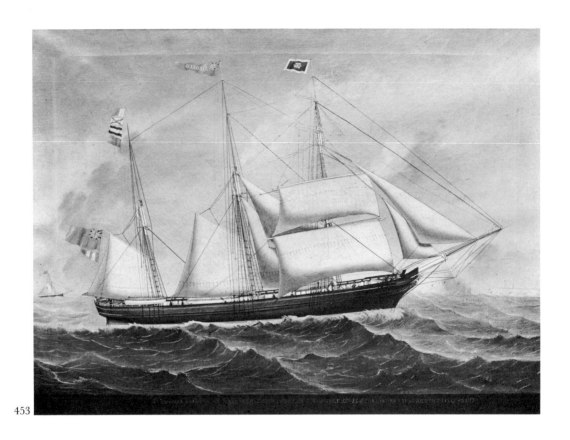

453

Whitcombe, Thomas
English (1763–1824)

455. *'Euphrates' and 'Triumph.'* Oil. 32¹/₂ x 46¹/₄ in. Signed
and dated: T. Whitcombe, 1799. British whaleships.
Source: Harold H. Kynett. 55.113

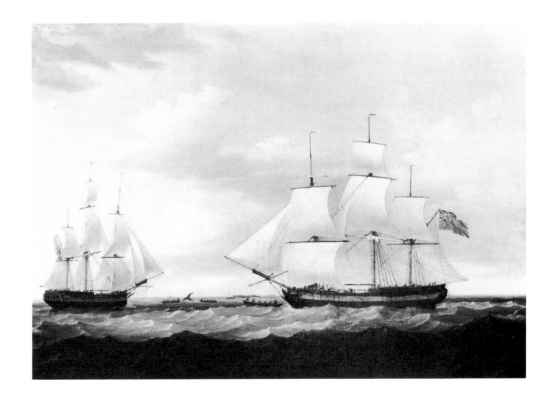

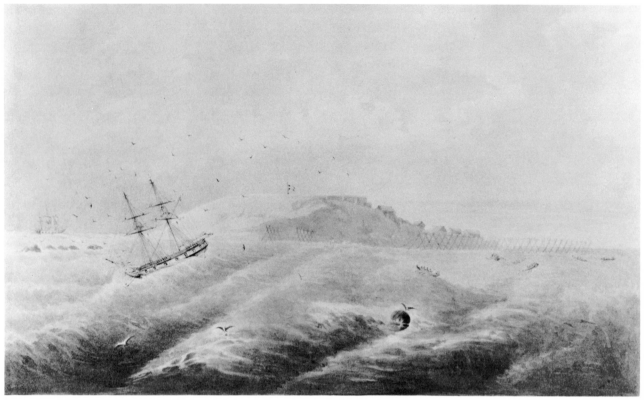

458

459

460

Whitehill, Florence
American

456. *Ship 'Clarissa Andrews' Cap! Jacob Weeks Thompson, 1832.* Oil. 19⁷/₈ x 23 ⁵/₈ in. Attributed to Florence Whitehill. Copy of a damaged painting, artist unknown. American ship, built 1831, Salisbury, Massachusetts. (Not illustrated.) Source: Arthur R. Wendell.　48.107

457. *Ganges.* Oil. 23³/₄ x 35³/₄ in. Signed: Florence Whitehill. Copy of a painting by George H. Greenleaf, a passenger on board the ship. American clipper ship, built 1854 by Hugh McKay, East Boston, Massachusetts. 1254 tons. Sold to Britain 1863. (Not illustrated.) Source: Arthur R. Wendell.　44.419

Whittle, R. P.

458. *Ichaboe.* Watercolor. 10¹/₄ x 15⁵/₈ in. Signed and dated: R. P. Whittle, January 4th [18]46. Source: Museum purchase.　57.481

459. *Off Ichaboe.* Watercolor. 9⁵/₈ x 15⁵/⁸ in. Signed and dated: R. P. Whittle Janᵞ 5th 1846; R.P.W. Source: Museum purchase.　57.480

Williams, J. A.

460. *Middletown.* Pencil. 16¹/₄ x 26⁷/₁₆ in. Signed: J. A. Williams [former first officer on the *Middletown*]. Long Island steamboat, built 1896, Philadelphia, Pennsylvania. Source: Samuel B. Hunt, Jr.　59.263

461

463

465

466

Willis, Thomas
American (1850–1912)

461. *Aloha*. Embroidery, satin sails, oil. 21⁵/₁₆ x 28¹/₄ in.
Signed and dated: T. Willis, N.Y. 1909. American
auxiliary brigantine yacht, built 1899, Brooklyn, New
York. Source: P. C. Bezanson. 57.873

462. *Aloha*. Embroidery, satin, oil. 20³/₄ x 34³/₄ in.
Attributed to Thomas Willis. American auxiliary
bark yacht, built 1910, Quincy, Massachusetts. (Not
illustrated.) Source: P. C. Bezanson. 57.874

463. *America*. Embroidery, satin, oil. 16 x 23³/₄ in. Signed:
T. Willis. American schooner yacht, built 1851 by
W. H. Brown, New York. Source: Rudolph J. Schaefer.
75.187.34

464. *Azalea*. Embroidery, satin, oil. 19¹/₂ x 25³/₄ in.
Attributed to Thomas Willis. American schooner
yacht, built 1857 by D. J. Lawlor & Son, Chelsea,
Massachusetts. (Not illustrated.) Source: Mrs. Harold E.
Blunt. 73.457

465. *Columbia*. Embroidery, satin, oil. 19¹/₂ x 29¹/₂ in.
Signed: T. Willis. American sloop yacht, built 1899,
Bristol, Rhode Island. Source: E. D. Morgan. 47.990

467

466. *Faustina*. Embroidery, satin, oil. 15³/₈ x 23³/₈ in.
Signed: T. Willis. American two-masted schooner,
built 1902, Gloucester, Massachusetts. Source: C. K.
Stillman. 37.62

467. *Gregory*. Embroidery, satin, oil. 19¹/₂ x 24 in.
Attributed to Thomas Willis. British auxiliary
steamship, built 1891, Newcastle, England. Source: Mrs.
Thomas S. Gates, Jr. 53.4573

155

469

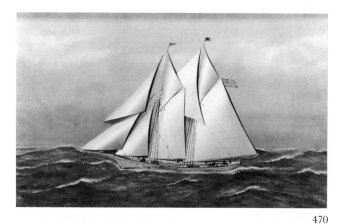

470

[WILLIS]

468. *Jesse Carll*. Embroidery, satin, velvet, oil. 17½ x
 31¼ in. Attributed to Thomas Willis. New York
pilot schooner, built 1885, Northport, New York. 62 tons.
81′ x 23′ x 10′. Off Sandy Hook. (Not illustrated.) Source:
Martin S. Kattenhorn Estate. 59.1298

469. *Sagamore*. Embroidery, satin, oil. 19½ x 31¾ in.
 Attributed to Thomas Willis. American auxiliary
barkentine yacht, built 1888, Bath, Maine. Source: Mrs.
Frank M. B. Myers. 59.1296

470. Unidentified yacht. Embroidery, satin, oil. 19¼ x
 31¼ in. Signed and dated: T. Willis, N.Y. 1906.
American schooner. Source: Mrs. William P. Peterson in
memory of William P. Peterson. 75.21

Wilson, James

471. *Appleton*. Oil. 23⅜ x 35¼ in. Signed: James Wilson.
 British clipper ship. Source: Mrs. Mary Stillman
Harkness. 35.29

Wilson, William Normanton

472. [Refitting.] Gouache. 24 x 17½ in. Signed: W. N.
 Wilson. Source: Helen Irving Cutler Estate. 71.42

471

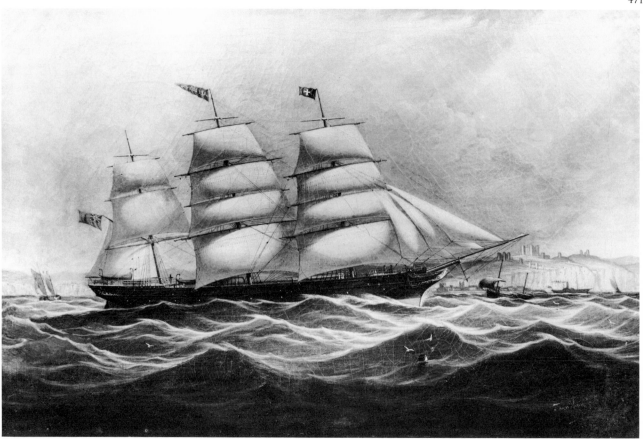

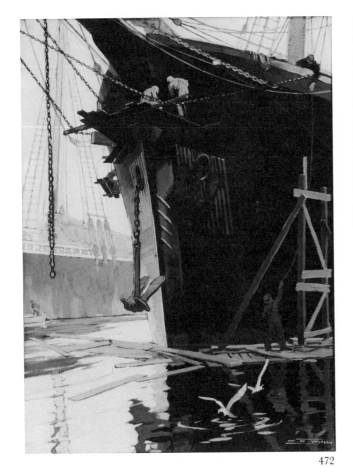

472

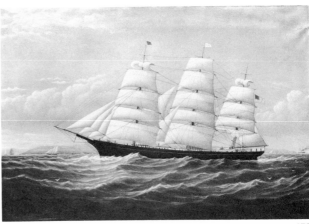

473

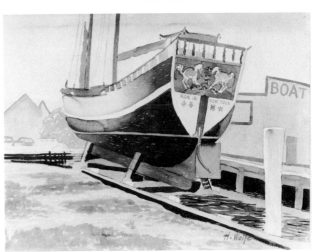

474

Witham, Joseph
English (active 1855–1895)

473. *M. P. Grace*. Oil. 27³/8 x 41⁵/8 in. Signed and dated: J.
 Witham, Liverpool, 1880. American ship, built
1875, Bath, Maine. 1928 tons. 229'9" x 42' x 27'8".
Source: Edmund Kellogg. 59.1381

Wolfe, Henderson

474. *'Mon Lei,' New York*. Watercolor. 17³/8 x 23¹/16 in.
 Signed: H. Wolfe. Ca. 1957. Chinese-American
junk. Source: Henderson Wolfe. 58.1301

Wood, Worden
American (active 1912–1937)

475. *Aloha*. Watercolor. 13 x 18 in. Signed and dated:
 Worden Wood [19]31. American auxiliary bark
yacht, built 1910, Quincy, Massachusetts. Source: The
James Foundation of New York, Inc. 61.21

Wotherspoon, George A.

476. *Sinking of the US Transport, 'Covington' July 2ⁿᵈ 1918*.
 Watercolor. 9³/4 x 19⁵/16 in. Signed and dated:
George A. Wotherspoon, 1939. Sketch for oil painting.
American steamship. Source: Mrs. Louise Wallis.
 55.917

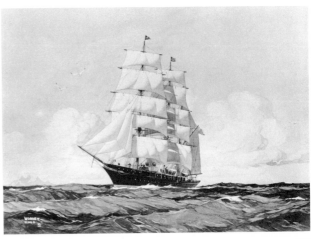

475

476

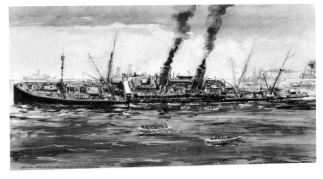

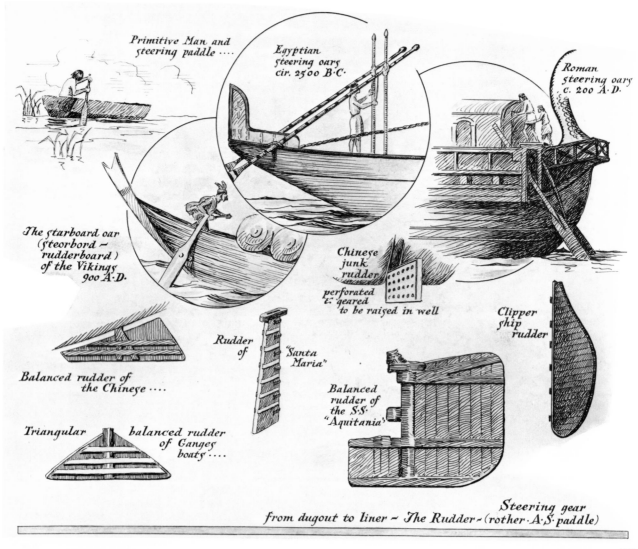

Primitive Man and steering paddle

Egyptian steering oars cir. 2500 B·C·

Roman steering oars c. 200 A·D·

The starboard oar (Steorbord ~ rudderboard) of the Vikings 900 A·D·

Chinese junk rudder perforated & geared to be raised in well

Balanced rudder of the Chinese

Rudder of "Santa Maria"

Clipper ship rudder

Triangular balanced rudder of Ganges boats

Balanced rudder of the S·S· "Aquitania"

Steering gear from dugout to liner ~ The Rudder ~ (rother·A·S·paddle)

477

Wright, W. Spencer
American

477. *Oar to Oil*, seventy-five ink, watercolor drawings. 12¼ x 19⅝ in. Signed: W. Spencer Wright. (Illustrated: 57.510.74.) Source: W. Z. Gardner

57.510.1–74, 57.511

478

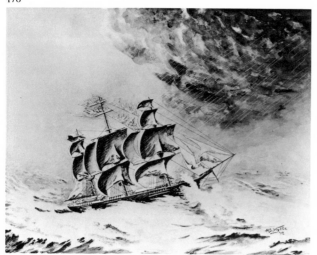

Wyllie, H. S.

Nos. 478–485 were probably painted from incidents described in logbooks, George B. Wendell master, in the collection at Mystic Seaport.

478. *'Benares,' Calcutta to Boston*. Watercolor, wash. 15¼ x 20⅛ in. Signed and dated: H. S. Wyllie [19]12. American ship, built 1856 by Hugh McKay, East Boston, Massachusetts. 1440 tons. Source: Arthur R. Wendell.

43.1283

479

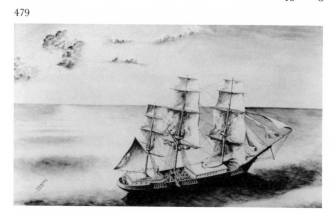

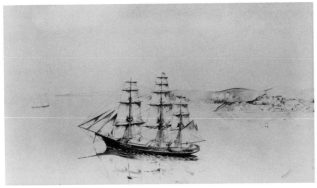

480

479. *'Benares,' Calcutta to Boston; burial at sea. 13 November 1858*. Watercolor. 12 x 21 1/4 in. Signed: H. S. Wyllie. American ship, built 1856 by Hugh McKay, East Boston, Massachusetts. 1440 tons. Source: Arthur R. Wendell.

43.1284

480. *'Galatea' off Alcatraz*. Watercolor. 12 1/2 x 21 15/16 in. Signed: H. S. Wyllie. American clipper ship, built 1854 by J. Magoun, Charlestown, Massachusetts. 1041 tons. Source: Arthur R. Wendell. 43.1287

481. *'Galatea' in a storm*. Watercolor. 14 x 17 in. Signed: H. S. Wyllie. American clipper ship, built 1854 by J. Magoun, Charlestown, Massachusetts. 1041 tons. (Not illustrated.) Source: Arthur R. Wendell. 43.1279

482. *'Ganges' in Calcutta Harbor 1856*. Watercolor. 15 3/4 x 20 in. Signed and dated: H. S. Wyllie, 1912. American clipper ship, built 1854 by Hugh McKay, East Boston, Massachusetts. 1254 tons. Source: Arthur R. Wendell. 43.1281

482

483. *'Ganges' dismasted in a storm*. Watercolor. 14 x 18 in. Signed: H. S. Wyllie. American clipper ship, built 1854 by Hugh McKay, East Boston, Massachusetts. 1254 tons. (Not illustrated.) Source: Arthur R. Wendell.

43.1290

484. *The 'Ganges' Jan^{ty} 25^{th} 1857*. Watercolor. 13 7/8 x 18 in. Signed and dated: H. S. Wyllie [19]12. American clipper ship, built 1854 by Hugh McKay, East Boston, Massachusetts. 1254 tons. (Not illustrated.) Source: Arthur R. Wendell. 43.1291

485. *'Piscataqua' Boston to Madras with cargo of ice*. Watercolor. 13 1/2 x 17 5/8 in. Signed and dated: H. S. Wyllie 1912. American ship, built 1852, Portsmouth, New Hampshire. Source: Arthur R. Wendell. 43.1280

York, William

486. *Benares*. Oil. 26 x 35 1/2 in. Signed and dated: W^m York 1858. American ship, built 1856 by Hugh McKay, East Boston, Massachusetts. Source: Herbert Wood. 49.706

485

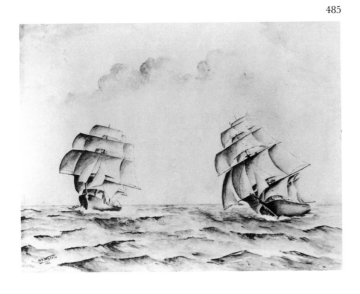

486

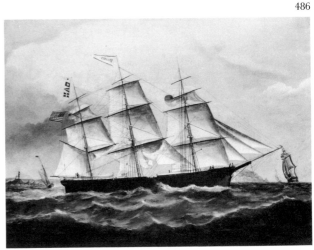

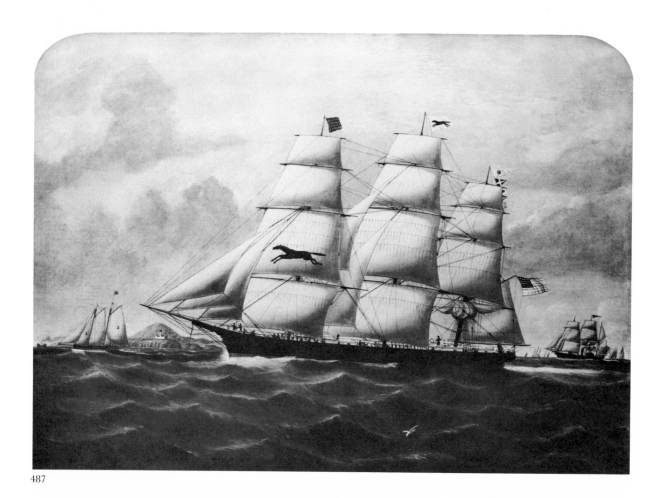

487

488

489

[YORK, WILLIAM]

487. *Ship 'Galatea' of Boston 1041 tons Regester off point Lynus March 5th 1862 Capt. George B. Wendell.* Oil. 25¹/₂ x 35¹/₂ in. Signed and dated: Wᵐ York L'pool, March 1862. American clipper ship, built 1854 by J. Magoun, Charlestown, Massachusetts. Source: Arthur R. Wendell.
43.1156

488. *American ship 'International,' Capt. J. L. Seavey of New York on the 10th of December 1860 Longitude . . . Latitude 10W.* Oil. 25¹/₂ x 35¹/₂ in. Signed and dated: W. York L'pool 1861. Source: Mrs. Carll Tucker.
67.75

489. *Leucothea.* Oil. 25¹/₄ x 35¹/₄ in. Signed and dated: Wᵐ York L'pool June 1860. American ship, built 1855, Medford, Massachusetts. 949 tons. 183' x 36' x 24'6". Source: Laurence J. Brengle, Jr.
53.4535

490. *Mary E. Russell.* Oil. 21¹/₂ x 32¹/₂ in. Signed and dated: W. York L'pool. American bark, built 1875, Addison, Maine. 575 tons. 147' x 31' x 17'. Source: Chauncey Stillman.
68.29

York (or Yorke), William G.

491. *Benjamin Webster.* Oil. 25³/₈ x 38³/₈ in. Signed and dated: Wᵐ G. Yorke 653 Atlantic Ave B'K'Lyn 1881. American bark, built 1873, Bath, Maine. 585 tons. 140'4" x 32' x 16'8". Source: Mrs. Mary Stillman Harkness.
33.3

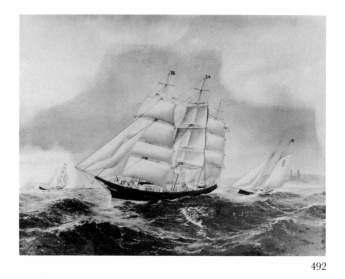

492

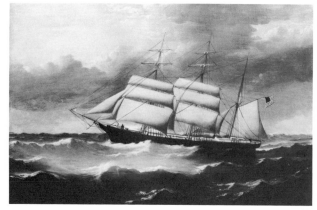

495

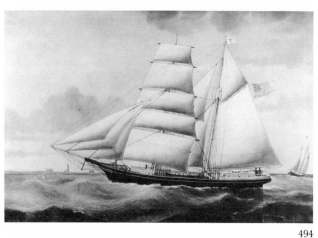

494

496

[Y O R K , W I L L I A M G .]

492. *Dauntless*. Oil. 21½ x 27¾ in. Signed: W. G. Yorke. American ship. Source: Clifford D. Mallory, Sr.

36.4

493. *Dreadnaught*. Oil. 25¾ x 35½ in. Signed and dated. W. G. Yorke 1877. American schooner yacht, built 1871, Brooklyn, New York. Source: Benjamin W. Case, Jr., Misses Emilie L. and Marie K. Case. 55.960
See color illustration opposite p. 184.

494. *Garnet*. Oil. 19¹⁵/₁₆ x 29¾ in. Signed and dated: Wm. G. Yorke, 1879. American brigantine, built 1877, Brooklyn, New York. 237 tons. 109′ x 27′ x 10′4″. Source: Miss Anna B. Hendrick Estate. 62.1258

York (or Yorke), William Howard
English (active 1858 – after 1913)

495. *Charles T. Russell*. Oil. 21¾ x 32½ in. Signed and dated: W. H. York L'pool, 1876. American bark, built 1875, Harrington, Maine. 731 tons. 140′ x 34′ x 19′. Source: Chauncey Stillman. 68.30

496. *Cyrus Wakefield*. Oil on board. 11½ x 17¾ in. Signed and dated: W. H. Yorke, 1887. American ship, built 1882, Thomaston, Maine. 2013 tons. 247′ x 43′7″ x 28′6″. Source: Laurence J. Brengle, Jr. 53.4541

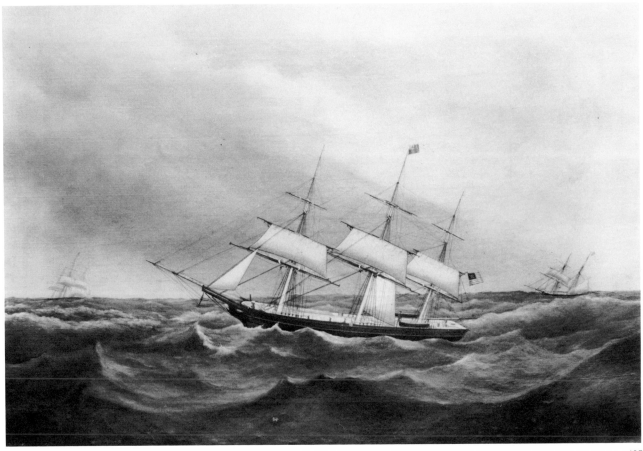

497

497. *'Agnes' Nat. Percival Master Hoboken, N.J. 1848.* Oil.
24 x 35⁵/₈ in. American ship. Source: Edward C.
Hammond. 38.390

498. *Alboni.* Oil. 23³/₈ x 39¹/₂ in. American ship, built
1852, Mystic, Connecticut. In California trade until
1861; sold to Germany 1863, renamed *Elsie G. Ruger.*
Source: Philip R. Mallory. 75.403

498

499. *Modern Oyster Steamer 'Amanda F. Lancraft.'* Oil on
paper. 11³/₁₆ x 17³/₁₆ in. American oyster steamer.
(Not illustrated.) Source: Museum purchase. 58.974

500. *America.* Oil. 19³/₈ x 23¹/₂ in. American schooner
yacht, built 1851 by W. H. Brown, New York. (Not
illustrated.) Source: New York Yacht Club. 49.220

501. *America.* Watercolor, gouache. 20¹/₄ x 28¹/₂ in.
British ship, built 1846 by G. Raynes, Portsmouth,
New Hampshire. 1137 tons. (Not illustrated.) Source:
The James Foundation of New York, Inc. 65.67

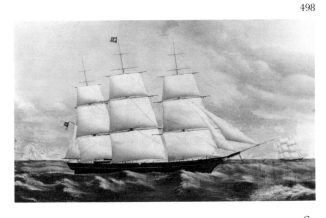

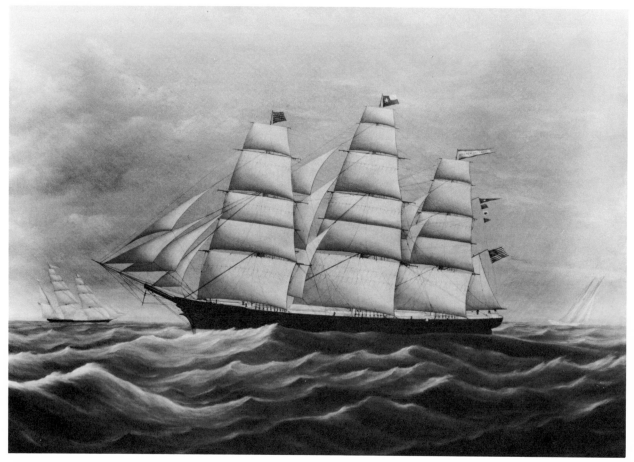

502

502. *Andrew Jackson*. Oil. 31³/₈ x 43⁷/₁₆ in. American
clipper ship, built 1855, Mystic, Connecticut.
Source: Mrs. Richard D. Wilcox. 41.662

503. *Aquidneck*. Watercolor, pen. 25³/₈ x 33¹/₂ in.
American bark, built 1865 by Hill & Grinnell,
Mystic, Connecticut. 140' x 29' x 13'. Ship-rigged in this
painting. (Not illustrated.) Source: C. K. Stillman and
Mrs. Harriet Greenman Stillman. 35.65

504. *View of the 'Artisan' of Boston* [Edward] *Smith Com^dr off
Queenstown 1871*. Oil. 26¹/₄ x 39¹/₂ in. American ship,
built 1855, Falmouth, Maine. 891 tons. 165' x 35'2"x 22'.
Source: Laurence J. Brengle, Jr. 53.4534

505. *Asia*. Oil on glass. 27¹/₄ x 19¹/₄ in. Dutch armed ship.
Source: Mrs. Carll Tucker. 67.73

506. *Avis*. Watercolor. 17¹/₂ x 22¹/₄ in. American ship,
built 1827, Bath, Maine. (Not illustrated.) Source:
C. K. Stillman. 38.559

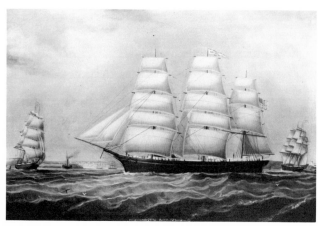

504

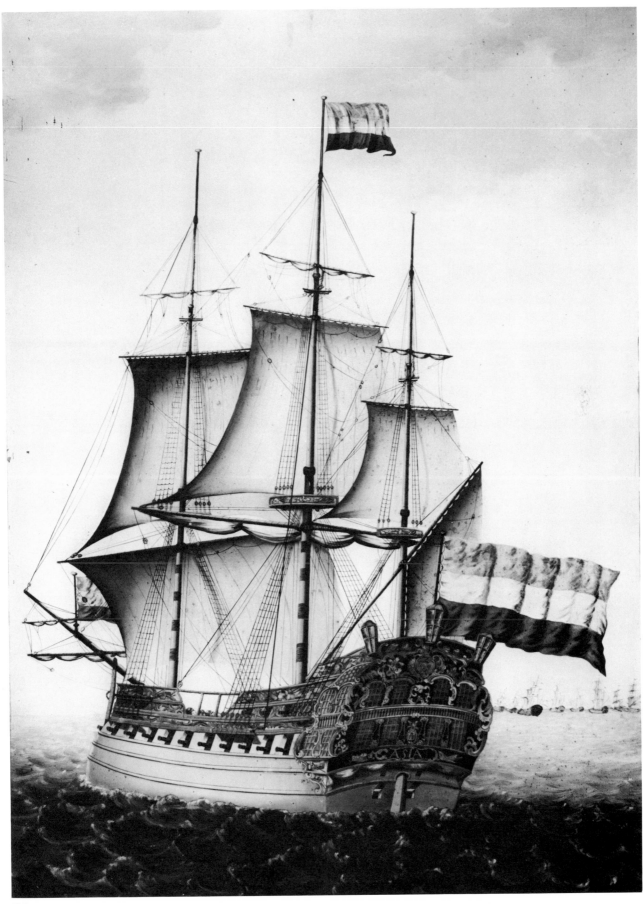

505

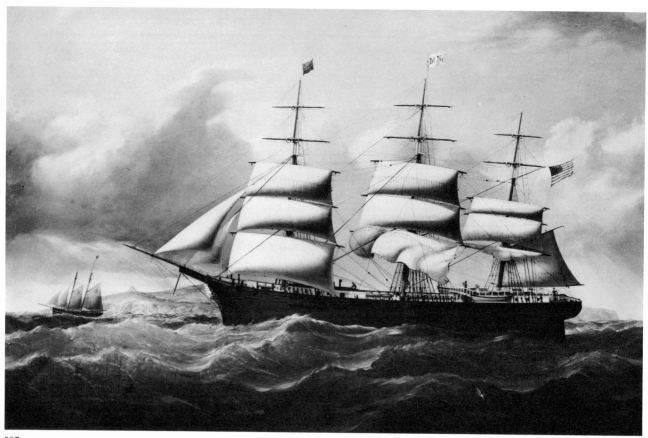

507

508

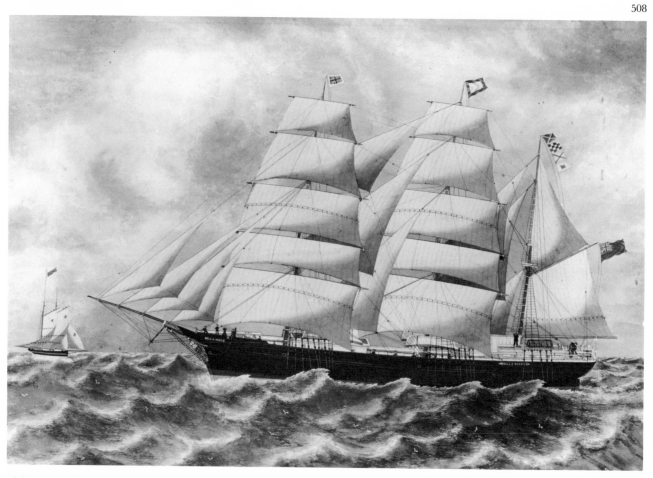

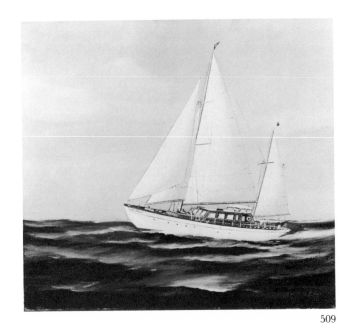

509

4 — Fulton's *Clermont* — *1807*.

511

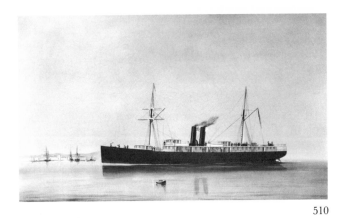

510

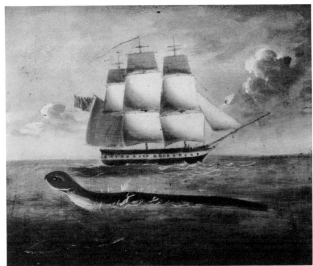

514

507. *B. D. Metcalf.* Oil. 23½ x 35½ in. American ship,
 built 1856, Damariscotta, Maine. 190' x 37'6" x
23'10". Source: Laurence J. Brengle, Jr. 53.453¹

508. *Bella Mudge.* Watercolor. 19¼ x 28 in. British bark,
 built 1873, North Scotland; home port Halifax,
Nova Scotia. 639 tons. 152'8" x 32'6" x 18'7". Source:
Mrs. Mary Stillman Harkness. 33.4

509. *'Bonnie Dundee* [IV],' *Capt. Rugby.* Oil. 18⅛ x 20¼
 in. American auxiliary ketch yacht, built 1940,
Stamford, Connecticut. Source: C. D. Mallory Estates.
 45.887

510. *City of Waco.* Oil. 21⅛ x 35½ in. American auxiliary
 steamship, built 1873, Chester, Pennsylvania. 240' x
25' x 27'. Sunk 1875. Source: C. D. Mallory Estates.
 45.33²

511. *Fulton's 'Clermont,'—1807* [*North River Steam Boat*].
 Pen, ink. 4¹¹⁄₁₆ x 6 in. American auxiliary
steamboat. Source: William Steeple Davis. 74.979.33

512. *U. S. Frigate 'Constitution.'* Oil on glass. 14½ x 18⅝
 in. American frigate, launched 1797, Boston,
Massachusetts. 1728 tons. (Not illustrated.) Source:
Laurence J. Brengle, Jr. 53.453⁸

513. [*Cunard steamships.*] Pencil. 14¹⁄₁₆ x 10⅛ in.
 British auxiliary steamships. (Not illustrated.)
Source: William Steeple Davis. 74.979.27

514. *Daedalus.* Oil on panel. 9½ x 11½ in. British
 corvette. Pair with 60.208. Source: Harold H.
Kynett. 60.207

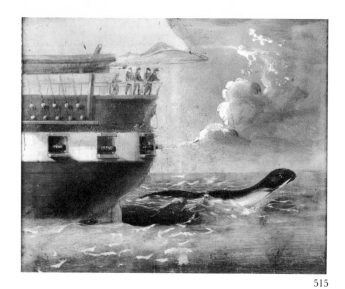

515

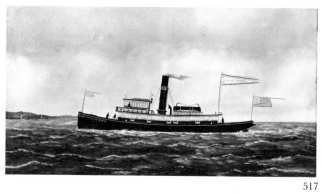

517

515. *Daedalus*. Oil on panel. 9½ x 11½ in. British corvette. Pair with 60.207. Source: Harold H. Kynett. 60.208

516. *David Crocket[t]*. Oil. 25⅝ x 37½ in. American clipper ship, built 1853, Mystic, Connecticut, for Hurlburt Line, New York to Liverpool. (Not illustrated.) Source: Joseph W. Spencer. 55.719

517. *Edward J. Berwind*. Silk embroidery, velvet, oil. 19½ x 35½ in. American tugboat, built 1902, Port Richmond, New York. Source: Daniel A. Newhall. 52.1159

518. *Egypt*. Oil. 17½ x 29½ in. British auxiliary steamship, built 1871, Liverpool, England. Source: Laurence J. Brengle, Jr., William C. Brengle, Mrs. Thomas S. Gates, Jr. 53.4575

519. *Elf*. Oil. 29³⁄₁₆ x 35½ in. American bark, built 1856, Staten Island, New York. Source: Edward C. Hammond. 38.392

520. *Elizabeth F. Willets*. Oil. 29½ x 41⅝ in. American clipper ship, built 1854 by Charles Mallory, Mystic, Connecticut. (Not illustrated.) Source: C. D. Mallory Estates. 45.325

521. *'Emerald' of Baltimore Chaˢ W. Buck Commander*. Oil. 27½ x 32⅜ in. American ship, built 1835, New York. 518 tons. 128'6" x 29'6" x 21'. Became a whaler out of New Bedford. Source: Mrs. Thomas S. Gates, Jr. 53.4566

518

519

521

Emerald of Baltimore Chas W. Buck Commander

523

522. *Burnt Steamship 'Euterpe.' Sunk in Bolivar Channel.*
 Galveston Harbor Coast. Wrecking Schooner 'Meteor'
getting out Cargo from the Hull Geo. D. Gilderdale Comdr.
Pencil. 15³/₄ x 20¹/₂ in. American steamship, built 1864,
Mystic, Connecticut. (Not illustrated.) Source: Miss
Barbara N. Gilderdale. 74.1049

523. *Fanny.* Oil. 24¹/₈ x 29¹/₂ in. American bark, built
 1849 by Charles Mallory, Mystic, Connecticut.
Source: Philip R. Mallory. 75.402

524. *'Francis Allyn' Captn J. Fuller.* Watercolor on leaf.
 1⁵/₈ x 6¹/₂ in. American two-masted schooner, built
1869, Duxbury, Massachusetts. Source: Museum
purchase. 72.54

525. *Franconia.* Oil. 14¹/₂ x 19¹/₂ in. American ship, built
 1834, Medford, Massachusetts. Source: Mrs. Mary
Stillman Harkness. 33.2

525

524

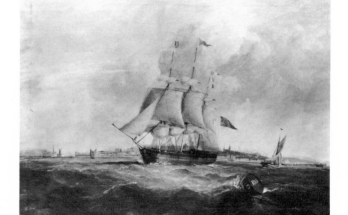

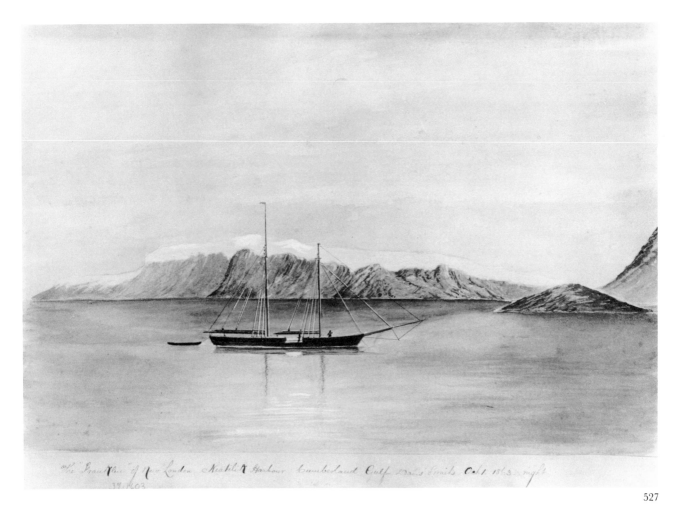

"The Franklin" of New London Niatilia Harbour Cumberland Gulf Davis Straits Oct 1 1863 night

527

526. *Franklin*. Watercolor. 17⁷/₈ x 22³/₄ in. American
 ship-of-the-line, built 1815, Philadelphia,
Pennsylvania. (Not illustrated.) Source: Miss Charlotte
R. Stillman. 33.14

527. *The 'Franklin,' of New London. Niatilia Harbour—
 Cumberland Gulf Davis Straits—Oct. 1. 1863—night.*
Watercolor, gouache. 9⁷/₈ x 15¹/₈ in. American two-masted
whaling schooner, built 1854, New London, Connecticut.
190 tons. Source: Savings Bank of New London. 39.1603

528. *Ship 'Ganges.' Geo. B. Wendell Com^d. Making Boston
 1857.* Oil. 23¹/₂ x 35¹/₂ in. American clipper ship,
built 1854 by Hugh McKay, East Boston, Massachusetts.
(Not illustrated.) Source: Arthur R. Wendell. 53.4550

529. *Engagement between the American privateer 'General
 Pickering,' Captain Jonathan Haraden of Salem, and the
British privateer ship 'Achilles,' Captain Williams; fought off
Bilboa, Spain June 4^th 1780.* Watercolor. 17¹/₂ x 22¹/₂ in.
American and British armed ships. Source: Alfred
Stainforth. 52.1158

530. *The American Barque 'Grecian' takeing the Crew from the
 French Brieg 'L'Espérance'—May 17—1834. Lat 16° 45"
50'. long 0ᵗ 10° 20'.* Watercolor, gouache. 21¹/₄ x 25¹/₈ in.
American bark. (Not illustrated.) Source: Laurence J.
Brengle, Jr., William C. Brengle, Mrs. Thomas S.
Gates, Jr. 53.3947

529

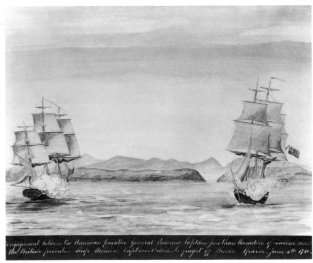

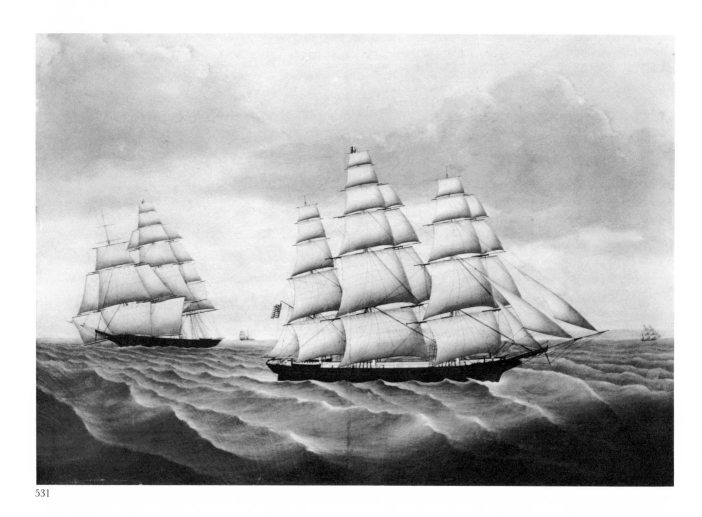

531

532

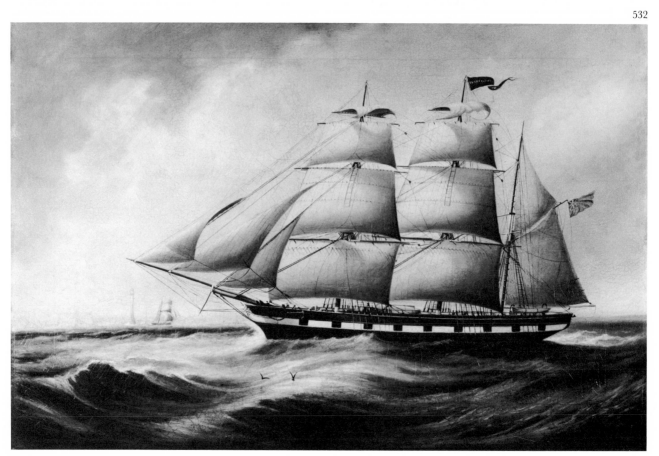

533

536

535

537

538

531. *Ino*. Oil. 31 1/2 x 46 in. American ship, built 1851 by
 Perrine, Patterson & Stack, Williamsburg, New
York. Source: Edward C. Hammond. 38.389

532. *Isabella Atkinson*. Oil. 23 3/4 x 36 in. British bark, built
 1862, Sunderland, England. Source: Estate of
George B. Mitchell. 67.240

533. *Louisa Beaton*. Watercolor, gouache. 18 1/2 x 26 1/2 in.
 American hermaphrodite whaling brig, built 1845,
Fairhaven, Massachusetts. 168 tons. 87'7" x 23'1/2" x
9'4 3/4". Source: Savings Bank of New London. 39.1280

534. *'Maria.' Captain Kimball R. Smith*. Oil. 23 1/4 x 35 1/2 in.
 American ship, built 1849, Hoboken, New Jersey.
397 tons. 127'4" x 25'10" x 13'1". Built for the coffee
trade. (Not illustrated.) Source: Edward C. Hammond.
 38.391

535. *Marion Gage*. Oil. 21 3/4 x 27 in. American brig.
 Source: Capt. Marion S. Eppley. 56.1051

536. *Mary*. Oil. 19 3/4 x 24 3/4 in. American ship, built 1854
 by B. Dutton, Marblehead, Massachusetts. Source:
Wendell P. Colton, Jr. 65.970

537. *Mary & Francis*. Oil on panel. 26 1/2 x 35 1/2 in. On
 reverse: Painted in Jefferson St No 20 N.O. Leans
1843. American topsail schooner. Source: Anonymous.
 62.1153

538. *Mohegan*. Pastel. 20 x 24 in. American steamboat of
 the Central Vermont Railway, built 1896, Chester,
Pennsylvania. 2783 tons. 265' x 43' x 16'8". Source:
Edwin B. Wheeler Estate. 45.762

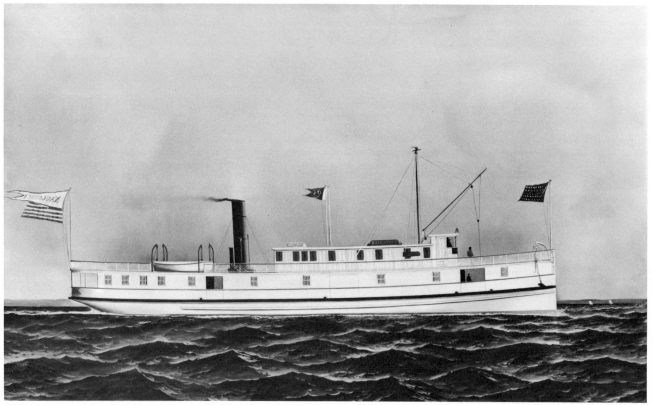

539

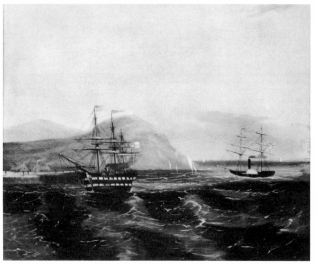

540

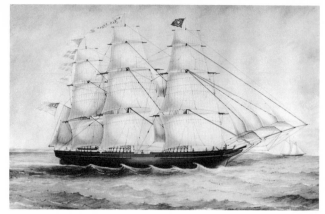

541

539. *Naugatuck.* Oil. 21³/₄ x 35⁵/₈ in. American steamboat, built 1887 by Pusey & Jones, Wilmington, Delaware. 223.61 tons. 130′ x 26′ x 7′2″. Lost 1937, en route from Pensacola, Florida, to Panama. Source: Mrs. Walter Parsons. 66.180

540. *Niagara* and *Leopard.* Oil. 23³/₄ x 28³/₄ in. British auxiliary steamships. Probably laying the first Atlantic cable, approaching Trinity Bay, Newfoundland. Source: Museum purchase. 59.649

541. *Ship 'Ocean Steed,' Cunningham Commander December 10ᵗʰ 1857, Dieppe.* Watercolor. 20³/₈ x 29 in. American ship, built 1853, Bath, Maine. 807 tons. 158′ x 34′ x 22′. Source: Laurence J. Brengle, Jr., William C. Brengle, Mrs. Thomas S. Gates, Jr. 53.81

542. *Ship 'Piscataqua' of Boston George B. Wendell Master.* Oil on board. 18³/₄ x 21 in. American ship, built 1852, Portsmouth, New Hampshire. Probably painted from incidents described in logbooks in the Seaport's collection. (Not illustrated.) Source: Arthur R. Wendell. 43.1286

543. [*Preussen.*] Oil on sailcloth. 13¹/₂ x 27⁵/₈ in. German five-masted ship, built 1902 by J. C. Tecklenborg A. G., Geestemünde, Germany. 581 tons. 407′8″ x 53′6″ x 27′1″. Lost off Dover, England. (Not illustrated.) Source: Mrs. Henry Eide. 55.707

544. *Richmond.* Oil. 23¹/₈ x 33¹/₄ in. American sloop yacht, built 1855 by D. O. Richmond, Mystic, Connecticut. 43′ x 18′ x 4′. Source: C. D. Mallory Estates. 45.334

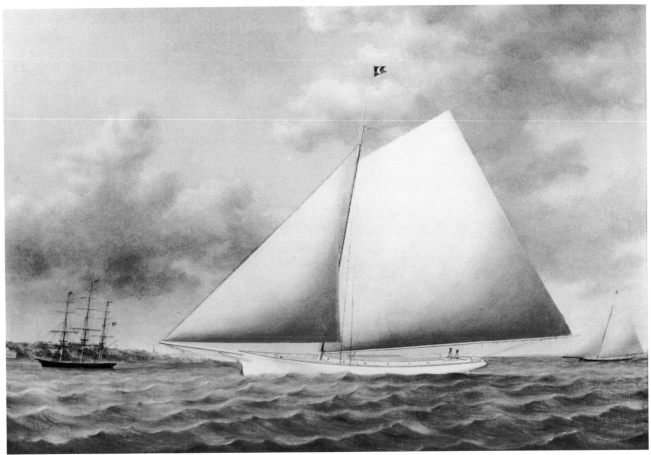

544

545

547

545. *Whaleship 'Robin-Hood' of Mystic.* Pencil, crayon, watercolor. 17¹/8 x 24¹/4 in. American whaleship, built 1824, Boston, Massachusetts. 395 tons. 113'9" x 27'10" x 13'11". Sold 1861 to be one of the "stone fleet" during the Civil War. Source: Museum purchase.

58.1433

546. *'Romsdal,' Glasgow, 1886 tons.* Embroidery, velvet, satin. 20¹/2 x 38 in. British ship, built 1877, Greenock, Scotland. 1887 tons. 275'9" x 41'1" x 23'5". Lost in hurricane in the Bay of Bengal 31 October 1891. (Not illustrated.) Source: Mrs. Carolyn R. Adams. 76.58

547. *H.M.S. 'Royal Albert.'* Oil on glass. 12 x 17⁹/16 in. British ship-of-the-line. Source: F. A. Spence-Brown.

55.1076

548

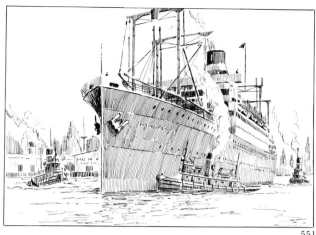

551

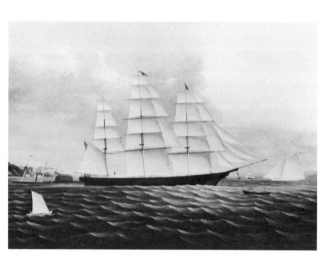

549

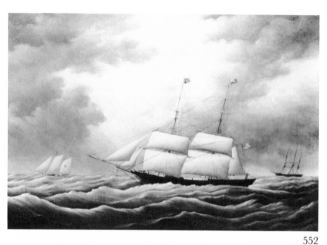

552

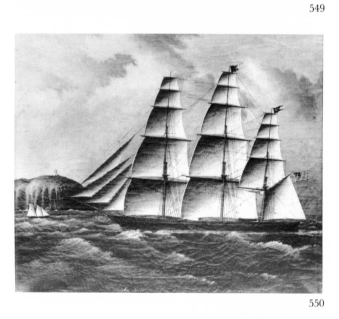

550

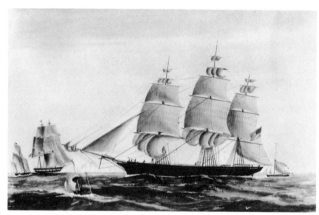

554

550. *'Sea Serpent' passing South Head San Francisco*. Oil.
33¹/₄ x 39¹/₄ in. American ship, built 1850, Ports-
mouth, New Hampshire. 1204 tons. 194'6" x 38'6" x
20'8". Sold to Norway 1874, renamed *Progress*. Source:
William C. Brengle. 62.477

548. *Sabine*. Watercolor. 17¹/₈ x 24⁷/₈ in. Unfinished
painting. American bark, built 1868, Portland,
Connecticut. Sold late 1870 to New York; about 1883 to
Norwegian owners. Source: Museum purchase. 70.338

551. *Southern Cross*. Pen, ink. 7 x 10¹/₄ in. American
steamship. Source: Mrs. Frank C. Munson. 52.833

549. *'Samuel Willets,' Charles Mallory Builder, Mystic 1854*.
Oil. 29¹/₂ x 41⁵/₈ in. American ship. Lost off New
Jersey 1857. Source: C. D. Mallory Estates. 45.328

552. *Sprite*. Oil. 29¹/₂ x 41³/₈ in. American brig, built
1856, Hanover, Massachusetts. Source: Edward C.
Hammond. 38.393

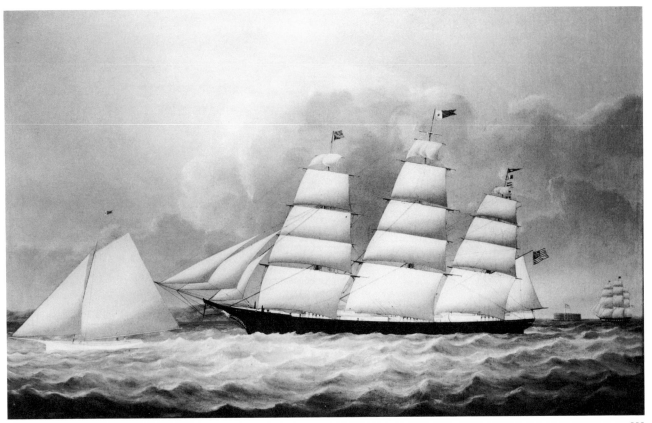

555

553. *Bark 'Sunbeam,' Capt. G. W. J. Moulton. Homeward Bound. June 15, 1886.* Crayon, pencil. 13⁷/₈ x 22 in. American whaling bark, built 1856, Rochester, Massachusetts. 255.31 tons. 106'4" x 27'3" x 15'2". (Not illustrated.) Source: Raymond B. West. 63.535

554. *Surprise.* Watercolor, gouache. 17³/₄ x 27⁷/₈ in. Watercolor copy of unknown painting. American clipper ship, built 1850, East Boston, Massachusetts. Source: Mrs. Mary Stillman Harkness. 33.10

555. *'Twilight,' Charles Mallory, Builder, Mystic, 1857.* Oil. 27³/₈ x 43¹/₂ in. American ship. 1482 tons. 200' x 40' x 22'8". Source: C. D. Mallory Estates. 45.324

556. *Victoria.* Oil. 29¹/₂ x 49⁵/₈ in. American towboat, built 1859 by Geo. Greenman & Co., Mystic, Connecticut. 180' x 29' x 9'6". (Not illustrated.) Source: Mrs. Harriet Greenman Stillman. 31.175

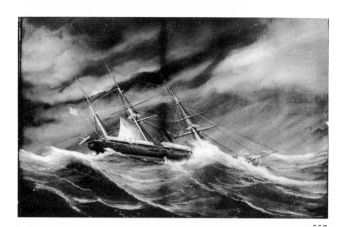

557

558

557. Unidentified American auxiliary bark. Watercolor, gouache. 16½ x 25¾ in. Source: Laurence J. Brengle, Jr. 53.3959

558. Unidentified bark. Wool embroidery. 15 x 20⅞ in. Source: Mrs. Thomas S. Gates, Jr. 53.3954

559. Unidentified bark. Watercolor, gouache. 20 x 29⁹/₁₆ in. Source: Capt. Marion Eppley. 56.1048

560. Unidentified American auxiliary bark. Wool embroidery. 23½ x 51³/₈ in. Source: Mrs. Gladys M. Mowry. 65.706

559

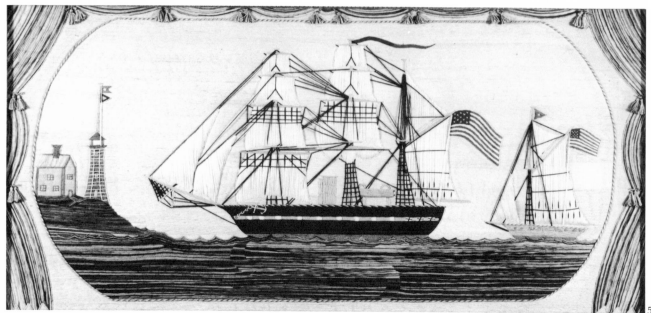

560

Nile Boats.

561

562

561. [Dhows.] Pencil. 6⁷/₈ x 4⁷/₈ in. Two views on front of drawing, six on reverse. On the Nile River. Source: William Steeple Davis. 74.979.34

562. Unidentified American motor cruiser. Watercolor, gouache. 11¹/₂ x 21⁷/₈ in. Source: Anonymous. 65.239

563. Unidentified pilot schooner #4. Oil. 23 x 31 in. (Not illustrated.) Source: Savings Bank of New London. 39.1555

564. Unidentified American ship. Oil. 23 x 34³/₄ in. Alleged to have been the vessel that brought the duPont family to the United States, 1800. Source: Savings Bank of New London. 39.1564

564

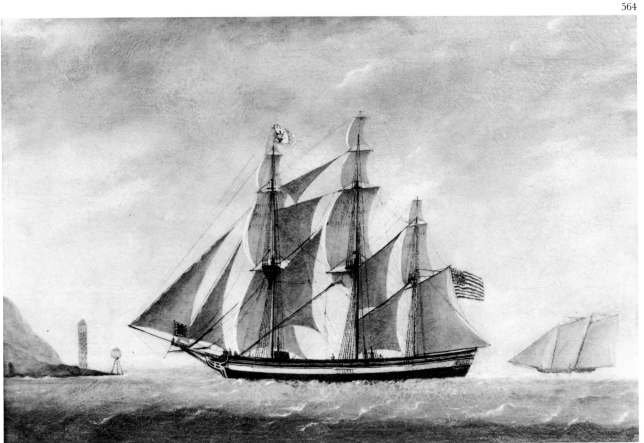

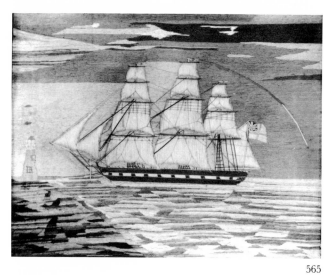

565

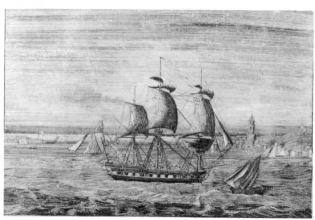

566

568

569

569. Bow deck view of unidentified sailing vessel. Watercolor. 10 x 7 in. Source: Phillip R. Mallory. 67.262

570. Unidentified sailing vessel burning at sea. Oil. 19^1/$_2$ x 23^1/$_2$ in. Source: E. D. Collins. 73.41

571. Unidentified sailing vessels on beach. Pastel. 6^3/$_4$ x 11^3/$_8$ in. Source: Philip R. Mallory. 67.281

572. Unidentified American whaleship. Oil. 20^5/$_8$ x 27^3/$_4$ in. Source: Anonymous. 67.200

571

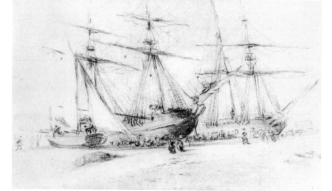

565. Unidentified British ship. Wool embroidery. 13^1/$_4$ x 16^1/$_2$ in. Source: Mrs. Thomas S. Gates, Jr. 53.3951

566. Unidentified armed ship. Colored grass. 5^1/$_{16}$ x 7^3/$_8$ in. Source: Harold H. Kynett. 58.1076

567. Unidentified British naval vessel and Spanish topsail schooner. Wool embroidery. 12^3/$_4$ x 18^1/$_2$ in. (Not illustrated.) Source: Wendell P. Colton, Jr. 65.985

568. Unidentified sailing vessels, anchored. Watercolor. 12 x 19^3/$_4$ in. Source: Philip R. Mallory. 67.285

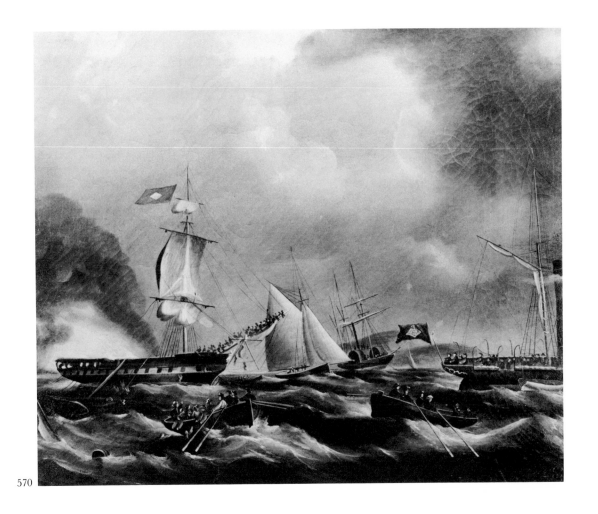

570

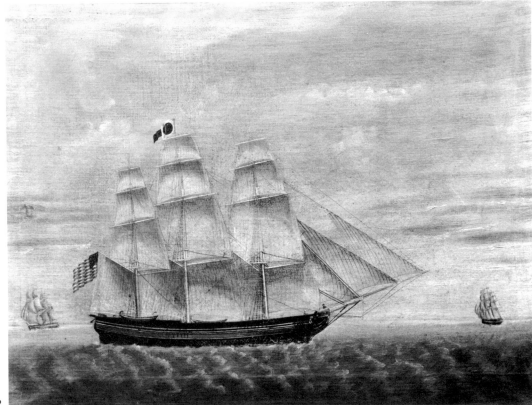

572

181

574

573. Sketchbook. Pen, pencil. 6¼ x 9⅜ in. Twenty-three drawings of merchant vessels, mostly British. (Not illustrated.) Source: Alfred Stainforth. VFM 967

574. Sketchbook. Pen, watercolor. 9³/₁₆ x 11¼ in. Eleven drawings of ships, seamen, sterns, flags, headlands, Boston harbor. Source: Alfred Stainforth. VFM 967

IDENTIFIED SCENES, ARTISTS UNIDENTIFIED

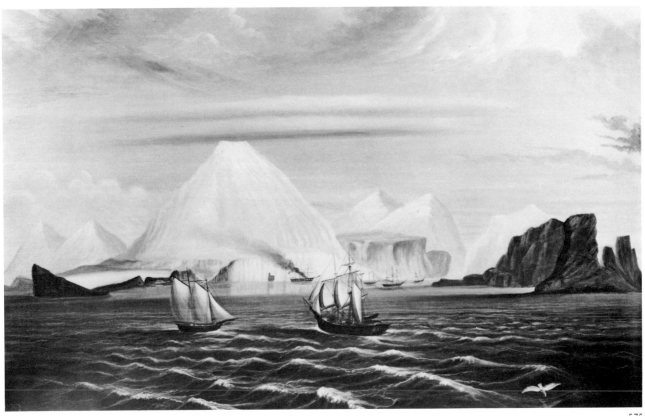

575

575. *Desolation Island* [Kerguélen] *South Indian Ocean*. Oil. 19½ x 31½ in. Source: Savings Bank of New London. 39.1265

576. *At Hastings* [England], *1820*. Crayon. 12 x 18 in. (Not illustrated.) Source: Philip R. Mallory. 67.267

577. *Heards Island, South Indian Ocean*. Oil. 19¾ x 31½ in. Source: Savings Bank of New London. 39.1256

578. *Lord Howe's Island S.S.E. dist 15 miles*. Pencil. 4⅝ x 7⁹⁄₁₆ in. Source: Museum purchase. 73.899.445

577

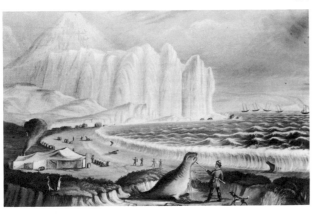

578

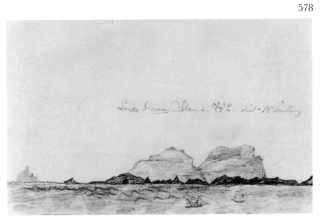

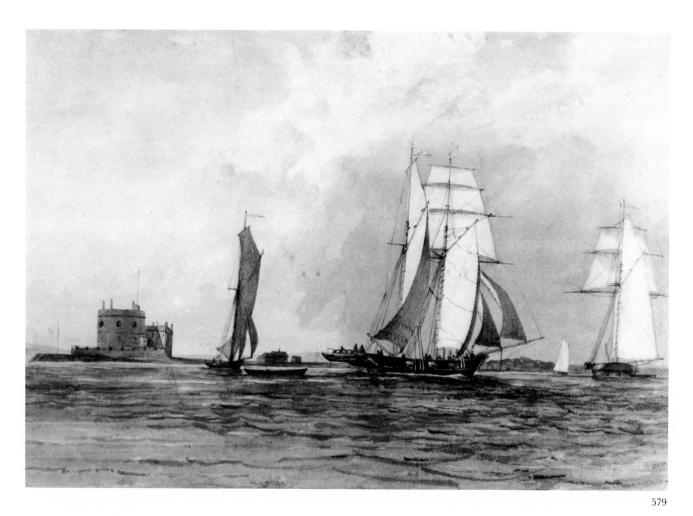

579. *Southsea Castle* [England] *1833*. Watercolor. 9¹/₄ x 13
 in. Source: Philip R. Mallory. 67.265

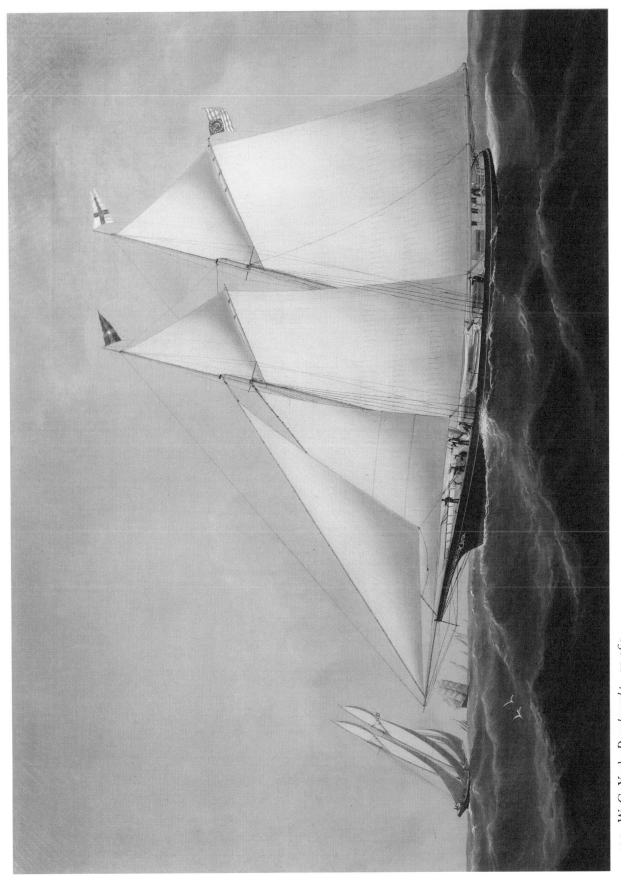

493. W. G. York, *Dreadnaught* 55.960

UNIDENTIFIED SCENES, ARTISTS UNIDENTIFIED

580

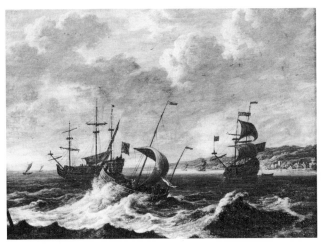

581

582

583

584

580. Unidentified beach scene. Watercolor. 13¼ x 21⅛ in. Source: Philip R. Mallory. 67.268

581. Unidentified harbor. Oil. 6¹⁵/₁₆ x 9 in. Source: Dr. Austin Lamont. 52.828

582. Unidentified harbor. Crayon, wash. 5½ x 9 in. Source: Philip R. Mallory. 67.273

583. Unidentified harbor. Watercolor. 5½ x 9 in. Source: Philip R. Mallory. 67.274

584. Unidentified marine scene. Watercolor, gouache. 5⁹/₁₆ x 8⅝ in. Dated in pencil on reverse: 1843. Source: Philip R. Mallory. 67.284

585

586

585. Unidentified marine scene. Watercolor, gouache. 5½ x 8⁵/₁₆ in. Dated in pencil on reverse: 1843. Source: Philip R. Mallory. 67.283

586. Unidentified shipwreck. Oil. 11¼ x 17½ in. Source: Anonymous. 73.143

587. Unidentified Dutch whaling scene. Oil. 32½ x 46½ in. Source: Miss Charlotte Steinmetz. 57.34

588. Unidentified whaling scene. Thirty Dutch tiles. Inscribed: Föhr Anno 1605. 25½ x 30 in. Source: Clement H. Watson. 53.3080

589. Unidentified whaling scene. Watercolor. 9³/₁₆ x 12¹/₁₆ in. Source: Laurence J. Brengle, Jr., William C. Brengle, Mrs. Thomas S. Gates, Jr. 53.71

590. *A Sailor's Prayer*. Watercolor, pen, pencil. 15 x 10 in. (Not illustrated.) Source: Mrs. Charles H. Martin. 47.1750

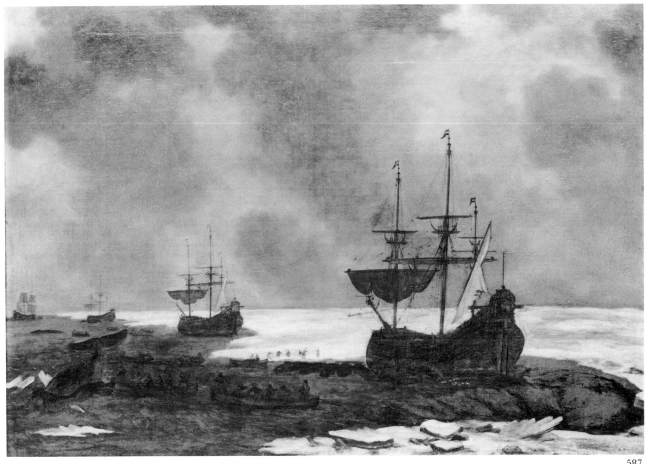

587

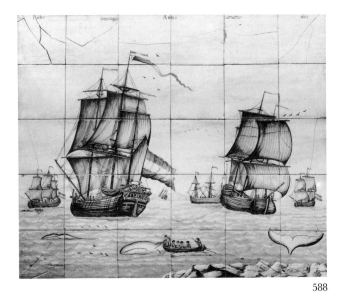

588

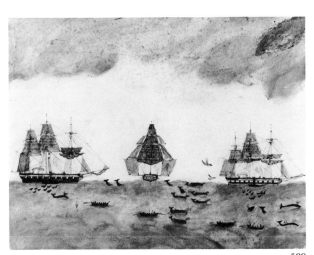

589

ORIENTAL ARTISTS

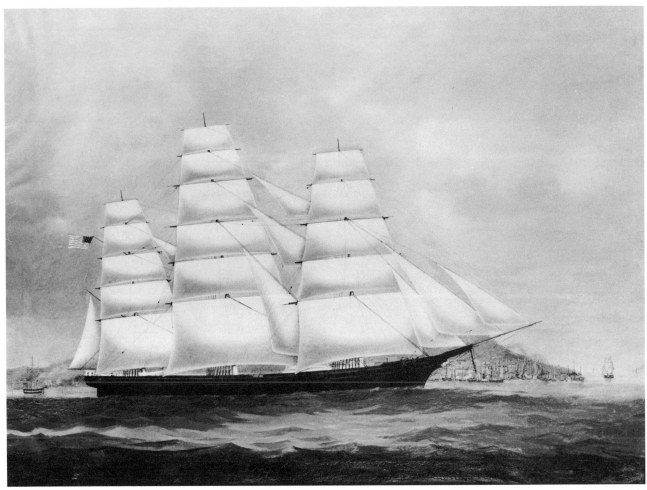

591

Hoy Qua

591. *Twilight*. Oil. 24 x 33 in. Coming into Hong Kong.
 Label on reverse: Hoy Qua Portrait [Map] &
Chart . . . ter. N°2. American ship, built 1857 by Charles
Mallory, Mystic, Connecticut. Source:
William C. Brengle. 55.1221

Kung Fong

592. *Carrie Clark*. Oil. 17⅝ x 23 in. Label on reverse:
 Kung Fong Photographer Foochow Road No. 73,
Shanghai. American ship, built 1874, Waldoboro, Maine.
Source: Miss Jessie M. Nutter. 63.1711

592

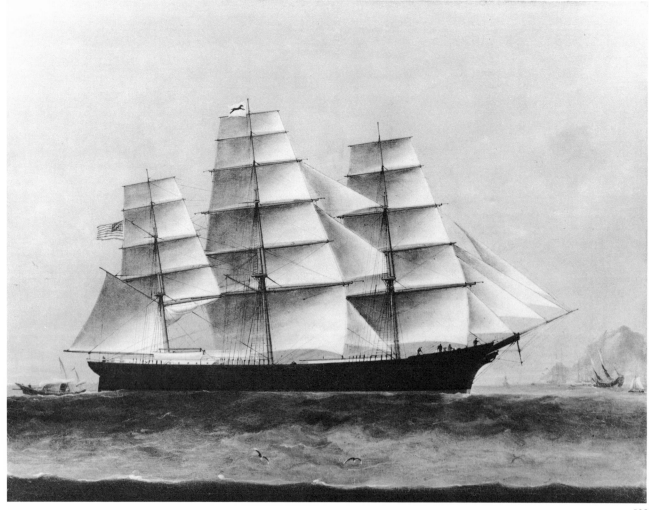

594

593

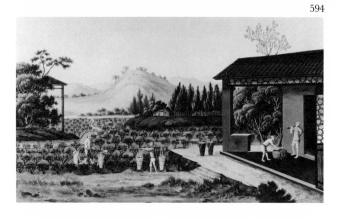

595

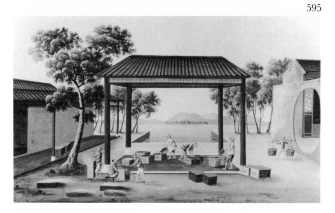

Lai Sung
(active 1850–1885)

593. *Great Admiral*. Oil. 22¼ x 29¼ in. Coming into Hong Kong. Stencil on reverse: Lai Sung Portrait Painter Hong Kong. American ship, built 1869, East Boston, Massachusetts. 1575 tons. 214'2" x 40'3" x 25'3". Source: Museum purchase. 59.239

Tinqua
(active 1840–1870)

594–596. Twelve paintings of tea culture. Watercolor. 7³/₈ x 12½ in. Attributed to Tinqua. (Illustrated: 70.47; 70.49; 70.50.) Source: Museum purchase. 70.39–70.50

Youqua
(active 1840–1870)

597. [Two Chinese ladies in garden.] Oil. 17⁵/₈ x 23¹/₈ in. Label on original stretcher: Youqua, Painter Old Street No 34. (Not illustrated.) Source: Mrs. Seth E. Barron. 45.768

598. [Two Chinese ladies in garden.] Oil. 17 1/2 x 22 15/16 in. Label on original stretcher: Youqua Painter Old Street No 34. (Not illustrated.) Source: Mrs. Seth E. Barron. 45.769

599. [Whampoa anchorage.] Oil. 16 7/8 x 30 in. Attributed to Youqua. Ca. 1850. Source: William C. Brengle. 53.4548

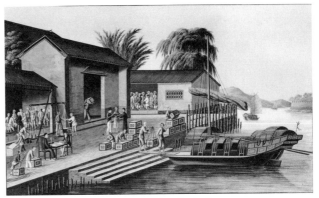

596

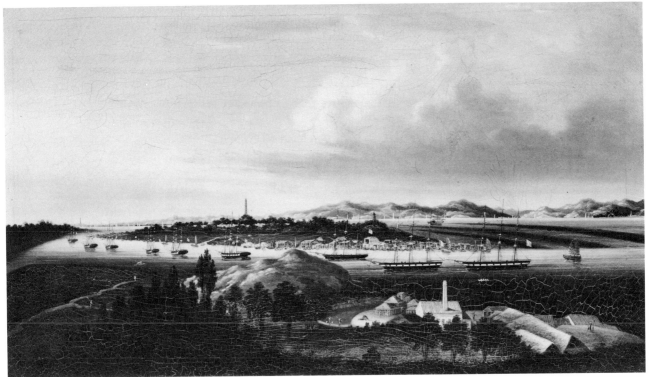

599

IDENTIFIED VESSELS, ARTISTS UNIDENTIFIED

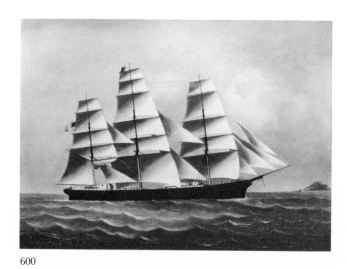

600

600. *Annie M. Smull*. Oil. 22½ x 31½ in. American ship, built 1868, Mystic, Connecticut. 1053 tons. Source: C. D. Mallory Estates. 45.336

601. *Beaver*. Oil. 17½ x 23 in. American ship. Source: New York Yacht Club. 48.1126

602. *Cavallo*. Oil. 17¾ x 23 in. Off Boca Tigris. American bark, built 1856, Mystic, Connecticut. 115' x 31'2" x 9'4". Source: Museum purchase. 78.88

603. *Charles L. Pearson*. Oil. 17 x 22⅞ in. American barkentine, built 1873, East Boston, Massachusetts. 664 tons. 153'5" x 34' x 17'5". Source: Harold H. Kynett. 48.889

601

BEAVER.

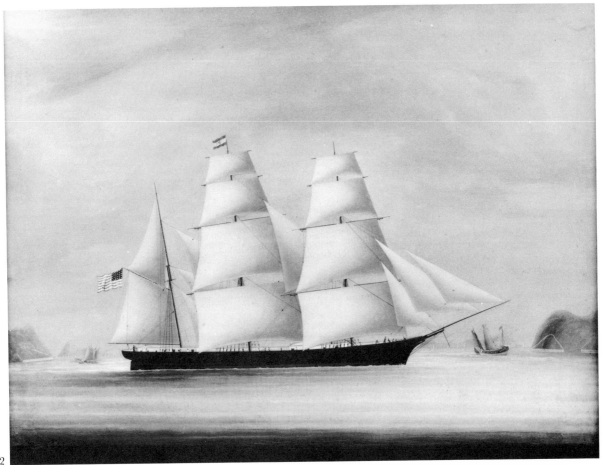

602

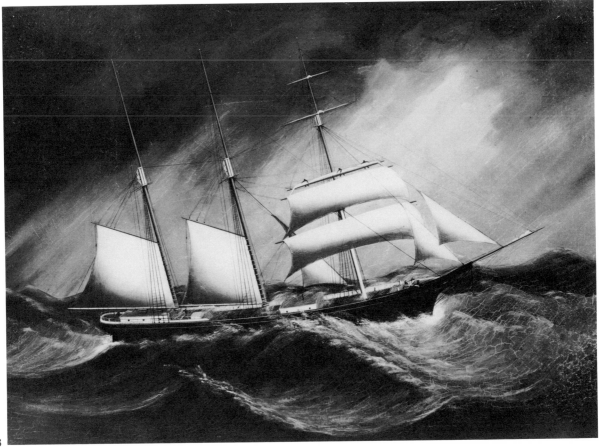

603

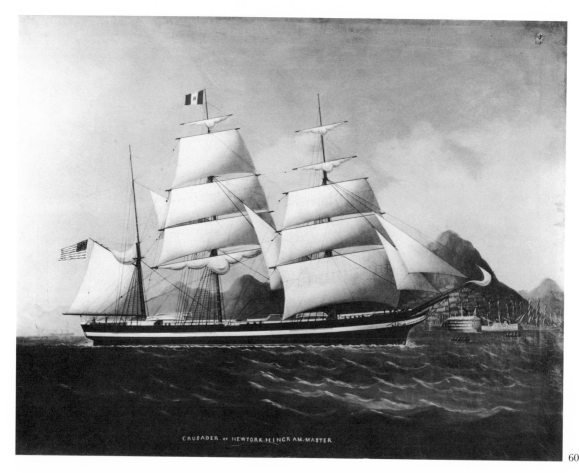

604

604. *'Crusader.' of New York: H. Ingram, Master.* Oil.
 22⁵/₁₆ x 29¹/₂ in. Coming into Hong Kong.
American bark, built 1847, Medford, Massachusetts.
Source: William C. Brengle. 55.1222

605

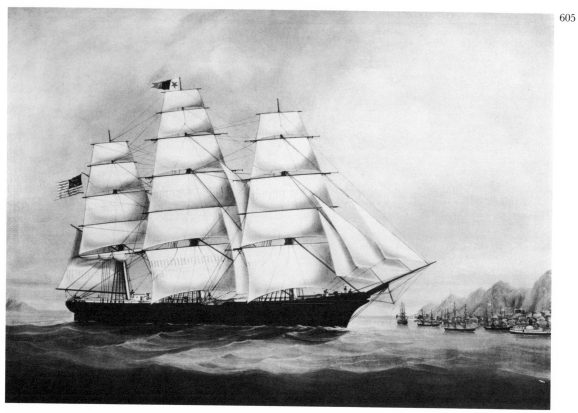

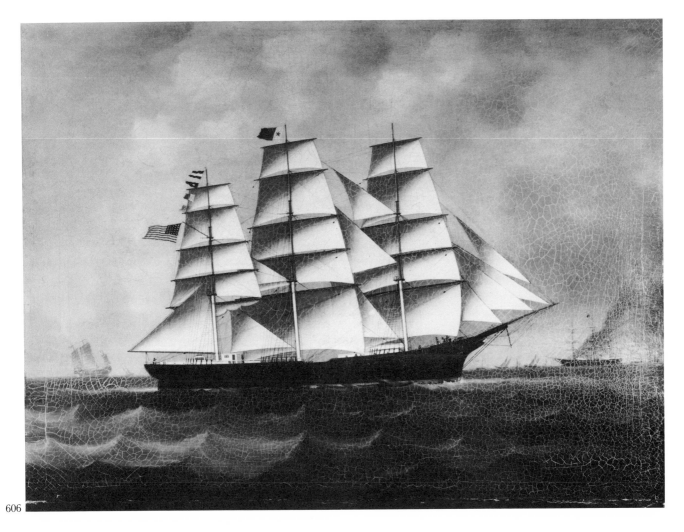

606

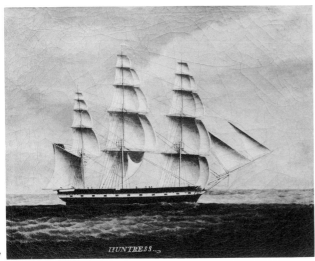

607

608

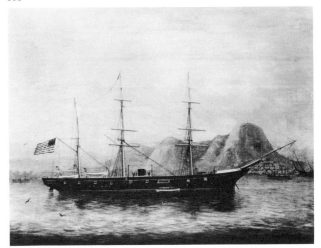

605. *Haze*. Oil. 28 x 39 in. Coming into Hong Kong.
 American ship, built 1859, Mystic, Connecticut. 795
tons. 151' x 34' x 21'6". Sold 1865, Mallory owned; lost
1886. Source: C. D. Mallory Estates. 45.331

606. *Haze*. Oil. 28¹/₂ x 37⁷/₈ in. Coming into Hong Kong.
 American ship, built 1859 by Charles Mallory. 795
tons. 151' x 34' x 21'6". Sold 1865, Mallory owned; lost
1886. Source: Museum purchase. 67.80

607. *Huntress*. Oil. 19³/₄ x 25¹/₈ in. American ship, built
 1839, Newburyport, Massachusetts. Source: New
York Yacht Club. 48.1127

608. *Iroquois*. Oil on panel. 17¹/₂ x 23¹/₄ in. Anchored
 at Hong Kong. U.S. steam sloop of war, built 1859,
New York. 1016 tons. 198'11" x 33'10" x 13'. Source:
Mrs. Thomas S. Gates, Jr. 55.1158

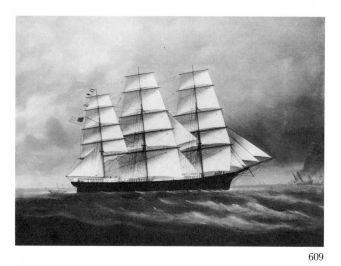

609

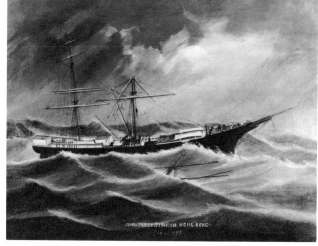

610

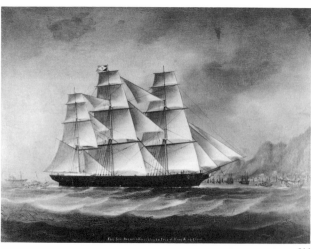

611

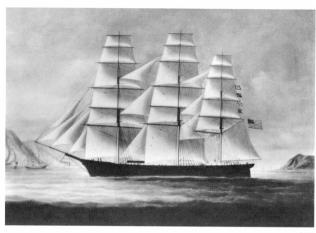

613

609. *J. A. Thomson*. Oil. 25¹/₂ x 34⁵/₁₆ in. Coming into
 Hong Kong. American ship, built 1869, Bath,
Maine. 1298 tons. 197' x 38'9" x 23'9". Source: Mrs.
Thomas S. Gates, Jr. 53.4561

610. *'John Currier.' Typhoon. Hong Kong, Oct. 21 1893.* Oil.
 17¹/₂ x 23 in. American ship, built 1882, Newbury-
port, Massachusetts. Source: Laurence J. Brengle, Jr.,
William C. Brengle, Mrs. Thomas S. Gates, Jr. 53.82

611. *Ship 'John Norman' entering the port of Hong Kong China.*
 Oil. 27⁵/₈ x 37⁵/₈ in. British ship, built 1855,
Barnstaple, England. 150' x 27' x 17'5". Source: William
C. Brengle. 55.1202

612. *Prima Donna*. Oil. 22³/₈ x 29¹/₂ in. American ship,
 built 1858, Mystic, Connecticut. (Not illustrated.)
Source: Mrs. Harriet Greenman Stillman. 39.640

613. *Prima Donna*. Oil. 25 x 36¹/₄ in. Coming into Hong
 Kong. American ship, built 1858, Mystic, Connecti-
cut. Source: C. D. Mallory Estates. 45.329

614. Unidentified bark. Oil. 28 x 37½ in. (Not illustrated.) Source: Anonymous. 71.312

615. Unidentified Chinese junk. Oil on panel. 18 x 23 in. Source: Laurence J. Brengle, Jr., William C. Brengle, Mrs. Thomas S. Gates, Jr. 53.77

616. Unidentified American ship. Oil. 19¾ x 26⁷/₁₆ in. (Not illustrated.) Source: Mrs. Stephen N. Bond. 54.1417

617. Unidentified British topsail schooner. Oil. 17½ x 23 in. Armed schooner coming into harbor. Source: C. K. Stillman. 54.565

618. Unidentified American auxiliary steamboat. Oil. 16½ x 25⅛ in. (Not illustrated.) Source: Anonymous. 76.165

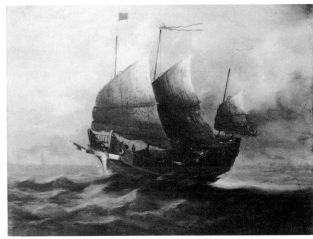

615

617

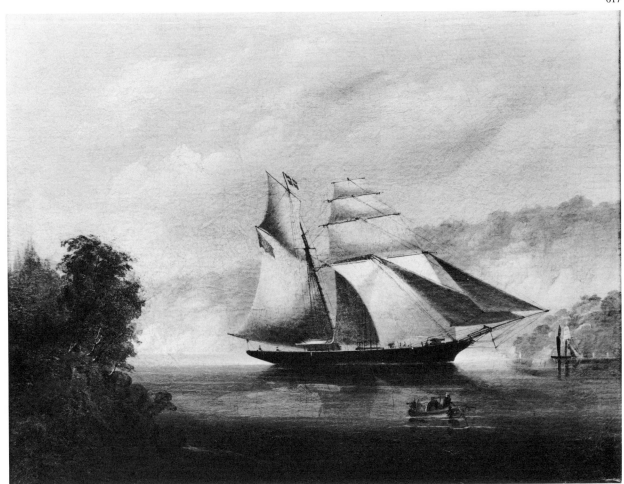

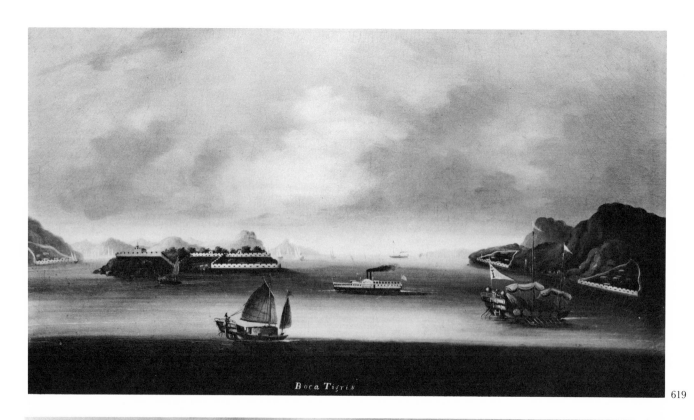

Boca Tigris

619

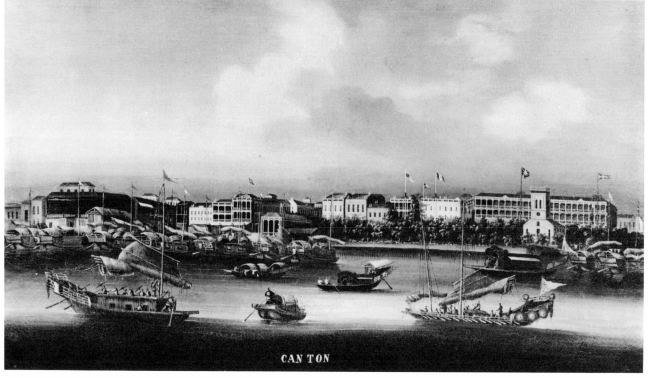

CANTON

621

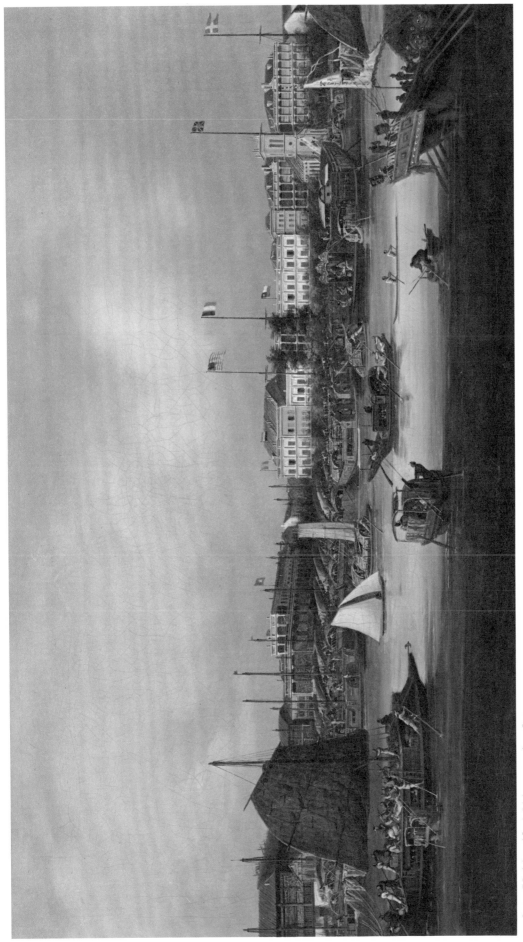

620. Unidentified Chinese artist, Canton 54.590

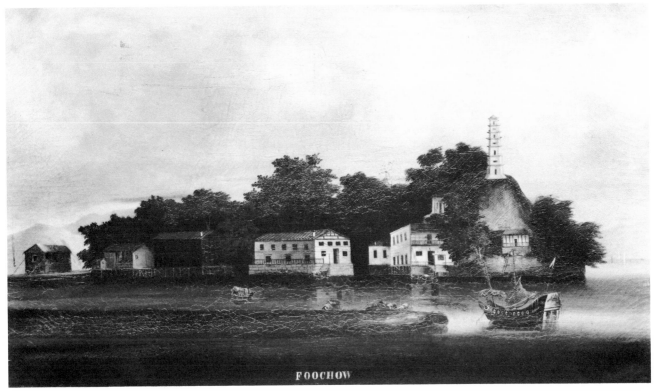

FOOCHOW

622

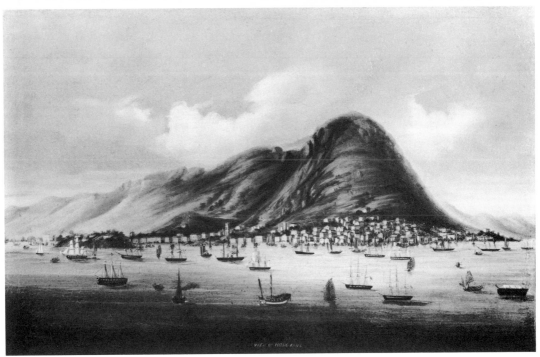

623

619. *Boca Tigris*. Oil. 17¹/₂ x 30 in. On Pearl River, below Canton. Source: Daniel B. Stannard, Mabel A. Stannard. 63.520

620. [Canton.] Oil. 16³/₄ x 29⁵/₈ in. Ca. 1855. River scene, *hongs* in background. Source: Mrs. Thomas S. Gates, Jr. 54.590
See color illustration opposite p. 200.

621. *Canton*. Oil. 17¹/₂ x 30¹/₈ in. Ca. 1850–1855. *Hongs* in background. Source: Daniel B. Stannard, Mabel A. Stannard. 63.701

622. *Foochow*. Oil. 17¹/₂ x 30¹/₈ in. Ca. 1860. River scene, buildings to the rear; pagoda on hill to the right. Source: Daniel B. Stannard, Mabel A. Stannard. 63.523

623. *View of Hong Kong*. Oil. 18¹/₈ x 28¹/₂ in. Ca. 1855. View from Kowloon. Source: Mrs. Thomas S. Gates, Jr. 54.591

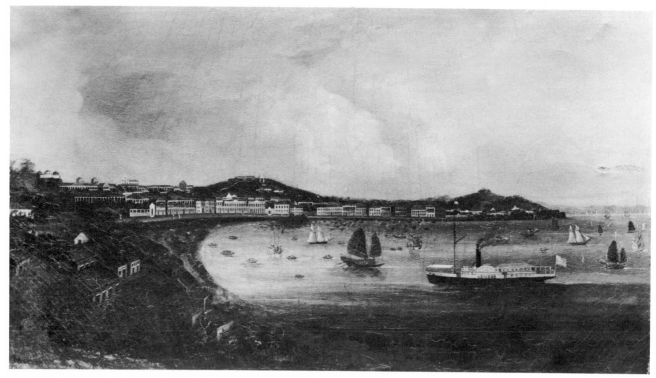

624

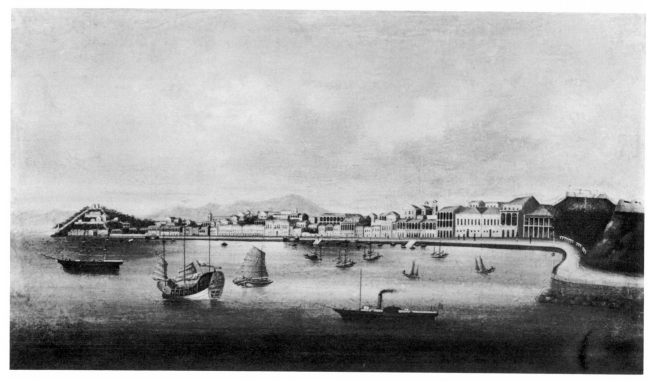

625

624. [Macao.] Oil. 17½ x 30⅜ in. Ca. 1845–1855. Inner
 harbor, U.S. steamboat to the right, city to the rear.
Source: Mrs. H. C. Cornwall. 47.223

625. [Macao.] Oil. 16¾ x 29¾ in. Ca. 1850–1855. Inner
 harbor, city to the rear. Source: Mrs. Thomas S.
Gates, Jr. 53.4536

626. [Macao.] Oil. 10⅝ x 15 in. Ca. 1850–1855. Praya
 Grande to the right. Source: Mrs. Thomas S.
Gates, Jr. 54.575

627. *Peiho.* Oil. 17⅝ x 30⅜ in. Ca. 1860. British attack
 on Peiho River, Taku Forts, 1858. Source: Daniel B.
Stannard, Mabel A. Stannard. 63.524

626

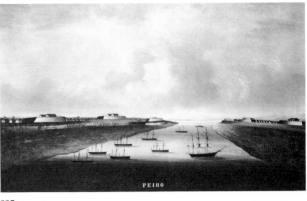

627

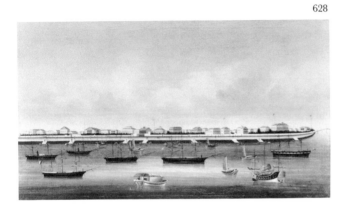

628

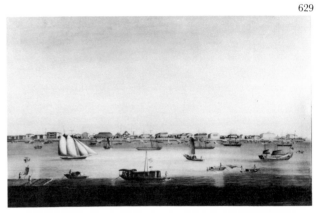

629

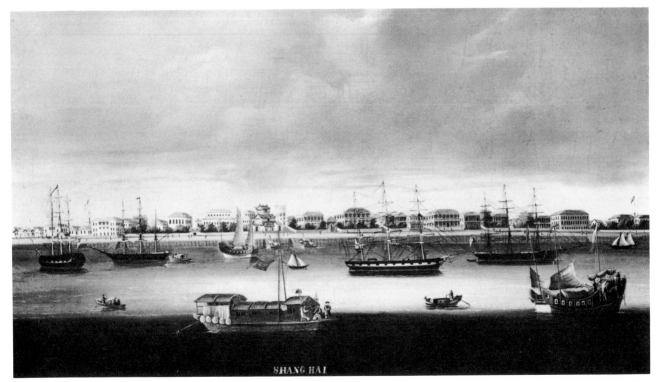

630

628. [Shanghai.] Oil. 17 x 30 in. Ca. 1860. View from the
harbor. Source: Mrs. Thomas S. Gates, Jr. 54.589

629. [Shanghai.] Watercolor. 18³/₄ x 31 ¹/₈ in. Ca. 1850.
Source: William C. Brengle. 53.4569

630. *Shanghai*. Oil. 17 ¹/₂ x 30 in. Ca. 1850. City to the rear.
Source: Daniel B. Stannard, Mabel A. Stannard.
63.521

203

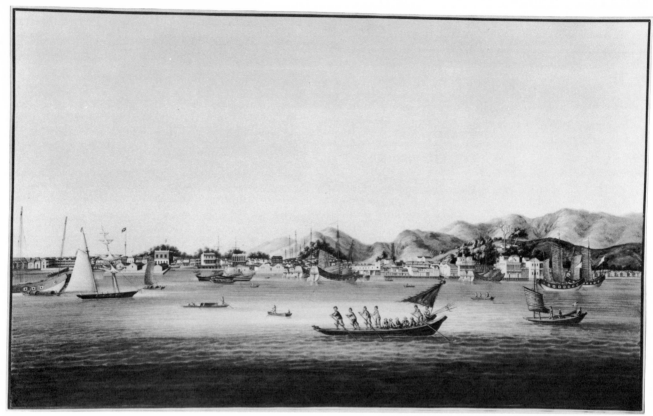

631

632

631. [Swatow.] Watercolor, gouache. 19¹⁄₈ x 31³⁄₈ in. Ca. 1850. Source: William C. Brengle. 54.588

632. [Whampoa anchorage.] Watercolor, gouache. 19¹⁄₂ x 31¹⁄₂ in. View of Dane's Island. Source: William C. Brengle. 54.587

633. *Whampoa.* Oil. 17¹⁄₄ x 30 in. Ca. 1850–1855. View of Dane's Island. Source: Daniel B. Stannard, Mabel A. Stannard. 63.522

634. [Flower Pagoda, Whampoa.] Oil. 20⁷⁄₈ x 15³⁄₄ in. (Not illustrated.) Source: H. F. Cornwall. 69.439

633

JAPANESE ARTIST, UNIDENTIFIED

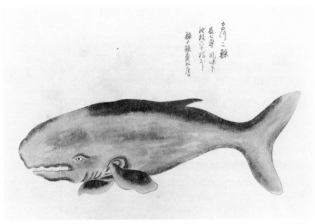

635a

635b

635. Whaleboat, varieties of whales, whaling tools.
　　Watercolor scroll. 10 in. x 68 ft. Source: James A.
Keillor, in memory of Colin B. Keillor.　　58.589

635c

INDEXES

VESSELS

Bracketed entries are not illustrated.

MASTERS

BACKGROUNDS

Bracketed entries are not illustrated.

CONCORDANCE OF
ACCESSION NUMBERS AND CATALOG NUMBERS

31.175	556	39.588	21	43.1116	418	45.327	27
32.88	292	39.640	612	43.1117	429	45.328	549
32.267	426	39.1256	577	43.1118	427	45.329	613
32.268	442	39.1265	575	43.1119	421	45.330	391
32.269	444	39.1273	147	43.1120	430	45.331	605
32.270	423	39.1275	146	43.1121	434	45.332	510
32.271	428	39.1280	533	43.1122	445	45.333	169
32.272	437	39.1550	407	43.1123	424	45.334	544
32.273	443	39.1551	406	43.1124	419	45.335	188
32.274	417	39.1555	563	43.1125	438	45.336	600
32.275	433	39.1559	18	43.1126	420	45.339	189
33.2	525	39.1560	218	43.1127	422	45.340	30
33.3	491	39.1563	132	43.1128	431	45.341	255
33.4	508	39.1564	564	43.1129	441	45.342	180
33.5	15	39.1586	89	43.1130	440	45.762	538
33.6	312	39.1603	527	43.1131	432	45.768	597
33.7	410	40.102	405	43.1132	439	45.769	598
33.8	59	40.138	404	43.1133	425	45.880	221
33.9	278	40.161	271	43.1134	436	45.885	272
33.10	554	40.221	51	43.1154	8	45.887	509
33.11	348	40.341	297	43.1155	9	46.202	214
33.14	526	40.405	31	43.1156	487	46.680	148
35.29	471	40.406	29	43.1279	481	47.223	624
35.65	503	40.407	28	43.1280	485	47.990	465
36.4	492	40.407A	33	43.1281	482	47.1750	590
37.62	466	40.408	34	43.1283	478	48.27	317
37.89	286	40.409	37	43.1284	479	48.28	318
37.105	170	40.410	32	43.1286	542	48.36	116
38.246	178	40.502	196	43.1287	480	48.83	397
38.318	370	40.503	202	43.1290	483	48.107	456
38.389	531	41.272	294	43.1291	484	48.887	392
38.390	497	41.662	502	44.230	64	48.888	95
38.391	534	43.796	389	44.285	280	48.889	603
38.392	519	43.797	390	44.419	457	48.957	76
38.393	552	43.798	386	45.323	129	48.958	120
38.556	396	43.799	388	45.324	555	48.1126	601
38.559	506	43.800	385	45.325	520	48.1127	607
38.561	83	43.1115	435	45.326	128	48.1156	363

48.1157	365	53.2552	20	53.4570	345	56.879	316
49.180	149	53.2562	91	53.4573	467	56.1048	559
49.183	207	53.2931.1–6		53.4575	518	56.1051	535
49.220	500		155, 156	54.565	617	56.1052	142
49.706	486	53.3080	588	54.566	403	56.1053	127
49.754	5	53.3945	275	54.575	626	56.1054	130
49.804	358	53.3946	307	54.587	632	56.1061	408
49.1416	23	53.3947	530	54.588	631	57.10	14
49.1438	181	53.3948	258	54.589	628	57.34	587
49.2740	123	53.3949	57	54.590	620	57.102	216
49.2779	110	53.3950	274	54.591	623	57.103	217
49.2865	162	53.3951	565	54.1209	122	57.393	168
49.3174	80	53.3954	558	54.1327	160	57.480	459
49.3175	74	53.3958	58	54.1337	354	57.481	458
49.3176	81	53.3959	557	54.1338	355	57.510.1–74	477
49.3177	77	53.3960	351	54.1417	616	57.511	477
49.3178	117	53.3961	201	54.1605	145	57.768	39
49.3179	395	53.3962	393	54.1606	325	57.769	40
50.3068	295	53.4529	452	54.1608	324	57.873	461
51.419	414	53.4530	253	54.1609	323	57.874	462
51.3351	451	53.4531	507	55.113	455	58.589	635
51.3997	144	53.4532	313	55.387	159	58.626	314
51.4008	296	53.4533	273	55.388	157	58.974	499
52.828	581	53.4534	504	55.389	158	58.1076	566
52.833	551	53.4535	489	55.507	114	58.1092	219
52.839	366	53.4536	625	55.544	263	58.1301	474
52.1158	529	53.4538	512	55.547	320	58.1303	277
52.1159	517	53.4540	183	55.707	543	58.1318	194
52.1424	7	53.4541	496	55.708	11	58.1433	545
52.2248	195	53.4548	599	55.710	12	59.239	593
52.2249	200	53.4550	528	55.719	516	59.263	460
52.2250	208	53.4551	346	55.917	476	59.647	211
52.2251	204	53.4554	337	55.959	25	59.648	319
52.2252	209	53.4555	344	55.960	493	59.649	540
52.2253	203	53.4556	151	55.965	322	59.650	206
52.2254	184	53.4557	338	55.967	411	59.738–796	161
53.71	589	53.4558	336	55.1076	547	59.1177	311
53.75	50	53.4559	448	55.1135	315	59.1195	301
53.77	615	53.4561	609	55.1157	87	59.1296	469
53.78	394	53.4562	285	55.1158	608	59.1298	468
53.79	335	53.4563	150	55.1202	611	59.1357	131
53.81	541	53.4564	340	55.1221	591	59.1362	82
53.82	610	53.4565	310	55.1222	604	59.1363	84
53.84	126	53.4566	521	56.70	79	59.1380	387
53.109	197	53.4567	308	56.176	133	59.1381	473
53.497	356	53.4568	341	56.794	402	60.207	514
53.2507	16	53.4569	629	56.878	349	60.208	515

60.276	101	65.55	49	67.73	505	69.313	113
60.278	100	65.67	501	67.74	75	69.359	176
60.279	102	65.79	382	67.75	488	69.377	329
60.280	104	65.236	94	67.76	124	69.378	330
60.282	97	65.237	93	67.77	384	69.439	634
60.283	98	65.238	134	67.78	125	69.525	212
60.284	103	65.239	562	67.80	606	69.820	135
60.285	99	65.409	139	67.98	177	70.39–50	
61.2	453	65.410	138	67.136	173		594–596
61.19	105	65.411	141	67.200	572	70.155	400
61.21	475	65.413	140	67.208	339	70.158	224
61.177	199	65.414	137	67.209–219	174	70.338	548
61.223	111	65.522	238	67.223	304	70.377	401
61.224	107	65.706	560	67.240	532	70.378	399
61.302	306	65.713	2	67.247	35	70.382	284
61.501	398	65.715	1	67.248	270	70.383	282
62.71	220	65.792	41	67.250	118	70.384	283
62.476	85	65.793	42	67.251	112	70.385	281
62.477	550	65.794	46	67.253	265	70.607	121
62.912	205	65.890	43	67.254	262	70.664	230
62.1152	326	65.891	45	67.255	268	70.799	343
62.1153	537	65.892	44	67.256	260	70.800	447
62.1251	293	65.893	47	67.257	266	70.832	256
62.1258	494	65.894	48	67.258	261	71.5	288
62.1287	171	65.966	185	67.259	267	71.36	179
62.1329	215	65.967	446	67.260	259	71.39	383
63.461	73	65.970	536	67.261	264	71.42	472
63.466	187	65.971	190	67.262	569	71.66	210
63.520	619	65.974	191	67.263	416	71.301.1	332
63.521	630	65.975	378	67.265	579	71.301.2	333
63.522	633	65.985	567	67.267	576	71.301.3–13	334
63.523	622	65.1028	115	67.268	580	71.312	614
63.524	627	65.1069	22	67.273	582	72.20	4
63.535	553	65.1088	368	67.274	583	72.51	364
63.537	19	65.1089	369	67.279	412	72.53	361
63.701	621	66.176	279	67.281	571	72.54	524
63.882	92	66.180	539	67.283	585	72.151	334
63.1711	592	66.194	454	67.284	584	72.152	309
64.38	55	66.223	289	67.285	568	72.486	152
64.259	327	66.225	298	67.289	413	72.490	153
64.278	38	66.226	300	68.29	490	72.491	154
64.444	257	66.227	299	68.30	495	72.493	254
64.615	357	66.245	222	68.31	192	73.14.1–7	376
64.616	360	66.248	347	68.34.1–14	175	73.14.8	374
64.692	353	66.278	362	69.37	3	73.14.9	373
65.53	136	66.286	56	69.47	186	73.14.10–14	376
65.54	359	67.61	287	69.228	415	73.14.15	375

73.14.16	376	75.79	241	75.448	88	77.324	17
73.21	164	75.82	251	75.462	26	78.10	165
73.41	570	75.84	243	76.1.5	226	78.32	328
73.116	252	75.94	229	76.1.22	239	78.33	53
73.143	586	75.102	234	76.1.89	246	78.70	223
73.144	198	75.109	233	76.1.117	231	78.88	602
73.181	305	75.134	244	76.1.130	250	78.99	65
73.403	213	75.144	235	76.1.138	245	78.117	13
73.448	24	75.178	237	76.1.143	249	78.139	232
73.457	464	75.187.9	371	76.1.153	247	78.148	331
73.899.445	578	75.187.10	450	76.1.159	240	78.197	109
73.491	36	75.187.14	225	76.22	163	78.238	290
74.7	291	75.187.18	90	76.28	367	79.24	96
74.13	350	75.187.34	463	76.50	302	79.39	62
74.60	228	75.188.1	381	76.58	546	79.100	166
74.928	321	75.188.2	143	76.66	303	79.154	167
74.979.27	513	75.188.4	352	76.81	372	79.166	276
74.979.33	511	75.291	71	76.84,85	377	79.167	248
74.979.34	561	75.292	172	76.147	54	79.189.1	108
74.1049	522	75.293	60	76.153,154	334	79.189.2	106
74.1074	86	75.338	242	76.163	379	HFM 156	269
75.21	470	75.339	236	76.164	380	VFM 668	6
75.32	63	75.399	66	76.165	618	VFM 964	342
75.33	72	75.400	69	76.172	78	VFM 965	409
75.34	67	75.401	182	77.47	227	VFM 966	449
75.35	61	75.402	523	77.174	10	VFM 967	573,574
75.36	68	75.403	498	77.175	193		
75.37	70	75.442	52	77.322	119		